THE DAY THE RENAISSANCE WAS SAVED

THE DAY THE RENAISSANCE WAS SAVED

THE BATTLE OF ANGHIARI AND DA VINCI'S LOST MASTERPIECE

NICCOLÒ CAPPONI

MELVILLE HOUSE
BROOKLYN · LONDON

THE DAY THE RENAISSANCE WAS SAVED

Melville House Publishing 8 Blackstock Mews
46 John Street and Islington
Brooklyn, NY 11201 London N4 2BT

mhpbooks.com facebook.com/mhpbooks @melvillehouse

ISBN: 978-1-61219-460-8

Library of Congress Control Number: 2015955589

Design by Christopher King

Printed in the United States of America
10 9 8 7 6 5 4 3 2 1

The publication of this volume has been supported by a translation grant
of the Italian Ministry of Foreign Affairs.

Questo volume ha beneficiato di un contributo alla traduzione
assegnato dal Ministero degli Affari Esteri italiano

In memory of Vincenzo Pertile (1920–2010),
who was a teacher in every sense of the word

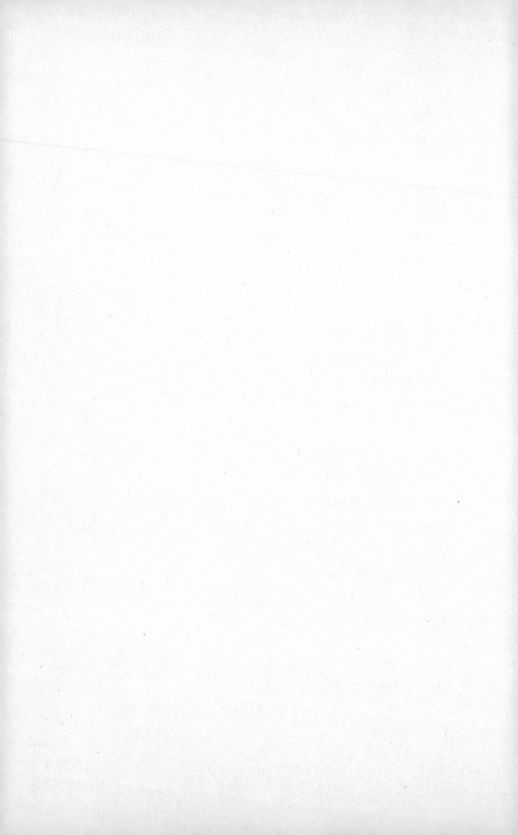

CONTENTS

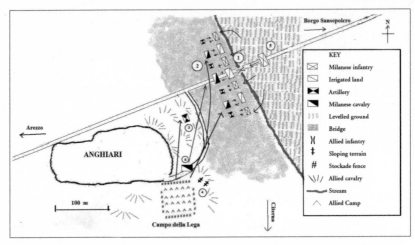

3:00 p.m. (1) Milanese troops, including a strong contingent of mounted infantrymen, head towards the bridge, with the aim of attacking the allied camp. (2) Having spotted the cloud of dust raised by the enemy army, Micheletto Attendolo gallops off to defend the bridge with only a few men. (3) Neri Capponi and Bernardetto de' Medici sound the alarm in the allied camp, simultaneously co-ordinating the counter-attack.

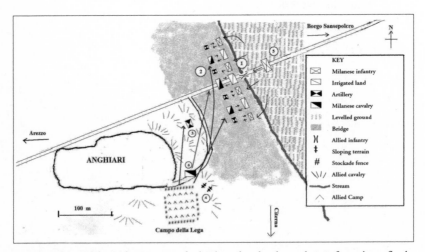

3:15–5:30 p.m. (1) The Milanese cross the bridge, also thanks to their infantry's outflanking manoeuvre and line up on the levelled ground. (2) Piero Giampaolo Orsini and Simonetto da Castel San Pietro rush to Attendolo's aid. The fight between the knights and foot soldiers grows particularly fierce as the Milanese try to break through enemy lines. (3) The Genoese crossbowmen are deployed on the hill's slopes, and target Niccolò Piccinino's troops from their positions. (4) The allies drag a few bombards out of their camp to enfilade the Milanese army's left flank. (5) Piccinino deploys his reserves to create a breach in the enemy front. (6) The galloping intervention of the allies' reserves re-establishes the balance between the armies.

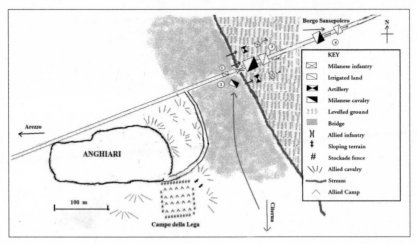

5:30–7:00 p.m. (1) Astorre Manfredi brings his men forward to repel the allies, creating a hole in the Milanese ranks. (2) The arrival of the League's *saccomanni* turns the tide in the allies' favour, and they manage to push the ducal troops back over the stream. (3) Although Piccinino has fewer troops at his disposal, he manages to close his ranks again and hold out for a little longer. (4) Exhaustion, the enemy's pressure and the wind blowing dust into their eyes cause the Milanese army's ranks to collapse and they are pursued by the allies right up to Borgo Sansepolcro.

INTRODUCTION

'For the sake of a nail the shoe was lost . . .' This is how a poem by the English poet George Herbert begins, which I learned as a little boy alongside a host of other nursery rhymes. Starting with the loss of a nail, then the horse, the knight and the battle, the ditty ends with the downfall of a kingdom. Following this sequence of single but interconnected events, Herbert's poem is seemingly deterministic, but it actually opens up an endless range of alternate conclusions which were far from unavoidable: the loss of a single nail doesn't necessarily entail the loss of that horseshoe, just like losing a battle wouldn't automatically lead to the downfall of a state. In fact, Herbert focuses on a precise sequence of factual events, and doesn't account for the different outcomes the events in question might have led to.

The events . . . as far as many historians are concerned, these are the domain of dilettantes or journalists, the 'pornographers of history', who exhibit a morbid curiosity for the most striking facts, but are nevertheless incapable of understanding the profound dynamics of Clio's world: 'the crests of foam that the tides of history carry on their strong backs', according to Fernand Braudel's celebrated

definition. However, all historians—whether they are providentialists, structuralists, postmodernists, or devout, agnostic or atheistic—must nevertheless reckon with the events, be it to confirm, contradict, or distort them, perhaps even going so far as to deny they ever occurred in the first place. Yet however true it remains that history and events are intimately intertwined, it's equally true that historians must routinely deal with substantial gaps in the narratives.

Despite what one might assume, there is still much we don't know even when it comes to the great figures of the past, which we should in theory know everything about. Yet this is perfectly logical if we consider, for example, all the coffee bills which we diligently consign to our trash bins, which, taken together, could tell us a great many things about our habits, revealing information that could prove of the utmost importance to historians if considered alongside other documents. To these we must add our daily actions, which are often forgotten by posterity, even when they involve other people, and simply because nobody—all too rightly—thinks it useful to write them down. These days, only a select few keep diaries, and this certainly won't be of help to the work of future scholars.

As a matter of fact, the real problem for historians doesn't lie in the abundance of documents, or lack thereof, but rather in how to interpret what we actually have. This is why it is crucially important to focus on events that almost definitely happened in the past, even if we cannot verify them beyond the shadow of a doubt. The memory of a particular event may have been transcribed by a single individual, and naturally, even if this person had been the most honest person who ever lived, not only would his or her account be constrained

by this person's hierarchy of values and priorities, but it would also reflect a limited perspective—the direct result of the impossibility of omniscience. For example, let's consider a hypothetical conversation between two friends in a room: each of them will have only a limited view of their surroundings and will primarily concentrate on a few words to describe what really sparked their interest. If these friends later transcribed their meeting, a relatively slow-witted reader might find apparently irreconcilable contradictions in both their accounts: the shape of the room could be described as either a square or a rectangle; one of the friends might have noticed that the other often picked his nose, which the other person of course wouldn't have mentioned. Fanatical devotees of deconstruction might then conclude that neither of them was telling the truth, whereas it would simply mean that each friend had merely stated a part of the whole truth. Hence, the historian must seek to find the common elements in both accounts, which will allow him to reconstruct the scene with the greatest possibly accuracy.

However, and keeping in mind the notion of the horseshoe nail, events are never isolated, but rather are links in a causal chain. Some of these links are larger than others and are more immediately evident: these are the pivotal turning points of history. The only example of this in Herbert's poem is the loss of the horse, and consequently that of the knight: the missing nail doesn't necessarily lead to the horseshoe falling off, just as the loss of said shoe doesn't trigger the horse's fall, and one cannot take it for granted that a single individual could alter the outcome of a battle, which might also end inconclusively in any case. Indeed, the very concept of a 'decisive'

battle is often rejected by modern historians, also because stability and continuity are more easily dealt with. In spite of this, some clashes exercise a mysterious fascination over us that no historical analysis will be able to dispel: for instance, the battles of Salamis, Hastings, Waterloo, Gettysburg or Stalingrad—just to mention a few—are seen as moments that altered the course of history, and this ultimately leads to the following question: what would have happened if the Persians, the Saxons, the French, the Confederates or the Germans hadn't been defeated?

'You can't reason about history with ifs and buts' is a mantra that is often cited, especially by contemporary historians, all of whom for that matter—and for a whole host of reasons—experience a kind of revulsion towards what has been called 'counterfactual history', or to put it another way, 'futuristic history'. However, examining the alternative outcomes of certain events in our past could serve to facilitate our understanding of said events and perhaps even suggest different interpretations to those that have become generally accepted. Logically, this approach isn't entirely unproblematic, given that there's always a risk of falling into the trap of historical relativism—not to mention the fact that debunking myths or acquired certainties could lead one to be burned in effigy (or sometimes even literally) by those self-styled gatekeepers of knowledge.

The story of the battle of Anghiari belongs to this former category insofar as the examination of the facts reveals an extraordinary variety of alternative outcomes which might have transpired all too easily. These days, it's difficult to accept that up until the second half of the fifteenth century, what we call the Renaissance had barely

gotten on its feet, and wasn't the mass artistic, cultural and intel-
lectual movement we like to think it was. In fact, the Renaissance
only truly got underway in Florence after 1434, due to internal fac-
tors; and even then, given the sudden political changes that were so
common in fifteenth-century Italy, there was no certainty that the
Renaissance would last. Whether we like it or not (and my friends
from Siena certainly don't like this notion) the Renaissance was an
exclusively Florentine phenomenon at its very start, but its survival
ultimately depended on the patronage of the wealthy. Any crisis,
even one of limited proportions, might have led to the drying up
of funding for the arts. In this respect, given what had taken place
before and what transpired afterwards, the outcome of the battle of
Anghiari played an all-encompassing role in shaping Italian history.
The nail was hammered back into the horseshoe.

Keeping this in mind, this book before you isn't simply an *his-
toire bataille* about the clash that took place on June 29, 1440; nor
is it merely an account of a fresco that has since gone missing, even
though this is one of this book's leitmotifs. To this day, there is still a
great deal of debate over the real casualty rates—Machiavelli tells us
only a single soldier died, whereas Willibald Block cites several hun-
dred—as though the number of those butchered could alone explain
a battle, or as though we could determine the true value of a work
of art merely by measuring its size. Instead, I have attempted to con-
textualise the events of Anghiari within their political and cultural
settings in order to allow the reader to understand the consequences
of certain actions. As for the painting of the battle, it was merely the
end result of a historical and artistic process.

I spent the past few months working in solitude, and not without encountering a few difficulties here and there. Tracking down the necessary documents was relatively easy, compared to the ways in which technology can betray us, or life's vicissitudes can get in the way—not to mention my own perfectionism, which has always gnawed away at me. Chancing across new books on the subject, or conversations with other scholars, often led me to rewrite entire paragraphs, if not whole chapters, in the attempt to produce as polished, and dare I say honest, a work as I could manage to put to paper. As such, I would first of all like to thank Aurelio Pino and Luca Formenton at Saggiatore for their infinite patience, which I often put to the test. Serena Casini, who also works at Saggiatore, was someone with whom I was able to discuss this tome's particularly Tuscan flavor. Monsignor Timothy Verdon and Professor Maria José Balsach proved of great assistance in helping me to understand the artistic development that took place during the Renaissance. I was also privileged to have long conversations with professors James Hankins and Arthur Field in regards to the world of fifteenth-century humanism. Professor Michael Mallett, who passed away in 2008, was among the first to prompt me to reflect on the importance of the battle of Anghiari. I would also like to pay tribute to Professor Gioacchino Gargallo of Castel Lentini for numerous inspiring leads when it came to the field of historiography. Ciro Paoletti, Mario Scalini and Marco Morin kindly enlightened me on the manifold aspects of war in fifteenth-century Italy. Domenico del Nero lent crucial help in the examination of Latin texts. Ersilia Graziani, of the State Archives of Rome, provided precious assistance when it came to papal

documents. Maurizio Seracini generously shared the results of his research on the fresco of the battle of Anghiari. Finally, I would like to thank my family, my daughters Francesca and Ludovica, and especially my wife Maria, who, although beset by her own problems, somehow found the time to correct my syntax. Because when all's said and done, only love remains.

A NOTE ON
OLD CONVENTIONS

Units of Time

In Renaissance Italy, time was calculated according to what would later be termed 'Italian time', which was based on sunlight and which differed from 'French time,' which has now become universal and is measured according to the Earth's rotation. The day would begin an hour after sunset, meaning—for example—that a twenty-four-hour period could start at five o'clock in the afternoon and last until nine o'clock the following evening, depending on the season. For the sake of ease, I employed modern timekeeping throughout the book.

The beginning of a solar year tended to vary, but the most commonly used dates were either *Nativitate* (Christmas) or *Ab incarnatione* (March 25); for instance, the Feast of the Annunciation was used to determine the beginning of the year in Florence until 1750. As above, I adopt modern dates, whereby each year starts on January 1.

Currencies and Units of Measure

As in most of Western Europe, the Italian monetary system was governed by the Carolingian Reform, which was based on a pound of

pure silver and its two subdivisions, the *solidus* and the *denier*, which worked out as 12 deniers to each *solidus*, and 20 *solidi* per *pound*. In fifteenth-century Italy, the *libra*, *solidus* and *denaro* formed the basis of all large-denomination currencies (the *libra*, it must be said, was merely used for accounting purposes), like the *florin* in Florence or the *ducat* in Venice. The number of *librae* could vary, meaning a *florin* could be divided into four *librae*, the *ducat* into six or seven. The clout these currencies exerted was determined by their rates on the foreign exchange market, as well as their intrinsic value: for various reasons, the *florin* would depreciate by roughly a third against the *ducat* throughout the fifteenth century.

Units of measure also varied; for instance, the Florentine *libbra* weighed around 339.5 grams, while the Venetians split the *libbra* into the *libbra grossa* (for heavy weights) and the *libbra sottile* (for light ones). Further complicating matters, linear or surface measurements were never the same, and it was often the case that a distance of a few kilometres between one place and another would suffice to produce a significantly different reading. As in other cases, I streamline this to match the modern decimal system.

Names and Designations

In everyday parlance, the terms 'Republic' and 'Commune of Florence' were used interchangeably, but from a constitutional point of view, the Florentine Republic only truly came into being in 1494 (although it had been called such before that date). Thus, and despite the fact the state was organised like a republic, I use 'Commune' throughout this text when referring to Florence. As for Venice, I

often use the moniker 'Serenissima', and 'Superba' in Genoa's case. I frequently employed 'ducal' when referring to the Milanese and the troops in their employ.

Proper names are applied according to their most common usage. Filippo Maria Visconti granted Niccolò Piccinino the right to append the dynasty's name to his own, and was later awarded the same privilege by Alfonso of Aragon. Nevertheless, I stick to 'Piccinino' since this was prevalent throughout the chronicles and official documents of the time.

In Florence, it was customary to call people by their patronymic as well as their surname, in order to avoid confusing them with relatives who bore the same name. Palla Strozzi was called Palla di Nofri Strozzi (Palla, son of Nofri Strozzi) to distinguish him from a couple of cousins who shared his name. Neri Capponi was simply referred to as Neri di Gino (Neri, son of Gino), and his surname was never used. Whenever the patronymic wasn't enough to distinguish one person from another—and this practice went back several generations—people made recourse to nicknames: Cosimo di Giovanni de' Medici (Cosimo, son of Giovanni de' Medici) was called 'the Elder' to set him apart from his nephew and namesake. For the sake of convenience, I use names and surnames, except for people like Luca di Maso degli Albizzi, whose patronymic is particularly important in the context of this history.

THE DAY THE
RENAISSANCE
WAS SAVED

PROLOGUE

The bearded man took a few steps back to let his eyes encompass the scene. The flurry of bodies around the banner was a compelling sight, as was the image of flesh and metal which had been so inextricably fused together into a single, terrible, convulsive mass. Some men were destined to live in a constant state of tension, especially those who'd taken up vocations where risks always lurked around the corner, all for the sake of turning a quick profit, if not everlasting fame. After all, the bearded man reasoned, he himself belonged to that category.

He observed the scene again. The surrounding light cut through the cloud of dust enveloping men and beasts, making the whole seem even more animated and dramatic. He focused his attention on one of the characters in front of him, a man in a red cap whose face was contorted into a furious, anguished scream. Everything seemed to revolve around him, as was fitting, given the entire affair indisputably pivoted around him.

It was a hot afternoon in June and someone on the village ramparts was keeping a watchful eye on the fortress in the distance as it loomed out of the mist that enshrouded the valley. The man's gaze was trying to detect something, but the undulating air on that sweltering afternoon was making everything blurry. The background music of birdsong and chirping crickets, coupled with the smell of freshly mown hay, was that of a typical summer day. Yet other sounds and smells permeated the surroundings: the rhythmic, steely clang of bodies on the move; men and beasts spurred forth by cries and curses; the pungent, oppressive stench of hundreds of horses and livestock that saturated the nostrils, its bitterness mixing with the dust raised by countless hooves.

The man briefly removed his cap to mop his sweaty brow and limped down from the walls: the limp was the legacy of an old wound, like the lasting back pain caused by constantly sitting on a saddle weighed down by heavy armour. These aches had worsened over the years, but at that moment, his physical ailments paled in comparison to his spiritual ones. The aims he'd pursued his whole life had just gone up in smoke thanks to his employer's sudden needs. Watching the knights file past him, the man in the red cap experienced intense envy at the thought that there were independent lords among their ranks, something which he'd never managed to become, despite all his efforts; and the march he was about to embark on would take him even further from those goals.

Or maybe it wouldn't. Some time ago, he'd discussed with his subordinates another path, which could potentially turn the situation on its head, and perhaps even help him fulfil his lifelong dream.

Alea iacta est, the die is cast, just like the condottiere who'd lived centuries ago had once said, whose sayings were constantly cited by the scholars orbiting his employer. After all, the man with the red cap thought, even his profession was a game, and its outcome often rested on a lucky throw of said dice. Especially if one of the players loaded his dice.

The horse was ready. The man with the red cap saddled up, the strain making his backache even more painful. Once this was over, he would vacation in some spa town, where he'd probably encounter some similarly indisposed colleagues.

He inspected the troops that stood in front of him to see that everything was in order, then, and turned his gaze towards the vale. He slowly raised the *bastone* (baton) in his hand, unleashing an explosive cacophony of trumpets, and the men and horses began to move in the direction of the plain, vanishing into a cloud of dust.

1

'NOW YOU HAVE TO PUT UP
WITH WAR . . .'

The bearded man cast a careful eye on the palace's great hall. Given its size, the endeavour he was about to embark on was colossal, to say the least, but would likely earn him both money and prestige. Of course, his current clients weren't as generous as the ones he was used to; but the troubles plaguing Italy had forced him to abandon what had served as his base for nearly twenty years and return to his native city. Luckily, he had built himself a solid reputation as an artist over the years, which had procured him the commission he was now about to begin—a work of art which, according to his new patrons' intentions, would send a strong political message regarding this regime's military capabilities.

Indeed, the city was in dire need of military success, and desperate to rally its citizens, renowned for their propensity for bickering, under a single banner. After decades of being ruled by a single family, which had nevertheless kept the semblance of pluralistic government, the city's inhabitants had recovered their freedom, thanks to the help of outsiders.

7

Yet this liberty had brought with it a series of troubles, not least of which was the rebellions of vassal communes; one of these had been giving the regime a particularly hard time over the past decade. All attempts to capture the city had failed, and the heavy taxes required to finance the war had sowed discontent among its citizens. Worse still, failures on the battlefield had created the widespread impression that the regime was on the verge of collapsing, and there were many who did nothing but wait for the return of the former ruling family. Therefore, the work of art commissioned from the artist would serve as a piece of propaganda both within the city and beyond.

The problem lay in choosing the subject. Even in the past, the city hadn't been renowned for its bellicosity, and the victories it had won on the battlefield could literally be counted on the fingers of two hands. Above all, he needed to find subjects relevant to the current situation: the ongoing war against the rebel communes and the city's resistance to those who'd previously tried to strip it of its independence. In the end, he'd been left with two options: the first went back to 1363, when the citizens had defeated the troops of the English condottiere John Hawkwood; the second was a clash so renowned that it had attracted the attention of historians of the highest calibre, among them Leonardo Bruni, Flavius Blondus and Bartolomeo Platina—and its memory had already been enshrined in several works of art. There was a hope chest in the city that depicted the second battle in question, and it belonged to the descendants of one of the politicians who'd served with the victorious army.

Before leaving the great hall, the bearded man worked out a few numbers in his head to help him figure out how he would sketch the scene. There was a lot of work to do: he had to hire laborers, purchase

cardboard and tools, find the wood for the scaffolding, and he would need great quantities of all of these in order to paint one of the greatest pictorial cycles the world had ever seen: The Battle of Anghiari.

Angelo della Pergola and Guido Torelli knew their trade. The condottieri, who served Filippo Maria Visconti, the Duke of Milan, were preparing a battle plan from their base at Borgo Sansepolcro, in the higher Val Tiberina, while observing the Florentine camp outside the fortified village of Anghiari, a few kilometres to the southwest. Visconti's captains had just received valuable information from a deserter regarding the discord between Bernardino Ubaldini and Ardizzone da Carrara, the enemy commanders. Moreover, they knew how shabby the army Florence had cobbled together really was, since the Commune was still recovering from the heavy defeats at Zagonara the previous year and in the Val di Lamone just a few months earlier. With the best soldiers already working for other potentates, the Florentines had been forced to enlist what little had been left over; and although some of the condottieri employed by the Commune enjoyed good reputations, the majority of the Florentine army were a motley crew of veterans who'd once served the now deceased Braccio da Montone, and leftovers scraped from the bottom of the mercenary barrel. Furthermore, the rifts among the Florentine commanders, who usually came from different military schools and whose personalities often clashed, were no laughing matter. The Milanese condottieri intended to capitalise on these factors.

Despite their enemies' inferior troops, della Pergola and Torelli

were aware of the risks involved in leading an attack on a fortified camp, making it necessary to lure the Florentines into unfavourable terrain. Torelli therefore began to provoke the enemy by sending small units of soldiers against the camp, certain that they would be repelled. But this was part of the plan to inspire in their enemies a misguided sense of confidence. The Milanese captains carried on in this manner for a few days until they'd determined the moment was ripe. On October 9, in the year of our Lord 1425, the Milanese forces followed the same script, but this time with a significant variation: the first offensive unit would be supported by a second and much stronger unit, so as to lure as many Florentine troops as possible out of the camp. The plan went off without a hitch, and just as the Milanese were about to retreat, the Florentines darted into hot pursuit of their enemy, only to find themselves face to face with the entire Milanese army. In the midst of the ensuing confusion, Torelli and della Pergola had the upper hand, beating the Florentines and forcing them to retreat. Bernardino Ubaldini, who'd lost control of his troops at the very start, was captured by the Milanese, while his comrades were only able to flee by digging their spurs into their horses' flanks.

Anghiari was the fourth consecutive battle Florence had lost in the space of fifteen months, in what had been a bona fide *annus horribilis* for the Commune.

The events that led to the battle of Anghiari had their origins in Italy's confused political situation between the end of the fourteenth century and the beginning of the fifteenth. At the start of the 1400s, the Duke of Milan, Gian Galeazzo Visconti, known as the Count of Virtù (from Vertus in the Champagne region, a feud he'd received

after his marriage to his first wife, Isabelle of Valois, the daughter of the French king John II), had succeeded in imposing his hegemony over large swathes of northern and central Italy through a shrewd and unscrupulous policy of expansionism. By the time of his death in 1402, Venice and Florence were the last states willing to stand up to him. The Papacy was not in a position to oppose the duke due to the 'Western Schism' in 1378, which had led to the creation of two pontiffs—the legitimate Pope, who mostly resided in Rome, and an anti-Pope who dwelled in Avignon. And as for southern Italy, it had long been a battleground between the houses of Anjou and Aragon—that is, when it wasn't used for the same purposes by the various branches of the Angevin dynasty. But Venice could do little to oppose Gian Galeazzo's expansionist aims, given that it ruled over a relatively limited territory on the Italian mainland; and the Florentines had their backs against the wall because the majority of Tuscan communes had chosen to swear fealty to Visconti. Politically isolated, surrounded by hostile neighbours and defeated on the field of battle, Florence appeared on the verge of falling into the duke's rapacious clutches.

Gian Galeazzo had split his dominions between his sons Giovanni Maria, Filippo Maria and the illegitimate Gabriele Maria. The youthfulness of the Count of Virtù's heirs, combined with the internecine warfare of the his guardians, plunged the Dukedom of Milan into utter chaos, a situation that allowed a few condottieri in Gian Galeazzo's service to claim Milanese territories for themselves. One of them, the Piedmontese Facino Cane, even became the de facto lord of the dukedom thanks to his domineering influence over Giovanni Maria. The Venetians and Florentines also took advantage

of the political confusion in Milan: the Venetians conquered a sub-
stantial chunk of Gian Galeazzo's eastern domains, annexing Vi-
cenza, Padua and Verona, expanding their state to the borders of
Mantua and Ferrara; and in 1406 the Florentines conquered Gabriele
Maria Visconti's Pisa after their blockade of the city—supported by a
fleet of galleys leased from Venice—put an end to the fierce and pro-
tracted siege (the Pisans having no intention whatsoever to submit to
the yoke of the Florentines, for whom they bore nothing but hatred).

In theory, a Florentine conquest of Pisa should have alarmed
Venice, as that would have forced it to contend with an economic
powerhouse that would thereafter enjoy the added benefit of an out-
let to the sea. But the Serenissima[1] had played its hand well: the Ve-
netians had succeeded in taking Padua in 1405, when the Florentines
had been too preoccupied with the siege of Pisa to assist the Paduans.
Moreover, the conquest of Pisa didn't prove to be such a bargain
for Florence: the sediment build-up in the Arno was rapidly silting
the Pisan harbour, thereby limiting its capabilities, and the acquisi-
tion of this new maritime outlet brought Florence into conflict with
other states along the Tyrrhenian coast. Genoa took a particularly
dim view of the new economic rival and convinced its French gov-
ernor (the city was then a protectorate of the House of Valois) to
defy previous agreements and refuse to cede to Florence the ports of
Livorno and Sarzana, and the guard towers protecting Porto Pisano.
In the end, Venice's help had proved to be a poisoned chalice for
Florence.

On the other hand, the extension of its *terraferma* (mainland)
territories proved to be a great boon for Venice. Not only had the

Serenissima managed to strengthen its security by extending its western borders to Lake Garda, it had also acquired an ample bread-basket from which to draw all the necessary supplies for its capital's survival. In addition, the conquests of Verona, Padua and especially Vicenza had created excellent investment opportunities for Venice's ruling class. On top of this, the acquisition of feudal fiefs that once owed their allegiance to the Visconti or other cities in the terraferma would prove to be crucial recruitment bases for the Serenissima. That said, Venice's expansion into northern Italy would also force the city to participate in the struggle for hegemony on the Italian peninsula, as well as effectively induce a kind of strategic schizophrenia in the Venetians, who would have to switch their focus back and forth between their mainland front and their eastern and Mediterranean fronts, which were themselves threatened by Ottoman expansion in the Balkans and the Aegean.

Milan's recovery began in 1412 with the murder of Giovanni Maria Visconti and the death of Facino Cane. Before leaving this world for the next, Cane bequeathed his mercenary troops, as well as his rather sizeable personal fortune, to Filippo Maria Visconti, on the condition that Filippo Maria marry Cane's widow, Beatrice di Tenda. Possessing all of his father's political acumen and unscru-pulousness, the young duke happily consented to marry a woman twenty years his senior, well aware of all the material and military advantages such a union would bring.

In his effort to reconquer his father's lands, the young duke had to contend with other pretenders to the Lordship of Milan—among them his cousin, Estorre Visconti, who'd taken possession of

Monza—and, depending on the situation, employ force, diplomacy or the underhanded methods used by Italian rulers at the time. For his military campaigns, Filippo Maria availed himself of one of the deceased Cane's lieutenants, the tough and capable Francesco Bussone—also known as 'Carmagnola', after the place of his birth. In a series of brilliantly led campaigns, Carmagnola reconquered Lombardy and parts of Piedmont, including Tortona, Alessandria, Vercelli and Novara. In 1421, in cooperation with the Aragonese fleet, Carmagnola forced Genoa to accept Milanese sovereignty, and the following year he resoundingly defeated the armies of the Swiss cantons, which had been sent to occupy Ticino at Arbedo (Bellinzona). Carmagnola also owed his successful reconquest of the Visconti territories to the fact that no other Italian potentate stood in his way: they were all otherwise engaged.

The election of Doge Tommaso Mocenigo in Venice in 1414 did much to slow the Serenissima's Western expansionism, as did the republic's war against the Ottomans and subsequent entanglement with Ludwig of Teck, the Patriarch of Aquileia, who enjoyed the military support of the King of Hungary—and future Holy Roman Emperor—Sigismund of Luxemburg. With a conflict brewing on their doorstep, the Venetians couldn't afford the luxury of opening a second front in Lombardy, and Mocenigo furthermore didn't consider the expansion of the terraferma as useful to the republic. In his political testament, Mocenigo implored his readers not to allow Francesco Foscari to succeed him, convinced that he would bog down Venice in expensive wars. A little less than two weeks after Mocenigo's death, his successor was punctually announced: it

was Francesco Foscari, and in a short period of time, all of the dead doge's worries would prove well founded.

During the first years of the Visconti reconquest, Florence had neither the interest nor the means to oppose the Serenissima's advances, given the distraction of more immediate and urgent threats: at the beginning of the fifteenth century, Ladislaus of Anjou, the King of Naples, had embarked on a policy aimed at annexing the entirety of central Italy to his realm, and had in a short time conquered Rome and reached Tuscany's borders. An alliance between Florence and Siena briefly managed to halt Ladislaus, who was also trying to impede Florentine efforts to bring the schism in the Catholic Church to an end. Florence's efforts to heal this schism were partly motivated by genuine piety, but they also arose from political considerations, given that the Papacy could serve as a buffer state between Tuscany and the Kingdom of Naples. For the opposite reason, Ladislaus had no intention whatsoever to expend any efforts to heal the schism, given that the existence of two rival pontiffs favoured his expansionist politics. All told, the Florentines were caught between a hammer and an anvil since they not only feared Ladislaus but also worried their territorial claims on the Romagna and the Val Tiberina would be compromised by a unified Church, which would likely prove tougher to deal with than a divided one. The oligarch Gino Capponi summed up this contradictory stance rather well in an aphorism he sent his son Neri sometime in 1410:

It would be in the interests of our Commune, as well as our Freedom, to see the Church remain divided; but it would be

bad for our souls: and thus we must do nothing to further the rift, but rather let nature take its course. And even if we could do anything, that should involve only spiritual concerns, and if their unity come at the cost of our Commune, so be it. Even the friendship of the Pope can be useful to our Commune, and none of you should oppose it; nobody can achieve anything, if not thanks to the Church's friendship.[2]

The Florentines had already tried to bring the schism to an end by supporting the convention of an ecumenical council at Pisa to resolve the issue. The council deposed both the pontiff in Rome and the one in Avignon and elected a new one, Antipope Alexander V. But the Pisan council's lack of substantial political authority only produced a single outcome: the creation of a three-headed Church, given the deposed pontiffs' refusal to move out. As though that weren't enough, Antipope Alexander V died after barely a year in power, and the Pisan council elected the ambitious Baldassarre Cossa, with the name of Antipope John XXIII. To begin with, the new Pope tried to reconquer Rome, assisted by both Florence and Louis II of Anjou, the pretender to the throne of Naples. After an initial success that saw Antipope John XXIII installed in the Eternal City, Louis's defeat on the battlefield led him to abandon the enterprise, forcing Cossa to seek an agreement with Ladislaus and offer him official recognition as the King of Naples. Ladislaus, who'd already managed to sign separate peace treaties with both Florence and Siena, was more than pleased to accept, since he needed time to reorganise his forces.

Nevertheless, Ladislaus marched on Rome in May 1413, forcing Antipope John XXIII to flee and compelling the Florentines, who'd just emerged from a strenuous conflict with Genoa for control of Livorno and Sarzana, to reach a new accord with the Neapolitan king. Everyone in Florence knew the Neapolitan king's thirst for power was unfettered by any treaty, and thus the city breathed a sigh of relief upon learning that Ladislaus had given up the ghost in August 1414. Just as with Gian Galeazzo, nature had proved to be Florence's best ally.

Ladislaus's demise also favoured the healing of the Church's schism. As soon as he'd returned to Rome, Antipope John XXIII had convened another ecumenical council, which nonetheless had to be called off almost immediately due to the Neapolitan offensive. Thanks to the willingness of Sigismund of Luxembourg, the Holy Roman Emperor,[3] the council reconvened in Constance, in southern Germany, and deposed all three Popes. All the same, the Council Fathers waited a couple of years before electing a new Pope, not wanting any obstacles in their way while they worked on the so-called policy of 'conciliarism', which in practice placed the Vicar of Christ under the authority of the Church's general assembly and obliged him to convene an ecumenical council every five years. When Martin V (also known as Oddone Colonna) was finally elected Pope in November 1417, he accepted some of the decrees issued at Constance, but also wasted no time in restoring Papal Primacy when it came to matters of faith. Martin left Germany the following April, after the ecclesial assembly was dissolved, and headed straight for Rome. Unfortunately for him, since a new power had arisen in the centre of the

peninsula, the political situation in Italy would force him to spend several years in forced exile from the Eternal City.

One could well say that violence had been a part of Andrea Fortebracci's (or Fortebraccio's) life since his childhood; as a young boy, he'd fought alongside his father Oddo Fortebracci, Count of Montone, in the internecine clashes in their native Perugia, where they'd numbered among the ranks of the *beccherini* faction. The rise of the enemy faction, the *raspanti*, forced the Fortebraccis into exile, and Andrea spent a good part of his life obsessed by a single idea: to re-enter Perugia as its lord and master. His roving lifestyle led him to enlist under the banner of the celebrated condottiere Alberico da Barbiano, but his obsession made him an unruly subordinate, especially given his propensity to abandon his employers whenever the opportunity to return to Perugia arose. Consequently, and also because he lacked the necessary economic resources, his career progressed slowly; and despite his obvious skills as a soldier, he was still a simple squadron commander by his early thirties. He broke this impasse in 1407, when the city of Acervia offered to make him its lord in exchange for his protection against the condottiere Ludovico Migliorati da Fermo. Fortebracci clashed against Angelo della Pergola, a deputy of Migliorati's, defeating him after a bloody battle just outside Acervia's walls, and which lasted several hours. By that time, he'd already been given the sobriquet of Braccio, which was also his battle cry.

Now that he had a respectable logistical base, Fortebracci began assembling his own mercenary army, organising it around a core of Perugian exiles. With his reputation firmly established, he sold his services to Florence in its fight against Ladislaus of Anjou, then

moved on to serve Antipope John XXIII. It was the latter who allowed Braccio to fulfil his lifelong dream, first by authorising him to collect tolls and duties in Bologna, then tasking him with bringing territories previously under the Church's control back into the fold, and awarding him the ancestral castle of Montone as his feud in recompense. John's overthrow in the wake of the Council of Constance and the delayed election of a new pontiff freed Braccio of all his responsibilities, allowing him to undertake the conquest of Perugia. Frightened, the Perugians offered the lordship of their city to the tried and tested—albeit unlucky—condottiere Carlo Malatesta, the Lord of Pesaro, so long as he protected them from Fortebracci. Braccio engaged Malatesta on July 12, 1416, at Sant'Egidio, to the south of Perugia, scoring a sensational victory that flung open the gates of his native city. Having become Lord of Perugia, he set to work expanding his dominions, even forging an alliance with Alfonso of Aragon, the pretender to the throne of Naples. This put him at odds with the Papacy, given that Martin V had made it a priority to restore the Church's domains to their original extent.

Martin arrived in Florence in February 1419, and would reside there for the following eighteen months. Conditions in Rome did not permit the Pontiff to return there immediately, as the Eternal City was still occupied by Queen Joanna II's Neapolitan troops, who had no intention of ceding their control to the Pope, despite the fact that the Pontiff had recognised Joanna as the legitimate heir of her brother Ladislaus. Martin could nevertheless count on the support of Louis III of Anjou, son of the deceased Louis II and pretender to the throne of Naples, who arrived in southern Italy in 1420, armed

with the Pope's blessing and an aim to conquer the realm, which he believed was his birthright. In order to defend her lands, Joanna was forced to quit Rome, but not before finding an ally in Alfonso, King of Aragon and Sicily. Childless and in her fifties, Joanna named Alfonso her heir, and simultaneously hired Braccio da Montone.

Enraged by his conquests, Martin V had grown obsessed with Fortebracci and had had him excommunicated the previous August. However, Braccio could rely on Florence's support, being bound to the city by his old record of service, as well as by the fact that two of his daughters had married Florentine men. The Commune welcomed the creation of a strong friendly state in central Italy that could act as a bulwark against potential threats. At the same time, however, the city's Guelph tradition dictated loyalty and deference to the Pope of Rome. For these reasons, the Florentines mediated to bring Braccio and Martin V to an agreement, a proposal both men willingly accepted, as they needed time to regroup. Fortebracci made his entrance into Florence on February 8, 1420, at the head of a magnificent procession of splendidly equipped knights, arousing the awe and admiration of its citizens. On that very evening, a throng of street urchins ran through the streets of the city, specifically under the windows of the Pope's apartments in Santa Maria Novella, impiously mocking the Pontiff with the following ditty:

Pope Martin, Lord of Piombino, Count of Urbino
He ain't worth a dime, ha ha ha ha!
Braccio is able, Braccio is ours, he wins all the time!
Ha ha ha ha![4]

Martin V, whose attachment to the dignity of his office was compounded by the proverbial haughtiness of the Colonnas, was incensed, and when the humanist Leonardo Bruni tried to calm the irate Pontiff by saying that, after all, it was nothing more than a caper, Martin scathingly replied that the children wouldn't have dared such behaviour without their elders' consent. The Pope began to nurse an aversion for Florentines, and his wrath exploded the following April, when the rulers of the Commune accepted an embassy from Bologna. Martin, who'd been trying to re-establish direct papal control over Bologna, considered such an action a direct affront to the Church, and wasted no time in placing Florence under interdict. The incident left Florentines with little doubt as to where the Pope's real political sympathies lay, and when Martin finally left for Rome in September 1420, whispers making the rounds of the city suggested that Martin 'wasn't a true friend of the Community.'[5] For his part, Martin had already devised a strategy to frustrate Florence and her allies more or less openly by lending his support to the Duke of Milan and his expansionist plans.

Papal endorsement proved a godsend for Filippo Maria Visconti, and not just from a political point of view. In September 1418, in a display of cynical ruthlessness worthy of his heritage, the duke had ordered the execution of his wife Beatrice on the charge of adultery and (contrary to what Giovanni Bellini's lyric opera *Beatrice di Tenda* would have us believe) he did so without showing any remorse for his actions. Having by then already appropriated the money, possessions and military resources of Facino Cane's widow, the duke opted to rid himself of Beatrice's presence, which had apparently

222

been made even more inconvenient by her authoritarian character, which, according to the words of the Milanese chancellor, Pier Candido Decembrio, had led her to treat her husband 'almost as though she were his tutor.'[6] Yet while popular tradition has always defended the innocence of the unlucky duchess, Martin V didn't show the slightest hesitation when he accepted gifts from the uxoricide Filippo Maria when he visited Milan that autumn. The two were bound by a personal friendship that pre-dated Martin's elevation to the Papacy, and the Pope furthermore saw in Filippo Maria a useful ally in the reconquest of the Church's domains in central and northern Italy. In exchange for his support, Martin was more than pleased to bestow his blessing on Visconti's conquest of Genoa.

Genoa's fall into Milanese hands alarmed the Florentines, who had succeeded in purchasing Livorno and the guard towers protecting Porto Pisano from Genoa at a dear price just in the nick of time. Florence and Milan had signed a treaty of friendship in 1420 that circumscribed both cities' spheres of influence. Although Filippo Maria's conquest of Liguria didn't strictly violate these accords, it still effectively established a Milanese presence in the Garfagnana and Lunigiana, both of which lay perilously close to Florence's borders. Visconti had also set his sights on Bologna, a city the Papacy had always considered an inextricable part of its dominions, but which the Milanese also coveted. Confronted with the duke's achievements, Florence was unable to devise an effective strategy to oppose him, as its rulers were constantly unsure about what was to be done; and the requests of the papal legate in Bologna for a pact of mutual assistance with Florence went ignored out of fear that it might antagonise the

Milanese Duke. For his part, Martin V caused Florence a number of other problems in his efforts to re-establish his authority in Umbria, having granted Braccio di Montone the Lordship of Città di Castello. Yet Fortebracci's campaign to conquer that city caused great dismay in Florence, given that the two cities were linked by bonds of fellowship. Torn between assisting Città di Castello and maintaining good relations with Braccio, the Florentines in the end opted for the latter, even going so far as to offer him a two-year contract and the command of 1,000 spears and 300 foot soldiers. The sacrifice of Città di Castello was justified by the Commune's need to raise an adequate military force in the eventuality of war with Visconti.

All the same, it wasn't for nothing that the duke had become famous—as Enea Silvio Piccolomini (who later became Pope Pius II) had very appositely said—for being 'a master of the art of simulation and dissimulation.'[7] When a Milanese embassy arrived in Florence in April 1422 to reaffirm the friendship between Visconti and the Commune, although the Florentine rulers were suspicious of Filippo Maria's real intentions, they were unable to formulate a concrete reply to what by then appeared to be an inevitable crisis in the offing between Florence and the duke. The idea of an alliance between Florence and Venice didn't get very far, given that many feared Visconti might interpret it as a provocation, the same fate that befell the attempt to forge a league with the Pope. As a matter of fact, the Pontiff was urging Filippo Maria to take an interest in the Romagna, a cost-effective way to bring the other cities of the region back into the papal fold. In the meantime, Martin was also preparing to settle his score with Braccio da Montone. Indeed, in light of the Pope's

subsequent behaviour, one can all too easily suspect he and Filippo
Maria had struck a Faustian pact to divide central and northern Italy
amongst themselves.

The crisis between Florence and Milan came to a head in May
1423, when Visconti's supporters took over the city of Forlì in a coup;
and although the duke hadn't directly intervened, everyone knew
he'd played a hand in the events. Nevertheless, over the course of the
following summer, the Florentines proceeded with caution, as the
strong peace party in the city was vigorously opposed to war with
Milan. In any case, the situation was deemed serious enough to jus-
tify the convocation of the Dieci di Balìa (Ten of War), a magistracy
that was only activated in times of war, which immediately set about
recruiting soldiers to reinforce the garrisons in the Apennines and
the Pisan countryside. The government was counting on Braccio di
Montone, but Braccio, busy expanding his domains in central Italy
in league with Alfonso of Aragon, only sent his employers a small de-
tachment of troops. However, he also advised the Florentines to hire
Pandolfo and Carlo Malatesta, even though Braccio had previously
defeated Carlo at Sant'Egidio. Indeed, Carlo had the reputation of
being 'used to losing,'[8] but also of being a solid and reliable captain.
Pandolfo had a personal score to settle with Filippo Maria, as the
duke had chased him out of Brescia a few years earlier—a city where
Malatesta had become lord in the wake of the political confusion fol-
lowing Gian Galeazzo's death. During the summer of 1423, Pandolfo
led an incursion into the Romagna with the aim of ridding it of the
duke's followers, but even though he was able to storm the fortress of
Forlì, the city remained under the control of Visconti's supporters.

Filippo Maria didn't linger to watch events unfold: in keeping with his Visconti heritage, he reacted with consummate ability over time. Aware of the aversion many Florentines felt towards war with Milan, the duke sent word through Niccolò III d'Este, the Marquis of Ferrara, that he was willing to reach an agreement with the Commune. Considering the costs of mobilising the military, as well as the added pressure of the peace party, even the anti-Milanese hawks agreed to come to terms, and a delegation carrying this message was dispatched to Ferrara. However, Filippo Maria's tactic was merely a ruse to trick the enemy into lowering his guard, and in January 1424, the Duke took over Imola, chasing away its lord, who, as it happens, was one of Florence's allies. Although this rendered any agreement impossible, indecision continued to gnaw at the Florentine government, since war would have exacerbated its already burdensome taxes, and its citizens were reluctant to agree to the compulsory loans imposed to pay for the war effort. Palla Strozzi tried in vain to encourage the Florentines to make a show of unity and to not worry over expenses when it came to safeguarding their security, invoking the principle outlined by *si vis pacem, para bellum* ('if you want peace, prepare for war'): 'If our enemy sees us in disarray, he'll be better able to attack us; he'll think only of war.'[9] But far from making any concrete decision, the government preferred to wait, and even tried to forge an alliance with Alfonso of Aragon and Venice, despite the fact that this wait-and-see policy was costing the Commune something in the realm of 45,000 florins a month.

Events took an ugly turn in the summer of 1424. On June 2, Braccio da Montone was defeated outside of L'Aquila by the combined

forces of Joanna of Anjou and Martin V, and the Perugian condot-
tiere succumbed to his wounds a few days later. It was a hard blow
for Florence: not only had the Commune lost its most valiant com-
mander, but the dismemberment of Braccio's domains in central It-
aly deprived the Florentines of an important bulwark to the south, a
situation aggravated by the rumours that Visconti and the Pope had
struck a deal. However, the worst was still to come. On July 28, the
Florentine army in the Romagna, led by Carlo Malatesta, suffered a
crushing defeat at Zagonara at the hands of Visconti's forces, led by
Angelo della Pergola, and Malatesta was even taken prisoner. Faced
with such a disaster, the Florentine government tried to close ranks,
but was unable to quell the resentment of many of its citizens, which
was summed up by Giovanni Cavalcanti's outburst:

> You never thought you would need anybody. We only learned
> about the lion after he asked the mouse for help. Now where
> will you run? Now you have to put up with war, and you con-
> vene the Dieci and you say that they'll terrify the enemy: go
> ahead and think these crazy thoughts, and don't employ any
> reason in your thinking. You have stirred this war without
> reason, and you have no regard for the counsel of our good
> citizens.[10]

Indeed, Florence had no one to turn to for help in that predica-
ment. The Queen of Naples was badly disposed towards Florence due
to the help it had given Braccio da Montone, and the same was true of
Martin V (who'd showed everyone he was worth more than a dime).

Among other things, the Pope flatly refused to grant the Commune representatives' request to recruit the remainder of Braccio's troops, which were now led by Oddo Fortebracci and Niccolò Piccinino. Several Florentines were reluctant to contradict the Pope, more for practical reasons than for idealistic considerations—Giovanni de' Medici, for instance, was worried about how his investments in the papal banks might fare, explaining the warning he'd made to his fellow citizens that their salvation depended on friendship with Martin. In the end, finding itself caught between a rock and a hard place, the Dieci di Balìa recruited Fortebracci and Piccinino, thereby risking the Pope's wrath. There was no other choice, especially after the talks with Venice regarding the creation of an anti-Milanese league had floundered, as had attempts to obtain Sigismund of Luxembourg's help. Meanwhile, popular discontent was growing in Florence, as the war had caused a scarcity of consumer goods, resulting in price increases. Furthermore, a widespread economic crisis caused a drop in the Commune's revenues, and the middle classes mainly shouldered the heavy tax burden. The attempts of a few oligarchs, led by Rinaldo degli Albizzi, to create a more efficient and equitable system of taxation, through the introduction of a catasto (public land register) ended in failure due to the opposition of conservative factions in the Commune, who were also widely mistrusted, though not without reason. In the meantime, military expenses had risen to almost 80,000 florins a month, but for all intents and purposes, this expenditure wasn't bearing any fruit.

In February 1425, Piccinino and Fortebracci were caught in an ambush by Visconti's forces in the Val di Lamone. Oddo was killed

and Niccolò was taken prisoner at Faenza. The lady of the city was Gentile Malatesta, Gian Galeazzo Manfredi's widow and a relative of the Florentine commanders Pandolfo and Carlo. Piccinino somehow managed to work his way into the lady's graces, as well as her son Guidantonio's, and convinced both to switch their allegiance to Florence. Given Visconti's aggressive policies in the Romagna, the Manfredis had reason to fear for their survival, and it was therefore in their interest to aid the weaker of the two. As for Piccinino, his friendship with the Manfredis would stand him in good stead in the years to come, and for the time being, the lords of Faenza allowed him to recruit men in their lands. Despite the fact he'd been defeated, the Florentines also renewed their contract with him, which came with 400 spears; and thanks to these, Niccolò was able to mount a successful defence against Visconti's attacks on the Manfredis' domains the following September. But the Romagna was only one of the fronts Florence needed to protect (and in truth it hadn't done so with much success). A subsequent sortie against Genoa at Rapallo failed miserably, while the defeat suffered at Anghiari in October jeopardised Florence's control of the Valdichiana. It was only thanks to an intervention by Piccinino, who hurried all the way from Faenza, that Arezzo and Cortona didn't fall into Visconti's hands, but all the losses suffered by the Florentines in little more than a year were putting the Commune's very survival at serious risk.

As if these disasters weren't enough, Niccolò Piccinino defected to the Viscontis in November. As his contract with Florence had been close to expiring, the Perugian condottiere had asked the Florentines for an additional sixty men-at-arms along with their retinue,

100 foot soldiers and a special personal bonus of 200 florins a month. Either out of avarice or because Niccolò's requests were untenable, the Dieci di Balìa refused him outright. Consequently, as he had already begun negotiations with Visconti's captain Guido Torelli, Piccinino didn't hesitate to enter into a contract for 1200 knights with the Duke of Milan, which he immediately put to use pillaging the countryside around Arezzo. Niccolò's betrayal provoked a fearsome reaction in Florence, and the government sentenced the backstabbing condottiere in absentia to life imprisonment, and meanwhile commissioned an insulting painting that depicted him hanging upside down by one foot. The only result was to inspire a deep-rooted hatred for Florentines in Piccinino, which would later prove an obstacle in preventing his rapprochement with the Commune.

Help finally came from an unlikely quarter: Venice. The Serenissima had started to worry about Visconti's expansionist politics, and this, coupled with Doge Francesco Foscari's bellicose nature, had pushed the Venetians to consider the usefulness of an alliance with the Florentines. Furthermore, Venice had developed its own designs on Lombardy and the Romagna, and had in addition drawn Ferrara into its sphere of influence (the saltworks of the Polesine were a highly sought-after prize). However, the Venetians didn't rush into war, and initially tried to seek a diplomatic solution to the conflict. When Filippo Maria rejected their proposal to mediate, and the Pope showed little inclination to assume the role of peacemaker— in fact doing all he could to encourage hostilities—the Serenissima decided to stop wasting time. On December 4, Venice and Florence signed a defensive alliance that committed them to fielding an

army of 16,000 knights and 6,000 foot soldiers, with the additional clause that every territory conquered in Lombardy would go to Venice, while those taken in the Romagna would be given to Florence. The treaty was actually more favourable to Venice than to Florence, and the Serenissima also secured a leading role in any eventual peace talks, something that practically conferred on it the right to determine the course of the war. Even the division of the spoils was in Venice's favour, given that the territories in the Romagna set aside for Florence were encumbered by a papal mortgage. Up to their necks in water, however, the Florentines were more than happy with the new alliance, seemingly oblivious to the fact they would have to spend 100,000 florins a month towards their upkeep of half the combined army, which stood at 8,000 knights and 3,000 foot soldiers.

Florence even tried to settle its score with Piccinino by trying to ambush him in his house near Città di Castello. The plot failed thanks to Niccolò's quick reflexes; he saved himself by jumping into a ditch half-naked. Even the attempt to poison him ended in miserable failure, and the cook who'd been bribed to commit the misdeed wound up being executed. It was the same fate that two of Visconti's agents had met a few months earlier, when they'd been caught in Venetian territory while scheming to murder Carmagnola: the Piedmontese condottiere had gone over to the Serenissima's side after the paranoid and treacherous Filippo Maria had deprived him of all his posts and even tried to have him arrested. But treachery was a part of the political landscape of fifteenth-century Italy, and the only thing that mattered was to try to survive in a world full of subterfuge and betrayals.

2

MARS, THE MERCENARY

There were almost twenty years between the bearded man and the secretary of the Dieci di Balìa, but they shared a similar mindset, especially in certain aspects. The secretary was always ruminating, citing examples culled from Greek or Latin classics; in fact, for him it was as though Livy, Polybius and Plutarch were the only authorities worth referencing. Among other subjects, the secretary seemed obsessed with the battles the Romans had fought, and how they had structured their military forces. He would also habitually assert how only the Swiss had preserved the ancients' virtues and organizational models, but that it would be possible to revive the civic and martial spirit of ancient Rome among his fellow citizens. After all, he had seen what that gentleman from the Romagna had been able to do: he had organised his subjects into a disciplined and efficient militia.

The bearded man reminisced about the time he'd worked for that gentleman, who'd been as affable as he was cruel, the very same man who'd had three of his old lieutenants treacherously strangled. The artist

31

had also seen the militia the secretary had so highly praised; a shame that it had been chiefly composed of professional veterans, who just so happened to be that gentleman's subjects. These were exactly the sort of people that were needed to deal with the hordes of French, German and Spanish soldiers who had transformed Italy into a gigantic battlefield over the past decade. The bearded man had experienced these acts of aggression firsthand when French troops had used the model for that great equestrian statue he'd planned as target practice, while the bronze he'd needed to cast that monument had been reallocated to artillery manufacturers. But it was pointless to try and talk to the secretary about mercenaries, against whom he nursed a fierce hatred: traitors, thieves and cowards were but a few of the epithets he'd used to describe these soldiers of fortune. For that matter, the secretary had been the one who'd masterminded the capture of a celebrated condottiere, a display of power which had nevertheless failed to increase the city's prestige—if anything, quite the contrary—and the one who'd said that the city's political weakness lay in its military ineptitude. The artist doubted that the conscripts whom the secretary planned on recruiting would be enough to rectify the situation, especially if they found themselves fighting against battle-hardened soldiers like the French or the Spanish.

But as far as the fresco in the great hall of the Palazzo Pubblico was concerned, the pair found themselves in agreement, despite their different motivations. The secretary saw the tribute to the battle of Anghiari as a means to inspire his fellow citizens to take up arms once again, strengthened by the virtues of ancient Rome. More prosaically, but displaying just as much ambition, the bearded man considered the pictorial cycle as a means to bring back to life something that had fallen into desuetude since the time of the barbarians' invasions in the dying days

of Rome, who like their contemporary incarnations, had relegated it to the scrap heap of history. In the same manner that the secretary wanted to revive the militia of Republican Rome—which had conquered Italy and a good chunk of the Mediterranean—the artist wanted to resurrect a technique of painting he'd learned about while consulting ancient texts. The battle of Anghiari wouldn't just be remembered as one of the city's successes, but above all as the bearded man's personal victory over oblivion and barbarianism.

Piccinino and Carmagnola's defections were typical of the times, but despite what was commonly believed (especially when it came to Machiavelli, who had a number of motives, including personal ones, to make such a claim), this behaviour wasn't limited to condottieri. Indeed, all Italian states vied with one another when it came to double-crossing their allies, but the phenomenon of mercenary groups was the direct result of the peninsula's political fragmentation and the inability—or rather, the lack of willpower—of various governments to create adequate armed forces among their own citizens. This was more than understandable given the bloody civic struggles that had characterised the thirteenth century and part of the fourteenth. However, there were some entities that owed their political and financial survival to arms and the sale of their military expertise. Moreover, most governments were more than happy to delegate the dirty work of war to others. Even when it came to communities made up of loyal and motivated citizens, the loss of human life during conflict represented a terrible blow to those cities' survival.

According to Florentine chronicles, the battle of Montaperti in

1260 caused 2,500 deaths in Florence, not counting the wounded and the prisoners taken. Given that the city had a population of roughly 75,000 at the time, the death of almost 10 per cent of its male citizens had a devastating impact on its social and economic fabric, and a good deal of the victims hailed from the city's middle and lower classes. Equally significant were the numbers of casualties: 1,700, who hailed from Arezzo and its surrounding countryside at the battle of Campaldino in 1289; and those from the Veronese countryside, 716, at the skirmish of Campaldino in 1387. In both cases, the losses incurred brought about momentous political changes for the defeated, and neither was an isolated example. The Pisans never recovered from the thrashing the Genoese dealt them at Meloria in 1282, and the over 11,000 men captured by the victors gave rise to the popular saying 'whoever wants to see Pisa should go to Genoa'.

Even in the case of conflicts which produced fewer casualties and prisoners, the absence of thousands of people from their habitual trades and crafts caused those communities considerable damage.

In addition, the number of people who wanted to avoid military service kept increasing, and anyone who possessed the means would hire a professional soldier who was willing to fight in his stead. Throughout the fourteenth century, the gradual disarmament of subjects under both republican and feudal regimes, motivated by internal security concerns, was merely the conclusion of a process that had begun the previous century. While citizens were growing disenchanted with the notion of military service, and the various Italian states were consolidating into *signorie* or republics, there arose a need to find people who were willing to fight—for a fee, of course. In any case, the mercenary life required years of training and practice, a

luxury reserved for professionals, aside from a few exceptional cases. The words of the Minnesänger Hartmann von Aue were significant, especially considering that the author chose an abbot to voice them: 'Anyone who stays in school until the age of twelve without ever spending any time on top of a saddle is doomed to behave like a cleric.'[11] Of course, the cavalry was the apex of the warrior's life, but even a simple foot soldier needed to be an expert in order to find employment and survive. The first professional mercenaries grouped into recognizable structures had already made their first appearance at the end of the thirteenth century, but it wasn't until the following decades that these companies began to grow exponentially. Local power struggles and the endemic wars between the peninsula's various potentates required a constant flow of soldiers, and thus the recruitment of men fit for such purposes. Although there were such individuals in Italy—the first mercenary companies certainly didn't lack an Italian component—Germany was the real hotbed of mercenaries up until the second half of the fourteenth century. Despite the image handed down to us through the literature of the time, the medieval knight was often half-starved, and owned little apart from his weapons and his horse; this, coupled with a rampant economic crisis in their country led many German men-at-arms to seek their fortune in Italy's fertile lands. The Treaty of Brétigny in 1360, which brought the first phase of the Hundred Years' War (1337–1453) to an end, and freed up a multitude of soldiers who'd fought for the English King Edward III, many of whom—including the famous John Hawkwood—decided to cross the Alps.

It didn't take long for these foreign mercenaries to wise up to the fact that they could reap enormous profits by hiring themselves out

to various warring states, or by participating in organised crime. In 1330, a band of eight hundred knights captured Lucca in a surprise attack, and the rich booty secured through this act of plunder was augmented by the 50,000 florins they secured once they sold the city to Genoa. Even if the case of Lucca was somewhat exceptional, the majority of Italian states repeatedly suffered extortion at the hands of mercenary companies. Between 1342 and 1399, Siena was attacked no less than thirty-seven times. The money paid out by the Sienese to keep mercenaries away amounted to four years' worth of municipal revenues, and that economic damage was exacerbated by the systematic looting of the surrounding countryside, which was the preliminary step before armed blackmail. The impact of these raids is still discernible in Ambrogio Lorenzetti's damaged fresco, *Allegory of Bad Government*, on display in Siena's Palazzo Pubblico, which is dominated by the violence inflicted by these mercenaries and set against a background of ravaged fields and homes either in ruins or engulfed by flames. To counter this problem, some states banded together in defensive alliances, so as to pay for the upkeep of a sufficiently large army to defend them. Nevertheless, the prohibitive costs involved in such operations led some communities to run the risk of exposing themselves to armed blackmail. In 1371, Lucca decided not to join a defensive alliance made up of fourteen other states, as its share of the contribution would have amounted to 30 per cent of its annual income.[12] However, had the Luccans chosen to join that alliance, the financial burden wouldn't have been especially onerous: by the middle of the following century, Italy's major states would see half their revenues spent on the salaries of their cavalries. For instance,

although Florence had an annual income of roughly 250–300,000 florins, it would spend 120,000 on 3,000 knights; Venice's income added up to a million ducats and it spent something in the realm of 644,000 florins for 16,000 knights. The record for the highest expenses, however, belonged to the Milanese, and the 20,000 mounted troops in the service of Duke Filippo Maria Visconti, which cost him 790,000 florins against an income of approximately 800,000 ducats (for the sake of clarity, one should keep in mind that the ducat had appreciated by 30 per cent against the florin). In 1433, on the conclusion of its war against Lucca, Florence found itself saddled with a public debt of 4,000,000 florins, largely thanks to its military expenses—a debt that came with 220,000 florins of yearly interest.[13] In light of the situation, it was no surprise that many Italian states resorted to extraordinary fiscal measures, despite the internal tensions they caused.

For mercenaries, war meant survival, as proved by a novella written by the Florentine Franco Sacchetti, which featured John Hawkwood as its protagonist. One day, two simple friars went to collect alms at the castle of Montecchio Vesponi, which was Hawkwood's residence at the time; and after they greeted the Captain with 'May the Lord give you peace', he replied, 'May the Lord take away your alms.' The explanation the Englishman gave those dismayed clergymen was typical of fourteenth-century mercenaries:

> How can you come to me and think you wish me well, and tell me that God wants me to starve to death? Don't you know that I live off war, and that peace would mean my ruin? And

as I live off war, so you live off charity; meaning the answer
I've given you was exactly what your greeting deserved.

Confronted by such ineffable logic, the two friars could only
shrug their shoulders and try to justify themselves with the follow-
ing: 'Forgive our corpulence.'[14] However, suspicion remains that
Hawkwood's answer more likely arose from boredom caused by
what couldn't have been just a simple request for alms—and which
probably came coupled with a lengthy sermon—rather than from
his philosophy of war. Still, it was certainly true that times of war
provided the best occasions for mercenary companies not only to
reap the spoils, but also to secure lucrative contracts with one of the
warring parties.

The phenomenon of mercenary companies was a snake eating
its own tail: the civil authorities stigmatised them for their violence
and haughtiness while simultaneously finding it more convenient
to risk these mercenaries as opposed to their own subjects or citi-
zens. Despite the blackmail and other acts of thievery various mer-
cenary companies inflicted, the Sienese didn't hesitate to employ
them on more than one occasion. During the war against Perugia in
1357–1358—the fight to control Montepulciano—Siena hired several
mercenary companies, including Hannekin Baumgarten's band, and
even attempted to secure the services of Konrad von Landau's Great
Company. However, Landau's defeat at Scalelle in an ambush laid by
the Florentines, who were fed up with his extortion and thievery, ulti-
mately wrecked their plan. One of the reasons why mercenary compa-
nies often transformed into bands of marauders was the need to earn

a living after they were demobilised at the end of hostilities. Foreigners in particular could not retire anywhere strategically important.

It was resoundingly clear that extended contracts were the best solution to this problem, both for the soldiers and for the governments they served. The trouble was that up until the fifteenth century, only a few states had the resources or willpower to put such a policy into practice. Florence, for instance, almost always refused to keep paying the price of war during times of peace, its ongoing relationship with John Hawkwood being the exception that proved the rule. On the other hand, the Visconti of Milan pursued the policy of grabbing as many talented mercenaries as possible, trying to buy their loyalty through the concession of fiefs and various other bonuses. Since it was vitally important to employ men with adequate recruitment bases, this policy contributed to the near-disappearance of foreign elements in Italian armies by the first decade of the fifteenth century. The soldier of the previous century had been replaced by a new breed of men-at-arms, who plied the trade of war not only for financial gain, but also with an eye to the political advantages they could derive from it.

The previously mentioned case of Braccio da Montone is possibly the most striking in this sense, but it wasn't the only one. Giacomo degli Attendoli (or Attendolo), nicknamed Muzio, hailed from a prosperous family of landowners from the Romagna, who were constantly embroiled in a vendetta against their neighbours, the Pasolinis, for control of the little town of Cotignola. According to legend, Muzio escaped from home at age thirteen, taking one of his father's horses with him so he could join up with Boldrino da

Panicale's company, even though it's fair to say that several of his kinsmen were already employed as mercenaries. He later entered the employ of Alberico da Barbiano, the well-known teacher of an entire generation of mercenary captains, where he found himself alongside the Perugian exile Andrea Fortebracci. It was during this period that Muzio earned the nickname that would make him famous, which, as the legend goes, he was given after Attendolo resisted his demands that the booty be shared: 'I think it won't be long before you'll want to beat me up,'[15] Barbiano supposedly told him, adding—not without a trace of humour—that he would henceforth call him 'Sforza.'[16] It's difficult to know exactly what and how much Muzio might have learned from Alberico, but the fact remains that along with Braccio, Muzio established his own military school, which would have a considerable influence on the art of war in thirteenth-century Italy, when the 'Sforzescho' school competed with the 'Braccescho' school. Although they were flexible in their approach to the business of war, successful mercenary captains in Renaissance Italy usually wound up favouring one of these schools.

Alberico da Barbiano earned his fame—which, for that matter, was undeserved—not only by being the first to redeem the Italians' martial honour in a fight against foreigners, after he defeated the Breton troops of Bertrand de la Salle and Jean de Malestroit at Marino in 1379, but also for having restored mounted troops to their original crucial role. Mounted troops had been devalued in the popular consciousness after the victories English foot soldiers won over French knights during the Hundred Years' War, as well as by the successes of Swiss infantrymen against the German cavalry

at the Battles of Laupen in 1339 and Sempach in 1385. Yet this was simply fallacious in the case of Sempach, as in the case of Poitiers in 1356 and Agincourt in 1415, all of which were essentially clashes between armies when knights fought on foot and achieved victories thanks to fortuitous circumstances or to the naïveté of the defeated. English archers massacred cavalrymen at Agincourt only because the French horses were impaled on the *chevaux de frise*, which had been placed there for that explicit purpose. During the second wave of attack, which was led on foot, there were so many French infantrymen crammed into such a small space, that moving and fighting became a daunting task, especially since the ground beneath their feet had turned into a muddy quagmire after the recent rains.

The old tactical subdivision of medieval armies, which placed the cavalry and infantry in separate squads, favoured combat on foot in cases where infantrymen equipped with spears (like Swiss halberds, for instance) or throwing weapons were capable of repelling a cavalry attack. Following the Treaty of Brétigny, when the 'White Company' (so-called for its men-at-arms' brightly polished armour; its ranks were made up of Anglo-Germans led by Albrecht Sterz and John Hawkwood) made its first appearance in Italy, the Italians were struck by how their enemy's knights fought on foot (although there was no dearth of precedents of the sort in Italian armies in previous centuries), each of them accompanied into battle by a page and a squire. These types of units, known as *lances fournies*, were fated to become the standard for contracts, or, as they were otherwise known, *condotte*—from which the term *condottieri* is derived—and the strength and pay of the contracted soldiers was calculated

according to how many *lances fournies* there were, even when they'd stopped serving their original tactical purposes.

According to most reports, Alberico da Barbiano had repristinated the value of cavalry charges, even though there were many cases throughout the fourteenth century when battles had been won by cavalry attacks; yet even if these reports were accurate, the prize for having perfected the tactic should be awarded to Sforza and his pupil Braccio. They developed methods whereby troops on horseback would work closely alongside the infantry, thus creating heterogeneous troop formations. Despite their collaboration, Sforza and Braccio's respective military philosophies were rather dissimilar, reflecting their different needs and capabilities. Braccio built his army around a small circle of Perugian exiles, and therefore devised a fighting method that allowed him to optimise the efficiency of his initially scanty forces. During a battle, his squadrons—which numbered a maximum of 150 knights, supported by a suitable number of foot soldiers—so as to keep the enemy under constant pressure, waiting until they'd weakened enough before sending his reserves against them, having held them back for that express purpose. Sforza, on the other hand, favoured the use of great masses of men, which enabled him to execute more complex manoeuvres, like circumventing the enemy's flanks. Sforza's system allowed him to integrate military units from different backgrounds into a consistent overall structure. And unlike Braccio, Muzio could always rely on the support of a large retinue of bellicose relatives, as well as on Cotignola, which served as an excellent recruitment base. Truth be told, to be a Braccescho or a Sforzescho meant far more than simply belonging to two different

schools of military thought; they were more like factions bound to one another by common birthplaces, family ties, or ties of friendship or camaraderie. This division wasn't limited to the world of mercenary companies; it was also a part of the wider Italian political game.

The Achilles' heel of the Sforzescho system was that its inflexibility impaired its ability to move rapidly, which was a key feature of the Braccescho system. Nevertheless, it would be wrong to think that adhering to one of these schools amounted to a tactical rigidity, and the best captains adapted their modus operandi as the situation demanded. Despite having been the pupil of brilliant cavalry commanders such as Ceccolo Broglia and Facino Cane, Carmagnola won the battle of Arbedo by having his men dismount and fight on foot after the Swiss had repelled the Milanese cavalry. Likewise, in 1447 the Braccescho condottiere Bartolomeo Colleoni defeated the French at Bosco Marengo using a typically Sforzescho manoeuvre, while he obtained his victory at Romagnano Sesia two years later by adopting the Braccescho style.

Muzio Attendolo had always had a reputation as a prudent commander, who in decisive battles preferred to wear his enemies out with prolonged operations; this also applied to Braccio, whose success was largely limited to the strict control he exercised over his own troops. Like his old colleague and later rival, Andrea Fortebracci, Attendolo nursed political ambitions which securing the Lordship of Cotignola couldn't satisfy. Indeed, the feoffment of this little town had been granted to him in 1411 by Antipope John XXIII, but taken away shortly after when Muzio entered the service of Ladislaus of Naples. In the south of Italy, Sforza could gratify his lust for power,

becoming a chief constable of the kingdom and being granted various fiefs. He nevertheless found himself mixed up in the intrigues that followed in the wake of Ladislaus's death, winding up imprisoned several times and even subjected to torture. He was ultimately saved by his relatives' influence, particularly the efforts of his sister Margherita, who showed no qualms about kidnapping some Neapolitan aristocrats in order to secure her brother's release. Through it all, Muzio managed to survive the constant political changes in the kingdom and was still chief constable in 1424 when he succumbed to a watery death in the swollen Pescara river while attempting to cross it to attack Braccio da Montone's forces under the walls of L'Aquila. Attendolo's mercenary company reverted to his son, Francesco, who would become his clan's most successful fighter, even though Muzio's other children ended their lives as lords of important cities.

Both Sforza and Braccio hailed from privileged military and social backgrounds: the latter was born into an aristocratic clan from Perugia, while the former came from a wealthy farming family in the Romagna. The story that Muzio was of peasant stock was a fib circulated by his supporters as well as by his enemies: when Sforza began working for Ladislaus, John XXIII ordered the 'villain from Cotignola' to be painted hanging from one foot with a hoe in his hand. Pope Pius II had contemptuously labelled Niccolò Piccinino a butcher's son; yet while it's certainly true that the condottiere's father owned a house with an adjacent butchery, and that Niccolò himself had been initiated into the guild of Perugia's butchers, his family belonged to the propertied middle classes and a long-established story had it that Piccinino's uncle had once been the *podestà*

(chief magistrate) of Milan. As a matter of fact, very few military commanders of note hailed from humble backgrounds in fifteenth-century Italy, if only because in most cases a family needed a solid, long-standing martial tradition to allow a boy of tender years to begin his military training. One must furthermore consider that the resources needed to purchase weapons, armour and all the other equipment were huge, and without them—save for a colossal stroke of good fortune—an aspiring warrior's career would end before it even began. It's also true that the operating costs of war would have a profound effect on both the technological development of weapons and the organizational structure of armies.

An explanation as to why infantries, or rather knights who fought on foot, had often played a decisive role on battlefields from the second half of the fourteenth century onwards can be found in the substantial effectiveness that throwing weapons had shown in penetrating armours of the time. A robust archer armed with an English longbow could exert a force of between 130 and 150 J of kinetic energy, while a crossbow could exert 200 J. While such weapons required significant physical effort from the archer, they were able to pierce through the steel plates used in fourteenth-century armour, even components as tough as breastplates—admittedly only at close range. All considered, knights had a better chance of surviving when fighting on foot rather than atop their steeds (since horses were particularly vulnerable to arrows or crossbow bolts), using their shields to protect themselves when they advanced towards the enemy. In other words, cavalry charges against a determined infantry force could prove disastrous, as the French were to learn

at the Battle of Crécy in 1346. The advances of Italian metallurgy drastically altered the playing field when, at the beginning of the fifteenth century, Milanese weaponsmiths introduced the technique of quenching and began tempering armour-plates, an improvement on the old approach of leaving forged metal to cool in the open air. The quenching technique wasn't easy to learn, but the results were immediate: by the second decade of the century, a suit of armour that weighed around twenty to twenty-five kilograms could resist projectiles hurled from the most powerful crossbows, and its plates had a Vickers hardness of roughly 350, compared to the 150 of plates that cooled in the open air.[17] Of course, suits of armour forged in the old style continued to circulate even after the introduction of the new methods, in part because of how expensive the latter were. In 1427, a complete suit of armour could be purchased for upwards of eighty florins, meaning more or less two years' worth of wages for a skilled worker. Logically, at the same time that the availability of 'modern' armour increased, their total cost tended to decrease, but it was still not unusual to pay fifty florins in 1450 for a secondhand suit that any smith could adapt to the new owner with a couple of hammer strokes. Given that the monthly salary of an average spearman ran in the realm of eleven florins a month (or eight Venetian ducats, since the ducat appreciated by 30 per cent with respect to the florin throughout the fifteenth century), anyone who wanted to pursue a career as a heavy knight required a sizeable starting capital. Moreover, the costs of a knight's equipment and mount were only the beginning in a long list of expenses required for a man-at-arms to go to war: the horses (at least two, including the battle-steed) needed

to be fed, groomed and fitted with horseshoes; armour and other equipment needed to be cleaned, polished, greased and oiled. Thus, a heavy knight required a retinue of at least three to four people on top of the other fighters who accompanied him into battle, all of whom had to be fed, clothed, armed and paid. An average person who led an active life needed roughly two kilograms' worth of calorific food a day, while a horse needed about twelve kilograms of fodder. Thus, a man-at-arms would seek a place with a company and sell his services to that company's commander in order to obtain the necessary funds and receive special discounts, hoping to accumulate enough capital and prestige to eventually become a condottiere in his own right.

The need to acquire a solid reputation and capital from the get-go meant that there were very few condottieri who came from humble backgrounds, despite what fifteenth-century humanists would have us believe. Muzio Attendolo's family was one of Cotignola's most important clans; Braccio da Montone descended from an aristocratic lineage (although it was precisely his lack of money that prevented him from making more headway in his career); Carmagnola hailed from the ranks of the Piedmontese petty nobility; and Niccolò Piccinino's family belonged to Perugia's middle classes.

The majority of those who belonged to the Italian feudal nobility had long practiced the art of war: the Colonnas, the Orsinis, the Colleonis, and the Carafas, to name only a few. After all, the lords of central Italian cities often became condottieri in order to protect themselves, raising their own armies whereas other potentates would have just hired mercenaries. For instance, the economy of the Duchy of Urbino was based on the fact that many of the Montefeltros'

subjects were employed as mercenaries in their lord's company.[18] Feudal contingents could be found in the armies of every single Italian state of the time, also because their governments were fond of granting feuds to prestigious condottieri in order to keep them close. The Viscontis employed this policy on a wide scale, which their successors as lords of Milan, the Sforzas, continued in their wake.[19] The relationship between feudalism, lordly power and the practice of arms would be a constant fixture of the Italian military panorama during the fifteenth century. In some parts of Italy, the line between the condottiere and the feudatory had become so blurred that it was almost impossible to tell them apart. The highly trained armies of Alfonso of Aragon and his son Ferrante (Ferdinand I) were mostly made up of soldiers recruited from the various Neapolitan feuds.

The increase in the costs of armour, coupled with the need to find horses suited to withstanding the knights' weight, led to a decrease in the number of men-at-arms in mercenary companies, and simultaneously conferred a greater social prestige upon them. While the lance long remained the basic administrative unit in military operations, it wound up assuming a different tactical function to its original structure; ultimately, the number of lances outlined in the terms of enlistment only indicated the number of paid knights, not their quality, and 'lance' came to stand for a group of five to six men: a man-at-arms, three or four lightly equipped knights—who were also called *saccomanni* (literally bagmen)—plus a couple of 'boys', or *piatti*, who were charged with looking after the lance's logistical needs, both on the battlefield and in encampments.[20] By the end of the third decade of the century, one could already estimate that the number of active men-at-arms in a company only accounted for a

fifth of its total strength, a situation confirmed over the following years when contracts began to underscore the proportion of 'real armigers' in a company. The greater protection enjoyed by the knight, which made him almost invulnerable, endowed him with an efficacy that made him the unchallenged protagonist in paintings depicting battles of the time.

The tactical and technological innovations of the first decades of the fifteenth century also had a notable influence on the organization and equipment of infantry forces. In fourteenth-century Italy, foot soldiers had essentially been split into three categories: lancers, pavesaris (named after the large shields called *pavesis*, which lancers and crossbowmen used for cover) and archers. The infantry's primary function was either to keep regular soldiers supplied or to act as a centre of defence during a battle. The infantry's shock effect was largely due to its use of arrows (in the case of English archers) or crossbow bolts. But by the middle of the fourteenth century, the Swiss, who had never made much use of cavalries, had already started to use foot soldiers armed with halberds in their offensives, and by the second half of the century, light foot soldiers were already used in skirmishes by the Neapolitan army, having been influenced by either the Aragonese or the Catalans, although infantry of the sort had already been a fixture of Italian armies since the twelfth century.[21]

Although Braccio and Sforza still made use of the old categories of foot soldiers, drawing on these elements, they introduced a new type of infantryman, who was armed with an oval shield, a short spear and a sword, and who fought alongside the cavalry. They thereby created synergy between mounted troops and foot soldiers on the battlefield, allowing an army to perform manoeuvres

effectively and rapidly. This increased speed also paid off during long marches, as it became an established custom to put infantrymen on horseback when the army was on the move. Niccolò Piccinino further entrenched this practice and ultimately achieved his fame due to his lightning dashes, which would have proved impossible when infantrymen had been forced to move on foot. After all, the English archers of the White Company had already become known for arriving on the battlefield on horseback and only dismounting when it was time to fight.

Italians continued to use crossbows, but throughout the course of the fourteenth century, their role became increasingly limited thanks to the introduction of firearms. The first 'muskets' had already appeared around the middle of the fourteenth century, but they were rather dangerous and unwieldy instruments. However, the technological improvements of the following decades encouraged the dissemination of the musket, which was not, as is commonly believed, due to the ease with which one could train a marksman. On the contrary, up until the second half of the fourteenth century, the musket remained difficult to use, and it is thus understandable why the majority of musketmen were well-paid professionals, often foreigners (a great number of them were German).

The success enjoyed by firearms can be evaluated by their destructiveness. A ball of lead weighing roughly thirty grams had a kinetic energy of over 2,500 J, and was capable of piercing through hardened steel plates, albeit only at close range. Moreover, despite being very slow to reload (marksmen were only able to fire a shot every three to four minutes, although expert musketmen could increase their firing rate), the smoke and the noise produced by the

muskets could have a decisive psychological impact on disorganised and jittery enemy troops. The wounds produced by a ball of lead also tended to get more easily infected than those inflicted by an arrow or a blade. The systematic murder of musketmen taken prisoner during battles in the early fourteenth century (or the promise of their lives being spared on condition that they switched sides) was indicative of the fear this weapon inspired in people.

The increasingly destructive efficiency of these tools of war would produce a similar increase in battlefield fatalities throughout the course of the fifteenth century. Not that casualties had been absent in previous eras, certainly the majority of losses in northern European battles occurred when the victors gave chase to defeated armies; and in Italy, foreigners had the reputation of practising 'bad war', which was characterised by savagery against civilians. Of course, mythology would have us believe that the kind of war waged by Italians was a farce, a legend that is still widespread today, and which owes much to the aversion that Machiavelli felt towards mercenaries, whom he described as unreliable, greedy and cowardly in his *Florentine Histories*:

> Combatants then engaged with little danger; being nearly all mounted, covered with armor, and preserved from death whenever they chose to surrender, there was no necessity for risking their lives; while fighting, their armor defended them, and when they could resist no longer, they yielded and were safe.[22]

While he was penning these words, Machiavelli still hadn't gotten over—and never would—the thrashing dealt to Florentine

militiamen at Prato in 1512 by professional Spanish soldiers. In addition, the author of the *Florentine Histories*, who elided—or wished to ignore—the situation in Italy during the fourteenth century, also didn't understand the nature of war during the early Renaissance. While he often showed great valour on the battlefield, the Italian condottiere never focused on causing the greatest possible harm to his enemies—save in circumstances when he was fighting a personal enemy—but rather wanted to exact the greatest possible economic damage. First of all, a dead man couldn't be ransomed, while soldiers who were captured and then freed after being stripped of all their equipment represented a burden for the state that had hired them, given that it was obliged to pay for their upkeep and to refurnish them with weapons and armour. (There was always a chance that some prisoners were never freed because the civic authorities or the condottiere's employer had a political motive to keep them in chains.) It's therefore understandable that the chronicles and reports of the time showed far less interest in the number of enemy combatants killed during a battle compared to the number of men and horses taken prisoner. Horses were particularly prized, given that even the cheapest horse was worth at least ten florins. Micheletto Attendolo was accused of practising 'bad war' because he had ordered his foot soldiers to disembowel the horses of the enemy Bracceschi at L'Aquila.

The risk of losing equipment, weapons and horses generally led commanders to engage in battle only when it was unavoidable, or at least when they thought they had a substantial advantage over their adversaries. Nevertheless, the Florentine Gino Capponi wasn't at all convinced this was the case:

Pitched battles aren't at all suited to our Community, because men-at-arms are like sheep: they must pursue their victory over time, and not with a single chance attached; because fortune belongs to the strong, and from the moment the battle begins to the moment it ends, nobody can be sure of victory because of the advantages they enjoy, because they are subject to a thousand dangers.[23]

Far from being the only ones to want to avoid pitched battles, condottieri were in perfect agreement with their employers when it came to this issue. In fact, the idea that wars could be more efficiently and profitably won by applying adequate pressure on the enemy—typically through the attrition and exploitation of the enemy's resources, wasting and pillaging the countryside, and forcing him to make increasingly unsustainable expenses over a long period of time in order to avoid political repercussions (uprisings, if not actual betrayals)—was fairly widespread. This explained why a state was less interested in winning a battle or two than it was in desperately trying to preserve its resources. Nowadays, John Hawkwood's victory at the Battle of Castagnaro in 1387 is considered his military masterpiece; however, at the time, his retreat from northern Italy towards Tuscany in 1391 was considered an even greater success because he had accomplished it while keeping his army intact. For these reasons, it was deemed essential to capture enemy strongholds, to deny the enemy the use of their logistical bases and to use such bases as bargaining chips in any eventual peace negotiations. Battles often occurred when an army would try to relieve a besieged castle, in which case notions of prestige—and the control

of the surrounding territory—prevailed over the fears of suffering a defeat.

In the event a castle or a city was conquered, the place was almost always looted. This usually occurred under the orders of the commander who'd triumphed, who would try his best to prevent his soldiers from abandoning themselves to excess. This concern wasn't just about acting civilly, but was actually the fruit of a well-considered military strategy. The notorious—and probably spurious—exchange of pleasantries that took place between Braccio da Montone and a few of Alfonso of Aragon's captains is emblematic of this mentality. While Fortebracci held that war needed to be conducted with the utmost determination, he also deemed it unwise to kill those who might one day prove valuable allies, or to destroy the property of people who might later become his subjects.[24]

While war in fourteenth-century Italy was effectively less ferocious than it was in other parts of Europe, it was not devoid of atrocities or violence against civilians. The sack of Volterra in 1472 by Florentine troops was particularly merciless, even though it was partly explained by the fact that Florence wanted to teach that rebel city a lesson, and the condottiere Federico da Montafeltro managed to limit the violence to half a day. Likewise, the fall of Casole d'Elsa in 1479 was followed by the massacre of its garrison and a horrible looting spree. Violence was unleashed with a vengeance in 1442, when Assisi fell to Niccolò Piccinino, even though this particular instance was influenced by the atavistic hatred that existed between Assisi and Perugia, as one can gather from the words of the chronicler Graziani:

Many, many women with their stuff and their children were seeking shelter in Santa Chiara's Church, whilst the city was being sacked; there came the Captain [Piccinino] and, when he saw all those women and children hiding in the Church, he told them, and especially the nuns of Santa Chiara, that it was not an appropriate refuge for them, and that they should choose a better place to go, as he would surely send them where they preferred: and he started to name all the lands around the town, and finally offered to take them to Perugia. But when they heard the name of Perugia, firstly the nuns, then the women, answered in concerto: 'We want fire to go to Perugia!' When he heard that answer, the Captain swiftly retaliated: 'Loot the city, loot the city!'; and everything was sacked, the monastery with the nuns, the women with their children: and they certainly had a lot stolen. Thus, they proceeded to loot all the other monasteries, and all the other houses, and just about everything else.[25]

Being from Perugia, on this particular occasion Piccinino behaved far more cruelly than he had in other circumstances; he also wanted to earn the approval of his fellow citizens, having set the goal of creating his own state in central Italy. Indeed, Niccolò was among the last examples of condottieri who constantly sought new contracts, although he had spent the majority of his military career in the service of a single employer, the Duke of Milan. Between the second half of the fourteenth century and the first years of the following one, the strengthening of the political and administrative structures

of Italian states led to changes in how soldiers were recruited, with various governments attempting more and more to be the key stake-holders when it came to hiring soldiers, taking on smaller groups on longer contracts, rather than employing large companies for short periods of time. In the case of cavalries, this practice gave rise to the term of *lance spezzate*,[26] men-at-arms who were hired along with their usual retinue by a captain handpicked by the government. In the case of Milan, lance spezzate were backed by ducal armigers, a special group of veterans who formed the core of Visconti's army.[27] In 1427, Venice had roughly 400 lance spezzate, while Florence had 150. Seven years later, Filippo Maria Visconti could command 1,200 armigers of the aforementioned type, a category also adopted by the Papal army around the same time.

The tendency of various states to recruit freelance soldiers wasn't limited to cavalries. Indeed, foot soldiers were the first to put this new practice to the test. After all, it's understandable that for certain services, like manning a garrison, governments preferred to rely on people whose dependants were close to hand. The custom of hiring individual soldiers applied even when recruiting troops to deploy on a battlefield; each group of twenty to twenty-five soldiers who were directly paid by the government and called *provvisionati* (stipendiary troops) was put under the command of an especially trusted infan-try constable. In the third decade of the fifteenth century, Milan could field a thousand of these provvisionati and one can find ref-erences to these kinds of soldiers even in Venetian records of the time. The ability to mobilise a nucleus of troops permanently bound to the state didn't only allow for a greater efficiency in budgeting

for military expenses, but also helped to rapidly expand armies in times of war, besides serving to avoid possible abuses of power like those perpetrated by mercenary companies in the previous century. In several cases, the governors of smaller states assumed the double role of condottieri and recruitment officers, since the physical and political survival of those states rested on the contracts those lords could obtain. The development that had led mercenary companies to transform themselves into well-organised units directly answerable to their employers would require another couple of centuries. In fact, it would be disingenuous to talk about standardised structures for armies before the second half of the seventeenth century, and in some countries, one would have to wait a further two centuries for the last vestiges of private property to disappear. In Great Britain, for instance, the buying and selling of officers' ranks inside regiments was only outlawed in 1872. Nevertheless, not all fifteenth-century Italian governments believed that directly employing mercenaries was necessarily the best option. Florence was accused of pursuing a reactionary policy by refusing to follow the example of other states and establish a permanent army of its own.[28] Rather, at least in the fourteenth century, the Commune preferred to hire small units on short-term contracts, renewing the contracts from time to time. Although not devoid of risks, this practice guaranteed that the various soldiers would be well-placed, and suitably equipped, to have their contract renewed.[29] However, the limits of this system became apparent during times of conflict, as the Florentines always lacked the forces they needed to allow them to quickly expand their armies, and thus were forced to avail themselves of whatever the mercenary

market could offer anyway, and often paid dearly for second-rate military equipment. This policy's repercussions can be deduced from the angry letter the Venetian Adjutant-General Belpetro Manelmi sent to Doge Francesco Foscari following the inspection of a Florentine contingent sent to aid the Serenissima:

> The people the Florentines sent us, which have been arriving here over the past few days, including the constables mentioned at the bottom of this report, are in a rather bad shape, they have little discipline, and even fewer weapons, and they brought far more servants and boys with them than what is fair and necessary; and in this band, although there are one hundred foot soldiers they don't have more than six shields and twenty helmets between them.[30]

Manelmi was renowned for being demanding and fastidious in his inspections; after all, even Venetian troops weren't always organised and equipped in strict accordance with the rules. However, Venice possessed an adequate administrative structure to redress all the defects in its army, while the Florentines, either out of choice or inertia, never managed to find a satisfactory solution to their military problems.

3

THE WAR OF ART

The horses . . .

The bearded man had always nursed a passion for those magnificent beasts, having previously painted, drawn and sculpted them. Now he could finally give his creativity free rein, partially redressing his inability to complete that large equestrian statue, the model of which was now at the mercy of people and the elements. He had been deprived of the opportunity to better previous masters of the form, who had produced statues depicting leading condottieri like Bartolomeo Colleoni in Venice and Erasmo of Narni in Padua. But now he had another opportunity to make up for it. The battle of Anghiari had been chiefly waged by cavalry troops and this gave the artist the chance to illustrate a dense, compact scene, a whirling mass of flesh and steel, focusing in on the clipped tableau to create an optical illusion of a visual flight to infinity.

There was no dearth of subjects to inspire him, and there were several paintings in the city he could use for his purposes, such as those the previous rulers had forcefully expropriated from their rightful owners (even

though the latter had been able to reclaim them once power changed hands again). The artist who'd created them had ably fused the combatants' bodies and brought them into perspective in a style befitting the new epoch, even though it was too abstract and mechanical for the bearded man's liking. Furthermore, he had always privileged a natural realism in his own work. He was primarily concerned with rendering the vivid image of tangled limbs and boiling blood.

He looked at the drawing he was working on once again. The dust in the air—those dense, grey clouds that always hovered above arid battlegrounds had been quite sultry that day in Anghiari—would play a central role in his painting and serve to give the scene a chromatic harmony. Looking at the drawing, one could already see the dust cloud whirling around the mass of combatants, whose twisted bodies and intense facial expressions—the hallmark of those headed into the fray to both escape and deliver death—he had begun to sketch. It was a realism most of his contemporaries found highly disquieting, which explained why they also didn't look too kindly on the fact that he dissected cadavers so as to better understand the anatomy of the human body.

The bearded man went back to work, the ink running loose on the sheets of paper in front of him, while the highly detailed shapes of human bodies and horses began to assume their shapes . . .

In 1424, the painter Lorenzo Monaco died before completing the frescoes for the Bartolini-Salimbeni chapel in Florence's Holy Trinity Church. Any layman admiring those paintings who wasn't aware of their exact dating might easily assume they belonged to the latter half of the fourteenth century, as they so closely resembled the

unoriginal style of Giotto di Bondone and his imitators.

The symbolic and realistic conception of space in this chapel's frescoes overlap and confuse the emotions of the characters in the midst of their daily lives, since the way they express these emotions is neither unique nor original. As is often the case with paintings from the Late Gothic period, human shapes are more stereotypical than authentic. However, something was about to change, as any acute observer at the time might have noted while looking at Gentile da Fabriano's *Adoration of the Magi* (housed today at the Uffizi Gallery in Florence). Even da Fabriano's characters are stereotypes, but their individual traits emerge more forcefully in comparison to those in the Bartolini-Salimbeni chapel, and not just when it comes to the greater level of detail accorded to the entourage of the Three Kings. Although they are somewhat in the background with respect to the Magi, there are two individuals of particular interest, one of whom is wearing a richly decorated red hat and staring directly into the on-looker. This is Lorenzo Strozzi, the son of Palla, the man who commissioned the painting and who can be seen next to his son, standing there with a falcon on his arm and dressed in resplendent damask. The two figures attest to the triumph of an individuality that refused to be suppressed, but that had nevertheless been dormant since the fall of ancient Rome. Nevertheless, father and son end up being swallowed up by the horde around them, lost in a sea of sparkling gold and overwrought details.

Masolino da Panicale was also partial to luxury, as can be deduced from the two rather banal moneyed types depicted in the upper right panel of the Brancacci chapel in Florence's Santa Maria del Carmine. Their facial expressions are very stereotypical and

Masolino has styled their bearing according to a tried and tested approach almost identical to the one he used for Adam and Eve in their primordial innocence. This is why it's not difficult to imagine how shocking Masaccio's frescoes in the Brancacci chapel must have appeared to his contemporaries, for showing Adam and Eve in the Garden of Eden as they experienced human emotions in all their raw, unabashed forcefulness—a task which Masaccio, or rather Tommaso di Ser Giovanni Cassai, accomplished rather commendably. Another equally shocking and significant trait of Masaccio's frescoes was the large presence of characters drawn from real life, including people like Masolino, his colleague, the humanist Leon Battista Alberti and the sculptor Donato di Niccolò Bardi, known to us as Donatello.

We can take this to represent the beginning of the triumphal march of individualism, of an aesthetic that employed man as the measure of all things, a principle formulated by the very same Alberti and inspired by a classical culture that was slowly re-emerging from the murky depths of the Dark Ages. On the lower right-hand panel in the chapel, Masaccio depicted the members of the Brancacci family, the main financiers behind the entire cycle of frescoes. But one would be hard-pressed to spot these faces huddled around St Peter while the latter is sat behind his desk, since the original faces were painted over in the wake of the Brancaccis' political misfortunes and their likenesses replaced by Filippino Lippi with those of people favoured by the new regime.

Unlike the Brancaccis, Masaccio's style, which eventually earned the label of 'realism', was fated to survive, even though the painter's name often risked being forgotten by history as just a minor

embodiment of an interesting, audacious, but ultimately transitory, moment in the history of art.

It's not happenstance that the arc of time during which Gentile produced his Adoration, or Lorenzo Monaco his frescoes or Masaccio his paintings, coincided with one of the most difficult periods in Florence's history, and no one at the time could possibly have foreseen that this crisis would determine whether Masaccio's 'realism' would survive to spread its influence or else fade into indifference. Three years earlier, Palla Strozzi might not have dared to spend those 150 florins he'd given Fentile da Fabriano to complete his Adoration for the Holy Trinity Church.

As it happens, despite the momentary relief that came from Florence's alliance with Venice, the Florentine government was still traversing rough waters. Ever since the defeats it had suffered in the previous two years, discontent had spread through the city's streets, and the political debates at the time all featured the usual refrain that the republic's tributary system had to be replaced by a more egalitarian fiscal policy. The estimo (estimate) tax on movable and unmovable goods, which had been levied since the eighth century, had been abolished in 1381 and replaced by a duty of 5 per cent on all goods. It was a system that allowed for not a few abuses, in that the government could use it to favour supporters and punish detractors. Furthermore, the exponential increase of the public debt was not being offset by new taxes, not to mention that this practice augmented the Florentine citizens' distrust of their rulers, and encouraged tax evasion. The crisis ushered in by the war with Milan served to highlight the fact that if Florence wanted to survive, it would have to restructure its tax system. Ever since he'd been in conflict with Filippo

Maria, Rinaldo degli Albizzi had urged the necessity of introducing a new tax system along the lines of the old estimo, which would still need to be more efficient. Rinaldo, an individual possessed of considerable political experience, had succeeded his father, Maso, as the nominal head of the Florentine oligarchy in 1417, which effectively controlled public life in the city.

Even though it would be misleading to call the two Albizzi the lords of Florence, it is clear that they could rely on a sizeable following among the members of the regiment (a term that encompassed all those wealthy enough to assume positions of civic administration). Maso had been able to earn the support of a single, but powerful party: the dynamic Guelphs and the equally important Wool-Carders' Guild. Maso had surrounded himself with a group born in reaction to the Ciompi Revolt (1378), which had seen the republic broaden its popular base. Maso degli Albizzi had already demonstrated an outstanding ability in exploiting situations to his favour, most notably in 1393, when, having noticed a conspiracy was in the offing, he'd had the degli Alberi family, old rivals of his, banished from the city. Maso had consolidated his power by strictly adhering to the letter of the law. Whenever the Albizzi government found itself opposed in the legislature, the trick it typically used to ensure the passage of controversial bills was to convene a plenary assembly that included all citizens with political rights and ensure that they voted for the creation of a balìa (a judiciary board that would only exist for a short period of time) and charge it with reforming the constitution.

For instance, it was precisely one of these judiciary boards that created a governmental body charged with vetting the political

trustworthiness of candidates vying for public office. This body enjoyed ample discretionary powers by approving or eliminating names from the electoral rolls that funnelled individuals to the three major branches of government: the executive, the Signoria, which was drawn from the eight official guilds and was led by a *gonfaloniere di giustizia* (standard-bearer of justice), and the two advisory bodies tasked with overseeing the Signoria: the Sedici Gonfalonieri (Sixteen Standard-Bearers) and the Dodici Buonomini (Twelve Good Men). The natural distrust that forms part of the Florentine character ensured every public office was only tenable for a short term, and each incumbent was subsequently barred from reoccupying the role for a number of years. Furthermore, any citizen who was known to be in debt or in arrears with their taxes was automatically excluded from the roll.

The constant re-shuffling that went on in the executive was partly compensated by the Consulte and the Pratiche, bodies convened in order to advise the Signoria on specific issues, and although their opinion was not binding, they still carried considerable weight. The constant presence of some individuals in the Pratiche furnishes us with a particularly good indication of who really wielded power in Florence. Regardless, as subsequent events would reveal, having to face a hostile executive could have dire consequences. The Albizzi oligarchy completely depended on the vetting body being staffed by people whose loyalties they could rely on, which was especially important since even the most dominant group did not enjoy unlimited power. Proof of this lies in the fact that it was often very difficult to exert control over both the guilds and the two civic legislative bodies, the Consiglio del Capitano del Popolo (or as it was more commonly

known, the 'Consiglio del Popolo') and the Consiglio del Podestà (or 'Consiglio del Comune'), without whose support no law could be passed.

Maso's adroitness allowed him to negotiate the turbulent waters of Florentine politics, exploiting every situation to his advantage, while the war against Gian Galeazzo Visconti and the conquest of nearby Pisa notably increased the oligarchy's prestige. On the other hand, Maso's son Rinaldo had to deal with an unfavourable situation abroad. To further complicate matters, Rinaldo was also considerably less skilled than his father in ensuring that the leading political forces would rally around him. All these situations occurred at a time when a new political force was already emerging in Florence.

The Albizzi oligarchy was probably right to look on the Medici family with suspicion. During his tenure as the gonfaloniere of justice, Salvestro de' Medici had been among the supporters of the Ciompi Revolt and the charge of demagogy would forever leave its taint on his kinsmen. This was why the Medici had so often fallen into the government's crosshairs, to the point that by the beginning of the thirteenth century only two branches of the family still remained in Florence, the others having been forced to abandon their houses under sentences of exile. Those who stayed preferred to keep a low profile, but nonetheless still dabbled in politics, even doing so outside the city walls, employing tactics that, while hardly original, had been sharpened over the course of several decades.[31] Giovanni di Averardo (nicknamed Bicci) de' Medici had begun exploiting his commercial reach to create an extensive banking network, and under John XXIII's papacy, he had become the Holy See's principal

moneylender. Even though Giovanni lost this position under Martin V, the Medici had nonetheless managed to secure a strong foothold in one of the most far-reaching financial systems of the early modern period. Exploiting their vast wealth and lending funds to badly strapped members of the *regimento*, so that the latter would further Medici interests, Giovanni began building a following in Florence. While the Medici didn't have an exclusive hold on this sort of clientelism, their full coffers allowed them to build a bigger network than most, which wasn't limited to the high walks of society. In fact, Giovanni and his sons always presented themselves as champions of the people. It's clear that Rinaldo degli Albizzi's support for the introduction of the catasto had been motivated by his desire to hinder the rise of the Medici.

The law put forward by the oligarchy's supporters provided for proportional taxation of all movable and immovable goods in the city and its surrounding countryside, not based on the findings of systematic evaluations carried out by specifically established commissions, but instead relying on periodically updated ledgers. Even though nominally in favor of the catasto, Giovanni de' Medici did nothing to ensure the measure was passed. One can easily understand why: his capital was for the most part tied up in financial investments and he thus risked having to pay far more taxes than those who'd invested in immovable goods, not to mention that the potential profit in any commercial activity did not always correspond to its eventual outcome. In other words, the *catasto* could be used as a political weapon to economically undermine political rivals. In order to protect himself, but also because he was aware of how necessary it was

to avoid the republic's collapse, Giovanni put forward his own proposal, according to which the people's movable goods could only be taxed to a ceiling of 60,000 florins. Even though the Medici proposal was scuppered, Giovanni avoided being tarred with the accusation of lacking civic responsibility and thus maintained a certain popularity amongst the lower classes. The new levy was only approved by a very slim majority in the two popular legislatures, thereby proving the Medici weren't the only ones who doubted its merits, or its efficacy.

The case of the Cambini family, who did all they could to conceal the extent of their assets,[32] is emblematic of the general distrust towards the catasto, which was also confirmed by a report on all the fraudulent returns filed by Florence's citizens. Giovanni de' Medici declared a network—encompassing all moveable and immovable goods—of 91,089 florins, which after the exemptions the law provided for, amounted to a taxable income of 81,072 florins, meaning he owed the state a total of 397. Nevertheless, by the time Giovanni died in 1429, his fortune was estimated at 178,122 florins—meaning a tax of 790 florins—double what he'd paid just two years earlier.[33] By concealing his assets, Giovanni had behaved more or less like everyone else in Florence and his political influence partly sheltered him from governmental scrutiny, despite the anonymous tips passed on by various informers who hoped to claim a cut of the profits derived from confiscated assets. On the other hand, Rinaldo degli Albizzi seemed to have been rather scrupulous with his own finances and paid 775 florins in tax, which was much more than the 507 paid out by Palla Strozzi, who was considered the wealthiest man in Florence. The government's assurances that this new tax should be considered

a necessary loan to help cover the republic's vast debts did little to encourage Florence's citizens to pay their taxes. The state's returns that year amounted to a measly 45,000 florins, only a drop in the ocean of Florence's financial worries, which had seen the republic forced to incur numerous loans simply in order to survive.

If the public deficit didn't increase right after the introduction of the catasto, this was only thanks to the peace treaty concluded between Filippo Maria Visconti and the Venetian-Florentine alliance in April 1428. The Duke of Milan had been obliged to enter negotiations by Venice's capture of Brescia and Bergamo, and above all by the disastrous defeat he'd suffered at Maclodio on October 11, 1427, at the hands of the Serenissima's troops led by Carmagnola. Even though the resourcefulness of Milanese gunsmiths had allowed the dukedom to recover from its losses and re-equip 5,000 horsemen and 2,000 footmen in only a few days, the overall cost of the war was taking a huge toll on Filippo Maria's coffers, and he would need time to recuperate. As was to be expected, the peace treaty concluded in Ferrara heavily favoured Venice, which retained Brescia, Bergamo and Cremona, while Florence only extracted a promise that Milan would disengage from the Romagna and guarantee the safe passage of Florentine goods through its territory: mere crumbs when compared to the estimated 3,500,000 florins that Florence had spent on the four-year conflict. Nevertheless, the republic badly needed peace so it could focus its energies on dealing with its internal disorder. The new catasto provided for the taxation of Florentine citizens located in other parts of the realm, but the officials tasked with collecting them had faced considerable difficulties pretty much everywhere.

Quite a few of Florence's vassal communes looked on these tax surveys as affronts to their liberties, which was exactly what eighteen citizens in the Volterra declared when they were arrested and thrown into Florence's putrid gaol Stinche for having opposed the tax censuses in their respective communities.

In Florence itself, many people muttered that the zeal with which the Albizzi were pursuing these policies had less to do with ensuring fiscal equality and more with the desire to identify what resources their enemies had been able to transfer outside the city walls. If it could be proved that the Medici had dodged their taxes, this could discredit them in the eyes of the poor, whom the Medici claimed to champion. In the end, the citizens of Volterra who'd been arrested consented to having their goods officially inventoried in exchange for their release, but once they'd returned home, they incited their fellow citizens to open revolt, simultaneously beseeching Paolo Guinigi, the Lord of Lucca, to come to their aid. Florence moved quickly to reconquer the rebel commune and Volterra consented to negotiations in November 1429, thanks in part to behind-the-scenes interventions by Cosimo de' Medici, who had assumed his father's political role when the latter passed away a few months earlier. Florence was primarily concerned with maintaining control over Volterra's alum mines, which explains why it was prepared to compromise, leading to a tax exemption for all Florentine citizens in Volterra that was finalised in 1431, and which should be considered a victory for the pro-Medici party. But by that time, the battle being waged between the Medici and the Albizzi had shifted locale to take place within the regimento. The situation was about to swell to dramatic proportions.

The republic's financial crisis, coupled with its various problems in the Florentine hinterland, had placed the Albizzi government in dire straits, and it now needed a triumph more than ever in order to quell internal opposition. Its eventual target was none other than Lucca, since Florence had never forgiven Paolo Guinigi for allying with Filippo Maria Visconti, not to mention helping the Volterra rebels. Besides wanting to both score a triumph and exact its revenge, there were other considerations that urged Florence to move against Lucca. The city was situated right on the border of the republic, and was arguably the gateway to the Po Valley. The republic's enemies could thus easily use Lucca as an access point to Florence. Furthermore, Lucca controlled a number of crucially strategic passes in the Apennines, and it had been the need to keep these open to Florence's goods and armies that finally prompted the city to conquer the citadel of Barga in the mid-fourteenth century. There were also questions of military prestige at play, since Florence desperately needed to improve its reputation for martial prowess after the heavy defeats it had suffered in the previous war. Last but not least, Lucca was one of Florence's most serious rivals in the silk manufacturing business, which was starting to overtake the wool trade as the city's chief source of wealth. Hawks clamouring for war began to abound in Florence and even the lower classes had been bitten by the war bug, a situation that rather favoured the Medici, who could now openly side with the government without alienating their supporters.

The hostilities against Lucca began towards the end of November 1429 in Sordina, when the condottiere Niccolò Fortebracci led a series of sorties into Lucca's territory. Fortebracci was officially acting

on his own initiative, and he legitimised his actions under the pretext of reclaiming the remainder of the 50,000 florins Lucca had promised his uncle, Braccio da Montone, in 1418 as a guarantee of a share in his booty. Paolo Guinigi's efforts to reach an accord with Florence all came to naught, a fate shared by the efforts of the dovish party in Florence, which was led by Niccolò da Uzzano. Uzzano, the grand old man of Florentine politics and one of the last living members of Maso degli Albizzi's group, argued that Lucca was an old loyal ally of the republic's, and that Florence's arrogance had been the primary reason why Lucca had briefly sided with Milan. Rinaldo degli Albizzi's followers retorted that Paolo Guinigi could not be trusted and that Florence's security depended on Lucca's conquest. To those who feared this war would trigger Filippo Maria Visconti's involvement, Neri Capponi offered the following rebuttal: 'We shouldn't give up on the Lucca campaign simply because we're afraid of the Duke of Milan, since conquering the city will restore the republic's reputation and give our citizens hope, thereby meaning the duke will refrain from entering the fray.'[34]

Capponi's assumption was based on the premise that the campaign against Lucca would be resolved quickly and without excessive financial costs. But Niccolò da Uzzano was far-sighted—and probably bearing in mind an aphorism that his friend, Gino Capponi, Nero's father, had once uttered: 'Laying siege to major cities and vast lands means incurring too many dangerous costs in the hope of conquering them'[35]—and he realised that the conflict could have disastrous consequences for the Albizzi oligarchy. Perhaps his suspicions had also been aroused by the support Cosimo de Medici had lent to

Florence's war hawks. The Albizzi had their way in the councils, and the creation of the Dieci di Balìa the following December was tantamount to a declaration of war. The prevailing sentiment in Florence was optimism, but the city's bellicose spirit had begun to worry its closest neighbours, especially the Sienese, whom Giunigi had taken the trouble to inform that, once Lucca fell, their city would be Florence's next target. Antonio Petrucci, the Sienese orator who had been pointlessly dispatched to Florence to settle the dispute between the Florentines and the Luccans, got the same impression, especially after he heard street urchins in Florence yell: 'Hail Mary, full of grace, once we conquer Lucca, we'll also conquer Siena,' as well as 'Lucca is shaking, Siena beware.'[36] Accordingly, as soon as he returned home, Petrucci did everything he could to convince his fellow citizens to lend their aid to Lucca. For the Florentines, hostilities had commenced with a crass lack of shrewdness.

Rinaldo degli Albizzi was sent to supervise the armies camped in the Luccan countryside, but it didn't take long for him to come into conflict with Fortebracci over how the war was being managed strategically. While Fortebracci favored conquering the castles and keeps of the Luccan countryside so as to create an impenetrable cordon around the city, Rinaldo instead wanted Lucca placed under heavy siege, according to the logic 'cut off the head, and all the other limbs will stop working.'[37] Rinaldo's motivations were strictly political, in that he was seeking to bring the war to a speedy conclusion so as to solidify his personal prestige, while Fortebracci favored military logic: every fortress in Lucca's hands was a thorn in the side of the besiegers. In the attempt to resolve the issue, and to speed up

military operations, the Dieci di Balìa sent another two commissioners, namely Neri Capponi and Alamanno Salviati, thus stoking resentment in Rinaldo, who interpreted such a move as a lack of confidence in his abilities. His resentment grew when Capponi and Salviati managed to conquer the castle of Collodi despite the harsh winter that conspired against the siege, and finally turned into wrath when his name was omitted from the reports sent by the other two commissioners, at which point he began a smear campaign against them with the Dieci di Balìa, spreading rumours that Neri Capponi wanted to become lord and master of Florence.

The grudge between Neri Capponi and Rinaldo degli Albizzi was long-standing. Even as far back as 1424, Rinaldo had taken it as a personal affront when Capponi had been entrusted with a diplomatic mission to Rome, where Rinaldo already resided in his capacity as the city's representative with the Papal Curia. Neri had dealt Rinaldo another insult when he'd taken Fortebracci's side on how the military campaign against Lucca was being waged, and Rinaldo had taken a dim view of the influence Capponi increasingly exercised on the condottiere from Perugia. The prestige that Capponi enjoyed among soldiers of fortune was well known, the result of the respect that he had for professional fighters and the competence he displayed on the field of battle. Besides being present at the siege of Pisa in 1406, where his father had served as commissioner, he had often been a member of the Dieci di Balìa and had on more than one occasion represented Florence in negotiations for the hire of mercenaries. During one of these missions, he had struck up a friendship with Braccio da Montone, a relationship that would extend to the

nephew of Niccolò Fortebracci. In fact, Neri Capponi had always been one of the major representatives of the pro-Fortebracci party in Florence, in other words that group of people who had begun by favouring a state of Perugia independent of the Holy See and had eventually wound up favouring a political and military alliance between Florence and Venice. Neri Capponi enjoyed a large personal following in Florence, and was renowned as a principled citizen devoted to the city's interests. Thus it was understandable that Rinaldo degli Albizzi—whose haughtiness was renowned—would consider him a dangerous rival. On the other hand, Rinaldo had begun to extend his own influence in the Santo Spirito neighborhood, lending his support to the political aspirations of some of the families in the gonfalone[38] of the dragon: namely the Serraglis, the Tinghis and above all the Brancaccis. Given that the Capponis had in turn begun expanding in the gonfalone of the Dragon, spilling out of the nearby *gonfalone of the nicchio* (mollusc), the confrontation between Neri Capponi and Rinaldo degli Albizzi was more than just a clash of personalities.[39]

The campaign that aimed to reduce the number of Lucca's fortresses wound up wounding Rinaldo, whose reputation depended on the war being rapidly brought to an end. Anonymous denunciations against him began to come thick and fast—one of the accusations being that he wanted to drag out the conflict so that he could personally profit from it. Rinaldo asked the Dieci di Balìa to let him return to the city to defend himself, but he was ordered to remain at his post, and the Dieci simultaneously denied him the additional troops he'd requested to close the circle around Lucca. In their hurry

to enlist men for the war, the Dieci di Balìa had made the mistake of recruiting Bernardino Ubaldini della Ciarda, Fortebracci's old enemy, and to repair the damage, the Florentine authorities found themselves forced to keep the two condottieri's armies separate from one another. Moreover, Fortebracci was not a little irritated to be denied the title of commander in chief (something the Florentines had carefully avoided, so as not to risk antagonising Ubaldini) and Fortebracci therefore hadn't led the war effort with adequate energies.

Rinaldo degli Albizzi finally managed to return to Florence at the end of March 1430, but it wasn't only his prestige that had been shattered to pieces: Florence's own reputation was also on the wane, while its enemies, whether actual or potential, were growing bolder at the sight of Florence struggling under the walls of Lucca. In an attempt to bring the campaign to a speedier close, the Dieci di Balìa, pressured by their citizens, decided to carry out the plan proposed by the celebrated architect, Filippo Brunelleschi: the construction of a dam on the Serchio river that would have flooded Lucca. Brunelleschi was conscious of his genius and extremely convinced of his own abilities. Yet while his talents as an architect, goldsmith and sculptor were undeniable, military engineering was not one of his strong suits. This became rather obvious when he presented his plans for flooding Lucca and Neri Capponi 'mocked it', demonstrating how the Luccans could easily turn the besiegers' plans against them.[40] Nevertheless, Brunelleschi had public opinion on his side, and after two days of discussions, he had the upper hand. As Capponi had predicted, the Luccans promptly carried out a sortie and sabotaged the Florentines' building site, causing the besiegers' camp to be flooded,

and prompting the diarist Giovanni Morelli to pass the following lapidary judgement: 'It was child's play, we lost time, money and works, there were forty thousand of us and we didn't conclude anything, but we lingered amidst the shame and damages.'[41]

The effects of the 'damages' were felt immediately. Recriminations abounded in Florence, with everyone trying to distance themselves from a war that had become unpopular. In a record dated April 26, pro-Albizzi supporters tried to dump the responsibility of the conflict on the pro-Medici party, accusing them of having instigated it for sectarian reasons. The problem of factionalism had been giving the Florentine regime headaches for some time already, to the point that a few years earlier, they had clamped down on religious brotherhoods, with each brotherhood being put under investigation on the suspicion—in the absence of evidence to the contrary—that they were nothing but meeting places for political cliques inclined towards subverting the state. Having to face increasing difficulties due to its continuous failures, the Albizzi oligarchy had developed a sort of paranoia towards the swelling internal opposition, which by then had become synonymous with Cosimo de' Medici. In this respect, Rinaldo degli Albizzi's description of political factionalism as a *morbum* (disease) that required an effective cure[42] was perhaps involuntarily ironic and prophetic.

Brunelleschi's failure was a harbinger of further troubles when it came to squabbling over political debates. Seeing the difficulties Florence was traversing, Siena decided to throw its lot in with Lucca; secretly at first, sneaking troops to Lucca through the Pisan countryside, an area that was smouldering with barely concealed

hostility against the Florentine oppressors. When the Florentines protested, the Sienese replied with a feeble excuse, saying that the operation was a personal initiative of Antonio Petrucci, but by then, personal politics had begun to coincide neatly with public policy: shortly thereafter, the Sienese appointed a war committee composed of twenty-seven members, while at the same time asking the Duke of Milan for his help. Filippo Maria Visconti had no intention of exposing himself—at least not for the time being—fearing that an obvious breach of the Peace of Ferrara would revive the old anti-Milanese coalition. However, the Duke was a resourceful man, especially when it came to surreptitious techniques. Filippo Maria had the condottiere Francesco Sforza, who was unpopular with some elements of the Milanese political and military establishment, on his payroll. Thus, intending to kill two birds with one stone, the duke went through the farce of firing Francesco, who subsequently announced that he planned to offer his services to the Kingdom of Naples. The masquerade allowed Filippo Maria to aid Lucca without violating the terms of the Peace of Ferrara. Officially a free agent, Sforza struck a deal with Giunigi and Petrucci whereby they secured 450 spears for a year's service, with Sforza receiving an advance payment of 24,000 ducats—which was actually a fairly trifling sum, but the Lord of Lucca, whose coffers had been drained by the war, couldn't afford anything more.

Francesco Sforza arrived in Tuscany in early July, passing through the Lunigiana. Although his forces had been reduced to little more than 1,500 horses and 600 foot soldiers, he managed to easily overcome the siege lines and enter Lucca. When the Florentines protested

against Sforza's actions, the Duke of Milan predictably told them that the condottiere was no longer in his service, and that he therefore didn't exercise any influence over him. The discord between its captains was seriously hampering Florence's war efforts, and unable to make its mind up between Fortebracci and Ubaldini, the city eventually settled on Guidantonio da Montefeltro, the Lord of Urbino, as its commander in chief. This took place in August, and in the meantime, Sforza kept himself busy carrying out raids in the Val di Nievole, until he was only five miles away from Prato. But Francesco had other plans and intended to exploit the situation to his advantage as much as he could. Disagreements with Guinigi over the strategic conduct of the war led him to abandon Lucca, retreating with his army to the Serchio river, and simultaneously entering into talks with Florence under the pretext of wanting to collect the sum the city owed his father. As it happens, Sforza was actually weaving a web of intrigues, which also included bringing Guinigi's lordship to an end (Guinigi was, in turn, suspected of wanting to sell Lucca to the Florentines), which, among other things, would give Florence the excuse to enter into peace negotiations. Sforza managed to get the Florentines to cough up another 50,000 ducats, and on August 15 he abetted a popular uprising in Lucca that led to the arrest of Paolo and his son Ladislao, as well as the looting of the Guinigi Palace, which netted Sforza another 60,000 ducats, in addition to the 12,000 he'd been paid by the victorious conspirators. The two Guinigis were transferred to Pavia, where Paolo died in a gaol two years later. No longer intending to remain in Tuscany, Sforza withdrew to Cotignola, abandoning Lucca's field defenses to the Florentines.

In theory, Paolo Guinigi's exit had removed the root cause of the conflict, but the peace talks between Lucca and Florence were stalled when the Florentines demanded the cession of Pietrasanta and Montecarlo, which would have reduced Lucca to a virtual vassal. But the Dieci di Balìa were eager to exact the highest possible profit from what had been a long, costly and humiliating war, and were counting on the fact that Lucca, extremely weakened by the siege and nearly bankrupt, couldn't possibly hold out for much longer. Hence, Florence's exorbitant requests looked like a deliberate attempt to undermine the negotiations, so that it could continue to blockade the city and eventually conquer it.

'Florentines are blind', an old Tuscan proverb says, and besides being short-sighted, the Florentine government had not reckoned with their host, namely Filippo Maria Visconti. The Duke of Milan had no intention of letting Lucca fall into Florence's hands, given that he was hoping to use the city as a potential springboard for future military incursions into Tuscany. Furthermore, if Florence were allowed to absorb the entirety of Lucca's territories, this would bring her right up against the borders of Genoa, which would inevitably imperil the Visconti hegemony over that city; after all, the Florentines had systematically aided the Genoese dissidents during the 1424–1428 conflict. But Filippo Maria still didn't feel ready to directly intervene and help Lucca, and thus resorted to the age-old trick of acting through a third party. On September 28, Lucca and Genoa, which was only nominally independent, concluded a mutual defence pact whereby Lucca ceded the fortresses of Motrone and Pietrasanta to Genoa as a guarantee against a financial loan.

Filippo Maria subsequently 'fired' another condottiere, Niccolò Piccinino, who was immediately recruited by Genoa. Once again, Filippo Maria had managed to strike both intended targets, insofar as the pro-Milanese Genoese needed military aid to bring their rivals clinging to the fortresses in the Apennines to heel. Once the campaign against the Fieschi and the Malaspina had been successfully concluded in Lunigiana (although he hadn't been able to capture Pontremoli), Piccinino 'officially' enlisted with Lucca, and on December 3 he engaged Florentine troops under the walls of Lucca. The skirmish was brief and rather bloodless, that is, if one didn't account for those few hundred troops who drowned in the Serchio during the rout—which was complete, given that Piccinino easily triumphed over the badly co-ordinated and discouraged Florentine troops. In the end, Piccinino entered the city amidst the jubilations of the people.

Piccinino didn't exploit his advantage. After all, he didn't need to: the rich booty he'd extracted from the Florentines needed to be distributed amongst his troops, and the winter season was unfavourable to military operations. Instead, Piccinino preferred to remain in Lucca, where he could get his troops back on their feet and plot his next moves. Both Florence and Milan wanted him on their payrolls, but Filippo Maria Visconti had an ace up his sleeve: Bianca Maria, his illegitimate but unmarried daughter. Since the duke had no male heirs, his future son-in-law would be in a propitious position to succeed him as the Lord of Lombardy—at least in a de facto capacity, since the region was technically a fief of the Holy Roman Empire. Over the coming years, Filippo Maria would routinely float

the possibility of marrying his daughter to both Piccinino and Francesco Sforza in order to keep them in his service. The future would show who would eventually win that game.

Piccinino's intervention in Tuscany roused the Venetians, who not only considered it a breach of the Peace of Ferrara, but also feared an alliance between Visconti and the emperor-elect, Sigismund of Luxembourg. For these reasons, the Serenissima agreed to renew the alliance that had been stipulated three years earlier and to lend its aid—especially from a naval point of view—to the Florentines. This assistance on Venice's part was of no small import considering the severe damage the Genoese fleet had inflicted on Florence's maritime commerce, which it crippled by blockading its ports. The arrival of Venetian galleys rebalanced the situation, and in August 1431, a flotilla of Venetian and Florentine ships attempted a surprise attack against Genoa under the command of the exile Antonio Fieschi, who also counted on the help of Genoese dissidents opposed to Milanese control. The Visconti fleet intercepted the allies off the coast of Rapallo, and even though they emerged victorious, they were nonetheless forced to return to their bases.

Matters weren't proceeding smoothly for the allies on any other fronts, either. Venice had suffered a serious defeat in a river battle near Cremona, while Florence's territory was being ravaged by the ducal troops based in Lucca. A conspiracy to overthrow Florence's dominion was uncovered in Arezzo in May, barely in time to prevent the conspirators from throwing open the doors of the city to Piccinino, who wanted to avenge the humiliation that devastated the city's surroundings. As though that weren't enough, Siena openly

sided with Visconti, who had also brought Sigismund of Luxembourg to his camp. Moreover, the Florentines were experiencing trouble with their own condottieri, as Guidantonio da Montefeltro had left their employ, and Niccolò Fortebracci was threatening to do much the same unless he was compensated for the losses he'd suffered the previous year. Cornered, Florence turned to Micheletto Attendolo, but even he made demands that the government decided were too exorbitant, so in the end it consented to Fortebracci's demands so as not to risk its army being left without a commander in chief. In any case, the natural progress of human events was already reshuffling the cards of Italian politics.

In January 1431, Pope Martin V passed away, leaving behind a situation fraught with problems for his successor. Following the Council of Constance, the Pontiff had convened an ecumenical council that was to be held at Pavia, but was almost immediately relocated to Siena due to an outbreak of the plague. The ecclesiastical assembly only lasted a few months, and, after reaching an agreement to reconvene in Basel in a few years time, broke up without having come to a conclusion on either of the matters it had meant to settle: the fight against the Hussite heresy, and the reform of the Church. As it happens, Martin hadn't liked the direction taken by the council, given that it had demonstrated a marked bias towards steering the reforms to curb pontifical power from the very get-go, a course especially popular with the French clergy, who favoured the autonomy of national churches while still keeping them under the jurisdiction of papal power. In July 1431, the council met at Basel, but only a few prelates answered the summons. This (along with the argument that

he was in poor health and unable to travel) furnished Eugenius IV, the new Pontiff, with the excuse to order the council dissolved and decree that a new convocation be held at Bologna within eighteen months' time. Nevertheless, the council held strong, and refused to disband.

Pope Eugenius IV was in no position to crack his whip, embroiled as he was in a tough fight with the Colonnas, the family of his pre-decessor. As though that weren't enough, Sigismond of Luxembourg signed an agreement with Visconti, arrived in Italy at the head of 800 Hungarian knights and set up his headquarters in Lucca. The Pope saw this as a threat against his own power and feared that Sigismund might act as the council's champion. Likewise, the Florentines were convinced that Sigismund wanted to revive the now archaic imperial claims on Tuscany. In fact, Sigismund was working towards secur-ing an official crowning as the Holy Roman Emperor, but his alli-ance with Filippo Maria Visconti was also directed against his old enemies: Venice, and the Pontiff, otherwise known to us as Gabriele Condulmer, who also happened to be Venetian. The Serenissima's expansionism towards the Friuli had brought it into direct conflict with the Empire, and the annexation of the Patriarchate of Aqui-leia in 1420, which usurped the rights of the Patriarch Ludwig von Teck, had been the last dirty trick the Venetians had played on Sigis-mund. Teck had often tried to reconquer his fiefdom *manu militari* with Sigismund's backing, and was also one of the most pugnacious conciliarist prelates present at Basel. As far as both Sigismund and Visconti were concerned, Venice's territorial expansion was directly linked to the weakening of papal power. Even Florence entered into

this equation, since the Pontiff, short of allies in his fight against the Colonnas, had taken Florence's side in the conflict.

While Venice's entry into the war eased Milanese pressure in Tuscany, the Florentines weren't having that great a time. The falling out between Niccolò Fortebracci and Bernardino Ubaldini had prompted both condottieri to seek employment elsewhere, and Ubaldini had even signed on to Visconti's payroll. On the other hand, the Duke of Milan had lost the services of the renowned Niccolò Mauruzzi from Tolentino, who was annoyed that Filippo Maria had passed him over for Commander in Chief and had showered his favors on Niccolò Piccinino instead. In the Spring of 1432, Ubaldini, having linked up with the Sienese troops commanded by Antonio Petrucci and Francesco Piccinino, sprang into action, stormed through the lower Valdarno, Pisano, Valdelsa and the Aretino, captured a series of strongholds, and left Micheletto Attendolo, who had fewer men, unable to do much to oppose him. The Florentines complained, 'When he was on our payroll, he never did much worth remembering. But he acted like Orlando when he was on the enemy's payroll.'[43] The Florentines also worried about the political repercussions that Milanese–Sienese military actions might provoke in their own territories. Bernardino hoped to appeal to the strong anti-Florentine sentiments in the city of Arezzo and the Pisan countryside, and his conquests in those areas were always characterised by a scrupulous respect for people's private property.

Niccolò da Tolentino's arrival in Tuscany played a part in somewhat restoring the balance in Florence's favour. The second half of May saw him in the higher Valdarno, trying to contain the enemy's

offensive in the Aretino and the outskirts of Montepulciano, while another army commanded by Micheletto Attendolo had been sent to protect Pisa, which was unable to do much to block the operations of the preponderant enemy troops in the Pisan countryside. Thus, in agreement with the Florentine commissioners, Tolentino deemed it necessary to move to the Valdelsa, having also received word that the castle of Linari was under attack. Even though he tried to get there as quickly as he could, Niccolò couldn't prevent Linari from falling into enemy hands, which forced him to retake it through a frontal assault. Linari's walls were later destroyed and many of its houses burnt down to punish its inhabitants for supporting Florence's enemies. Meanwhile, Florence had managed to capture the important stronghold of Pontedera and had placed Gambassi under siege. Ordering most of his foot soldiers to mount horses—probably behind the squires—Tolentino managed to catch up to the enemy and engage him on June 1 on the vicinity of San Romano, between Pisa and Pontedera. The battle didn't last long and Attendolo also intervened to contribute to the Florentine victory. The losses on the Visconti side were mostly material: 150 suits of armour and 600 horses had been captured, but there were few fatalities.

The campaign led by these two condottieri was splendid, and the thrashing they'd inflicted on Filippo Maria and the Sienese was remarkable. Florence's government publicly recognised their deeds, ordering, among other things, that an annual procession of thanksgiving be held for San Rossore, whose head was preserved in the Florentine Church of Ognissanti, in the shape of a bust that had been sculpted a decade earlier by Donatello.[44] Still, the stories that made

the rounds in Florence (all too artfully, we can assume) differed substantially from the official report produced by the Florentine commissioners. Some even ridiculed Tolentino, who had supposedly let himself get surrounded by the enemy, and was only rescued by Attendolo's lucky appearance.[45] The Sienese paid close attention to these rumours, to the point that the local chronicles described the battle as ending in a Florentine defeat. As a matter of fact, the recent successes of the Florentine army were not especially useful even to the Albizzi oligarchy, though it desperately needed victories. For a start, Niccolò da Tolentino was notoriously close to Cosimo de' Medici; therefore, it's more than plausible that Rinaldo degli Albizzi didn't wish to exalt anything that could be interpreted as a Medici victory. One should also not ignore the fact that one of the Florentine commissioners at San Romano was Bernardetto de' Medici, Cosimo's cousin and close collaborator. As though that weren't enough, the other commissioner present was Luca di Maso degli Albizzi, Rinaldo's brother, who, despite his blood ties with the leader of the oligarchy, had gone over to the Medici side—'out of envy', or so said Machiavelli[46]—but probably more likely because he was at odds with Rinaldo's politics and because his wife was Aurelia di Niccolò de' Medici, whose sister was married to Simone Tornabuoni, who was first cousins with Francesco, one of Cosimo de' Medici's banking agents. In any case, if the Albizzi oligarchy had indeed circulated all those rumours belittling the victory of San Romano, then their behaviour was no different from that of a man who emasculates himself in order to spite his wife.

It's likely that a few years after the events of June 1432, Lionardo

di Bartolomeo Bartolini-Salimbeni, one of the Dieci di Balìa, com-
missioned from the painter Paolo di Dono—commonly known as
Paolo Uccello[47]—three large panels depicting the battle. Given his
governmental position, Bartolini had access to official records, and
furthermore, at least in appearance, the pictorial sequence of events
closely follows the descriptions given in the histories of the time, like
Neri Capponi's and Matteo Palmieri's.[48] The canvases are especially
noteworthy due to the perspective representation, whereby the back-
ground, which depicts a quasi-idyllic pastoral scene, gradually fades
away from the fighters in the foreground. Uccello had worked with
Lorenzo Monaco, and certain elements of the Late Gothic period are
still visible in the panels of *The Battle of San Romano*, which today
have been divided between Florence, London and Paris. But do the
three paintings actually depict the battle that took place on June 1,
1432? The examination of the armour carried out by Lionello Boccia
has allowed us to date the canvases to approximately 1436–1441,[49]
and much water had flowed under the bridges of the Arno in be-
tween the battle of San Romano and the completion of the paint-
ings, including a whirlwind of events that would forever change the
history of Italy. Therefore, as we shall see later on, it's not a bad idea
to consider other subjects besides Niccolò da Tolentino's victory. At
any rate, it's an established fact that the evolution of the arts in the
fifteenth century was shaped and marked by the experience of war.

4

A CURE FOR THE STATE

The bearded man bent over his notes, studying them carefully. Together with the secretary of the war magistracy, he had agreed upon a detailed plan, a flurry of ideas he would now have to put into practice. The protagonists were all present: Neri Capponi, Pietro Giampaolo Orsini, Micheletto Attendolo, Rinaldo degli Albizzi . . . He lingered awhile on the last name on that list, reflecting on man's mutable destiny, of which Rinaldo was a prime example. It was almost ironic that the painter was now in the employ of Rinaldo's former enemies, the very men who had determined his fate—what the secretary had called 'chance', suggesting that one could slap it around, just like one could a woman. For that matter, the secretary was known to have a wandering eye when it came to women.

The artist went back to the text, re-reading what he had written on Niccolò Piccinino. Piccinino was the one who intrigued him the most: capable, brave and unscrupulous; if it hadn't been for the Patriarch of Aquileia, who had spotted the dust cloud raised by Piccinino's soldiers,

things would have turned out very differently—or perhaps Attendolo had been the first one to notice it . . . But the bearded man was more intrigued by the prelate, whom he depicted with hands joined in prayer to invoke St. Peter the apostle, who emerged before Piccinino's eyes wrapped in a cloud. While it was an image the secretary hadn't fully approved of—and the bearded man himself had a reputation for being an unbeliever—he knew it would please his employers, inspired as they were by the sermons of that Dominican friar whom they said had restored their freedoms. Overlooking the fact that they hadn't hesitated to have him executed and then burned his corpse. Martyrs have always proved useful, right to the bitter end.

Dust and smoke. These were the elements the bearded man was most interested in: it was said that the thick dust raised by human feet and equestrian hooves mixed with the dense haze of artillery fire to cause a great deal of carnage on that distant summer day. Re-creating that effect in a painting was a challenge, which the painter believed he was suitably equipped to meet; after all, he was considered a distinguished engineer, as well as an expert on firearms. It didn't matter much that he'd copied the designs for his cannons from other authors' works. Of course, when it came to depicting the battle he would have to be careful to make the human protagonists stand out, without altering the visual impact of the battle itself. It was a tightrope act in which he would have to balance the animate and inanimate worlds.

He returned to his notes. Piccinino's speech to his soldiers and Rinaldo degli Albizzi would be the starting point, the first scene of his painting; fitting, considering Rinaldo degli Albizzi's personal travails were at the roots of the entire affair.

•

While pacing a room from end to end, Filippo Maria Visconti would customarily reach the other wall, turn around, rest his back against that wall, and then give himself a little push with the ball of his foot, speaking only in a hushed whisper that forced his audience to listen very carefully. Watchful courtiers knew that although Visconti wasn't quick to fly into a fury, it still wasn't a good idea to incur his wrath; the throbbing vein at the base of his neck indicated a brewing rage at any moment, and whoever had provoked his scorn would soon receive the duke's punishment, which tended to be humiliating.

Yet as far as Filippo Maria was concerned, revenge had to wait for the most appropriate moment, regardless of either people or politics. The circumstances of his youth had taught him the arts of concealment and duplicity, which he had refined over the years in order to keep from drowning in the stormy seas of Italian politics (indeed he himself had contributed significantly to those tumults). In his foreign policy, Visconti played the various Italian rulers against one another, while in his domestic policy, he kept the dukedom's different factions in check, including his mercenary captains. Culturally speaking, the duke belonged as strongly to the world of Italian humanism as to courtly central-northern Europe; as for his physical aspect, he seems to have resembled one of the grotesque figures one may find in Late Gothic art—though the descriptions we have of the duke come from either his enemies (like Pope Pius II) or those who, like Pier Candido Decembrio, praised him highly when he was alive but lost interest in him after he died.[50]

However, all of them were in agreement when they described

Filippo Maria as an impressively built man, with a long face and large restless eyes, features that stand out in Pisanello's portrait. The duke had commissioned the artist to adorn the hall of a castle at Pavia with frescoes that featured hunting scenes and various members of the Visconti clan. Although they have since been lost, using descriptions left behind, we can imagine that Pisanello had executed a work of great pictorial elegance, similar to his cycle *St. George and the Princess* in the Church of Sant'Anastasia in Verona. What's most striking about these paintings, besides the poetic sophistication of the subjects and their environments, is Pisanello's blunt, brutal view of reality: the refined features of St. George and the Princess of Trebizond contrasted with the raw image of the two hanged men in the background. The Duke of Milan was the perfect embodiment of this contrast between the sacred and the profane, being both a strongly devout man and extremely superstitious, capable of both great generosity and cold-blooded ruthlessness.

Although Filippo Maria by no means exercised a monopoly on these traits—rulers of the time were not exactly known for their light touch—he had mastered the art of unscrupulous politics, where ethics played a rather limited role, if at all. His reply to Eugenius V, who'd asked him to cede a few fortresses in return for the expiation of his sins, is an apt example. The duke replied that although he considered the health of his body less important than the health of his soul, he nevertheless preferred the salvation of both to that of his state—Machiavelli wouldn't have been able to teach Visconti anything he didn't already know. Filippo Maria's irreverence was proverbial, as were his abilities to conceal, weave intrigues and create

divisions. Unfavourable propaganda has perpetuated a perception of
the duke as a crooked, twisted tyrant solely intent on crushing the
very idea of freedom in Italy, an idea which Hans Baron has defined
as 'Florentine civic humanism'. In recent years, Baron has contrib-
uted a great deal to the negative impression of the Visconti dukedom,
which he considers a throwback to the Middle Ages, a precursor of
the Napoleonic state and even the Hitlerian state—Baron was a Jew
after all—but Baron does not take into account, or rather is unwill-
ing to consider, that all the other Italian states during the fourteenth
and fifteenth centuries were 'medieval' in some manner or other, and
each pursued a policy of expansionism that was just as aggressive and
reactionary as Visconti's.[51]

As a matter of fact, Filippo Maria Visconti's politics was a reaction
to the centrifugal forces at work in his dominions, not to mention
his state's economic and strategic needs. Given the dismemberment
of Visconti lands in the wake of his father's death, Filippo Maria's
tendency to favour feudal lords and the smaller cities of the dukedom
seemed calculated to appeal to leaders beyond the walls of Milan
(smaller cities, on the other hand, were all too keen to oppress their
neighbouring countrysides). Conquering and holding on to Genoa
had obsessed Milan's rulers throughout the entirety of the fourteenth
and fifteenth centuries, as it was the only significant port in their
immediate vicinity; and despite the bad history between them, the
Genoese benefited from Filippo Maria's rule, as was shown when
the duke pushed for a trade agreement between the Superba[52] and
the North African state of Tunis.[53] Having to contend with Venetian
expansionism in the east, which threatened to cut Milan off from

the Adriatic sea, and Florentine expansionism in the south, which aimed to conquer localities of great strategic importance to Milan's security, Filippo Maria had no choice but to pursue an aggressively no-holds-barred policy of his own, a skill he had no doubt mastered.

It's not unlikely that Visconti's scheming had caused Carmagnola's downfall. The condottiere had already become suspect to the Venetian authorities, who had hired him after he'd left Milan—where he was not only reluctant to obey unpalatable orders, but also (as far as his employers were concerned) too timid when it came to taking initiative. The duke's numerous attempts to convince the condottiere to return to fight for Milan (which Carmagnola regularly reported to Venetian authorities) further fuelled fears of negotiations between Carmagnola and Fillipo Maria. In addition, the condottiere's wife was Antonia Visconti, one of the duke's relatives, and Carmagnola's territorial ambitions were well known. Finally, the condottiere was summoned to Venice under a false pretext, arrested, tried for treason, sentenced to death by beheading and ultimately executed on the evening of May 5, 1432, between the columns of St Mark's Square.[54] The question of Carmagnola's guilt has always been controversial, and internal debates within the Venetian government regarding his punishment suggest that the evidence against him wasn't overwhelming. Nevertheless, as Michael Mallett has pointed out, once the Venetian authorities decided to arrest him, his death was a foregone conclusion: 'Imprisoning or exiling a man like that would only pose endless problems or risks, while a public execution held the great advantage of giving his colleagues and eventual successors a salutary warning.'[55]

However, suspicions linger that Filippo Maria Visconti played

a role in this matter, which seems to be confirmed by later events. The person chosen to replace Carmagnola, albeit without the title of Captain General, was Gianfrancesco Gonzaga, Lord of Mantua, who displayed as much reticence as his predecessor, probably because he wasn't interested in alienating Sigismund of Luxemburg, from whom he hoped to secure official recognition both of his lordship of Mantua as well as the title of Marquess. The only campaign the Serenissima managed to undertake had been against the pro-Milanese rebels in the Valtellina, which ended in disaster: on November 19, at Delebio, Venetian troops were crushed by the combined forces of the Milanese and the Valtellinese under the command of Niccolò Piccinino, which left several thousand dead on the battlefield, losses compounded by the 2,000 men taken prisoner, among them the *provveditore* (district governor) Giorgio Corner. Contrary to the rules of war, Filippo Maria had Corner thrown into prison at the Forni (Ovens) of Monza, and subjected him to torture in an effort to extract the names of Carmagnola's accusers. Corner held out, and so Visconti circulated the rumour that he'd died, even going to the lengths to give him a fake funeral. It was only in 1439, after Corner succeeded in getting word out to his family, informing them that he was still alive, that the Duke agreed to release his prisoner, but the exhausted *provveditore* passed away shortly thereafter.[56] Filippo Maria's relentlessness towards Corner cannot be explained in terms of revenge *sic et simpliciter*, the Duke being too rational and experienced to let himself be guided by his emotions. One should instead consider that Visconti feared Carmagnola's trial might have compromised his network of spies in Venice's territories, or perhaps that

he'd even alerted the Serenissima to Visconti's plans to return Brescia and Bergamo to the ducal fold, a plan to which the condotierre been privy.

Shortly afterwards, the Venetians exacted their revenge in Valtellina, but by then all the contenders were exhausted and Filippo Maria needed to catch his breath in order to pull off a manoeuvre he'd been planning for some time. Sigismund of Luxembourg had turned out to be a fairly useless ally, being more interested in reaching an agreement with the Pontiff to obtain his long-sought-after coronation as Holy Roman Emperor. For his part, Eugenius IV had shown himself willing to comply with Sigismund's request, assuming that Sigismund's backing would prove useful in smoothing over the most radical demands of the conciliarists at Basel, which was especially important after Eugenius had attempted to dissolve the council (a decree the council had of course deemed illegitimate). Incidentally, Sigismund had let the Florentines block him inside the walls of Siena, and he would therefore be unable to come to Visconti's aid. Furthermore, the lords of Mantua and Ferrara were pushing for an accord between Sigismund and the Pope, relying on the fact that after Eugenius's coronation as Emperor, he would surely grant them titles to make them direct feudatories of the Empire, and confer upon them the same international juridical status as the Duke of Milan, which would somewhat shield them from the expansionistic aims of both Milan and Venice. Although, as had been shown with the case of the Patriarchate of Aquileia, the Serenissima didn't trouble itself over legal subtleties when its interests were at stake.

The Peace of Ferrara, brokered by Niccolò III d'Este and

Ludovico I, Marquess of Saluzzo, was signed on April 26, 1433, and it more or less sanctioned the restoration of the status quo *ante bellum*, even though it ratified Filippo Maria's control over Pontremoli, and thereby gave him a toehold in Tuscany. However, the duke was obliged to put up with Venice's sovereignty over Bergamo and Brescia, which meant having the Venetians on his doorstep. In addition, the treaty bound the Florentines not to meddle in the affairs of Lombardy and Liguria, while Visconti was obliged to do the same with regard to Tuscany. Sigismund finally obtained his long-desired investiture as Holy Roman Emperor when he was crowned by the Pope's hands in Rome on May 31 the following year. Gianfrancesco Gonzaga was granted the title of Marquess by the Emperor, while Niccolò d'Este obtained recognition for jurisdiction over his territories, which thereafter belonged to the Holy Roman Empire.

During his visit to Ferrara, Sigismund was treated to an oration in classical Latin by Niccolò's son Leonello, who'd been tutored by the Veronese humanist Guarino Guarini. The pedagosit Vittorino da Feltre belonged to Gonzaga's court, and was celebrated for the school he'd founded, which combined the ideals of humanism with Christianity. Such was his fame that Pisanello portrayed his likeness in a commemorative medal after his death.

Minting medals that bore the portraits of famous people represented a return to the classical era, while in Mantua, Pisanello would paint a series of frescoes that depicted the battle of Louverzep, an

episode from Arthurian myth, and preserved the French names of those pictured in sinopia. The theme and style of these paintings looked to the north, beyond the Alps, towards the world which the historian Johan Huizinga defined, indeed somewhat exaggeratingly, 'the autumn of the Middle Ages.'[57] The medal depicting Vittorino da Feltre—as well as many others—coupled with the tournament of Louverzep represents the dilemma of artists like Pisanello, who 'were well aware of what was happening around them, and who couldn't fail to notice the evolution of Italian art.'[58] Yet it would be wrong to think of this evolution as being single-tracked and having a precise destination: whenever he had to appeal to a painter in his poems, Guarino Veronese invariably chose Pisanello; in his *De Viris Illustribus* (1456), the humanist Bartolomeo Facio certainly mentions the architect and philosopher Leon Battista Alberti, but places him among orators, while the painters he mentions are Gentile da Fabriano, Pisanello, and the Flemish masters Jan van Eyck and Rogier van der Weyden. As far as he was concerned, the only sculptors worthy of notice were Lorenzo Ghiberti, son of Vittorio Ghiberti, and Donatello 'who manages to bring people's faces to life, approaching the glories of the ancients.'[59] Facio doesn't mention Masaccio, which is strange, given that both Donatello and Ghiberti the Elder had already begun to distance themselves from the world of International Gothic art and were moving closer to the naturalism favoured by the humanists, which Masaccio also championed. It's no coincidence that artistic taste in Italy still oscillated between the International Gothic and Renaissance styles by the middle of the fifteenth century.

One could also say that the cultural world of the Italian peninsula

as a whole was teetering between the symbolist style of International Gothic, which was devoutly Christian, and Humanistic Realism, which exhibited pagan tendencies. There were those who saw danger in the rediscovery of the ancient classics, and an incident involving Carlo Malatesta, when he was serving as tutor to Gianfrancesco Gonzaga's nephew, is a case in point: Malatesta had had Virgil's statue in Mantua torn down (even though Virgil had famously predicted the coming of Christ) 'under the pretext that it was an affront to the Christian faith'. His action was strongly condemned by humanists of the time, who deemed that only an ignoramus could think the effigy of a poet 'could lead Christians to worship idols.'[60] Malatesta had a reputation for piety, as did Enea Silvio Piccolomini (to whom we owe the above-mentioned quote), who chose the name of "Pius" after he was elected Pope, in tribute to 'Pius Aeneas' from Virgil's *Aeneid*; and the illusion that the classical world could fully coexist with Christianity was to have very important ramifications.

Even Filippo Maria Visconti was reputedly devout, being accustomed to praying a few times a day, thereby exhibiting, as his biographer Decembrio put it, 'a preoccupation with placating God that was rather similar to that of a religious soul's'. Yet Visconti wasn't really filled with genuine Christian sentiment; on the contrary, he saw religious practice as a means to ingratiate himself to the Creator; it is thus no surprise that he was also superstitious—he was particularly afraid of thunder and lightning—and very attentive when it came to his astrologers' opinions.[61] His attitude towards the Church would always be marked by a formal respect towards that institution, even though it was not unmarked by ruthlessness and opportunism. He

would display these qualities throughout the long papacy of Euge-
nius IV, who would become one of the principal targets of Filippo
Maria's machinations, even though the ink on the treaty signed at
Ferrara had yet to dry.

The peace of 1433 would give way to one of the most dramatic
settlings of scores in Italian history, shaping its political and artistic
direction for centuries to come. Florence had had to put up with the
conditions of the Treaty of Ferrara against its will, having left the
negotiations almost empty-handed; in fact, it had wound up with
a handful of nails, to employ a Florentine idiom, since the costs of
the war had made a heavy impact on the Commune's public debt.
Rinaldo degli Albizzi, who'd been one of the strongest supporters
of the war against Lucca and Siena, felt the political rug was being
pulled out from under his feet, all to the benefit of his rival Cosimo
de' Medici. Truth be told, Albizzi had only himself to blame for this
situation, insofar as that, unlike his father Maso, he'd been unable
to keep the vote-counting under strict control, allowing candidates
who displayed lukewarm attitudes—if not outright hostility—
to the current regime to appear on the electoral rolls. In addition,
Rinaldo didn't possess his father's ability to cultivate personal re-
lationships, often letting his own feelings, rather than opportun-
ism, influence his choices. When Maso decided to destroy someone,
he first took care to isolate them politically to avoid any repercus-
sions. Whereas, to borrow from Dante, Rinaldo never truly mastered
that art.

That he could no longer rely on his government's stability was
something Rinaldo should have realised the previous year, when he'd

attempted a sudden attack against Neri Capponi. When, in January 1432, Neri had appeared in Rome without an official mandate to urge the Pope to help the Florentines against Sigismund of Luxembourg and the Sienese, Rinaldo had flown into a rage: not only did Albizzi consider himself the privileged interlocutor between Florence and the Holy See, but in virtue of his title as ambassador to Rome, he had also convinced himself he could recruit Sigismund—whom he'd met during one of his missions abroad—as an ally. Capponi's initiative hadn't only risked thwarting Rinaldo's diplomatic efforts, but had also made him lose face with Sigismund. Invoking the *Lex Contra Scandalosos* (Anti-Defamation Law), which had been passed at the height of Florence's war with Lucca to prosecute troublemakers stirring up disorder within the city, Albizzi managed to have Capponi condemned to life in exile on March 28; but the moment Rinaldo was obliged to return to Rome on a diplomatic mission, the government annulled the action against Neri, barely two months after it was issued. The entire affair should have put Albizzi on his guard: not only could he not rely on his government's unconditional support, but he had also made himself a powerful new enemy, who would make him pay dearly as soon as the right opportunity presented itself.

Rinaldo had been dealt another setback when the Florentine delegation to Ferrara was recalled, his insistence that Florence should obtain favourable concessions from that treaty conflicting with the desires of his fellow citizens, who wanted to bring a rather useless and costly war to an end. Although chewing the bitter cud of the humiliation he'd suffered in the field of international relations, of which he considered himself an undisputed master—given that the

Florentine delegation also included Cosimo de' Medici, besides the pro-Albizzi partisan Palla Strozzi—Rinaldo had the opportunity to blame others for the dishonourable peace. Furthermore, Niccolò da Uzzano, who had a reputation for restraint and was the last surviving key member of Maso degli Albizzi's circle, died in February 1433, removing the last obstacle to Rinaldo's ambitions. Although Uzzano had found himself isolated due to his loathing of the Luccan war, he had nevertheless been a reputable and experienced statesman, who had often urged Rinaldo to keep the electoral rolls under control to prevent pro-Medici supporters from filling government posts. However, Uzzano had also opposed himself to any act of violence against Cosimo de' Medici, fully aware that once he started on that road, there would be no going back.

Rinaldo focused himself with consummate ability on destroying his principal rival, waiting for the opportune moment to strike. This presented itself the following September: the new Signoria, which had taken office at the beginning of the month, only counted two of Cosimo's supporters among its ranks, and the gonfalonier of justice, Bernardo Guadagni, worked hand in glove with Albizzi. Guadagni's family had been financially ruined by the Revolt of the Ciompi in 1378 and Rinaldo had squared Bernardo's debts in order to allow him to hold public office. Furthermore, Guadagni was related to some of the Medicis' most vocal opponents. The only problem that remained was how he could get his hands on Cosimo without causing any unrest. Medici was summoned to the government palace on September 7, under the pretext that he was needed for a legal procedure limited to eight citizens. Rinaldo has cast his net, and he would have to

wait and see if this big fish he was trying to land would deign to get caught in it.

Indeed, Cosimo should have understood that the Albizzi were plotting against him. One of his supporters had tried to warn him about going to the palace, telling him that Albizzi had covered Guadagni's debts and that 'Ser Rinaldo doesn't throw prime cuts to the dogs.'[62] Despite the alerts (and the fact that Guadagni had stood in Medici's way before, in the Consulte), Cosimo simply shrugged his shoulders: Giovanni dello Scelto, a prior and an (alleged) friend of his, had reassured him that there was nothing to fear and that in any case the gonfalonier's family had always been hostile to the Albizzi, given that they'd always done all they could to ensure the Albizzi never held public office. It is also likely that Cosimo, who'd been on holiday at his estates in the Mugello, had underestimated his enemies' determination, despite the fact that Florence had been teeming with soldiers for the past few days. The record of the events that followed comes to us from Cavalcanti, who operated on the periphery of Florentine politics, as well as from Cosimo himself, who wrote his memoirs ex post facto, thereby making them somewhat reliable, at least to a certain point.[63] As a matter of fact, despite the candour Medici had shown by putting his head in the lion's mouth, he had nonetheless taken preventive measures in May the previous year: he had entrusted his most important papers and vast quantities of money to various religious congregations, and transferred equally vast sums to foreign branches of the Medici bank.[64]

When Cosimo entered the palace he was immediately arrested and locked up in the tower. Albizzi supporters rioted in the square

below, asking that a parliament be reconvened somewhere it would
be protected by fully armed soldiers. It goes without saying that the
Signoria's proposal for the creation of a caretaker government en-
dowed with extraordinary powers was warmly welcomed, and it con-
demned Cosimo and his cousin Averardo to exile that very evening.
The accusations against them were vague but hard-hitting: they had
purposefully prolonged the conflict against Lucca, sabotaged Flor-
ence's war effort to discredit the regime, and had conspired against
the Commune, which as their family history since the Revolt of the
Ciompi proved, they had always opposed. Nevertheless, given that
the charge of treason carried a sentence of death, the punishments
imposed on the Medici were rather mild: both were to remain in ex-
ile for a year, Cosimo in Padua and Averardo in Venice. The motiva-
tion behind this clemency isn't difficult to guess: Rinaldo's coup had
only half-succeeded, since Cosimo's brother, Lorenzo de' Medici,
had managed to escape to the Mugello, while Averardo, who'd been
promptly informed of his cousin's arrest, had gone on the lam. There
were genuine concerns that a harsh sentence could trigger an upris-
ing by pro-Medici partisans, a faction feared by the moderate ele-
ments in government, and this was why the plot to murder Medici
in prison had been abandoned. (Cosimo took great care to take out
a life insurance policy by giving his jailer, Gonfalonier Guadagni, a
handsome bribe, which he also extended to a number of his other,
supposedly indomitable, enemies.)

That the government had cause to fear displays of strength was
confirmed the day following Cosimo's arrest, when the condottiere
Niccolò da Tolentino, backed by troops recruited by Lorenzo de'

Medici, marched his company from Pisa to Florence under the pre-
text of wanting to lend his assistance to the Commune in the event
of riots. It was widely known that Cosimo and Niccolò were friends,
and the condottiere was ordered to turn back. Cosimo would later
complain of his friend's lack of commitment, blaming it for his
prolonged stay in prison. In fact, everyone was wisely pursuing a
wait-and-see policy: the pro-Medici partisans hesitated, so as not
to compromise the safety of their leader, while the pro-Albizzi par-
tisans didn't dare make an attempt on Cosimo's life—despite the
wishes of a few extremists—for fear of triggering a popular uprising.
After a few days had passed, pressure began to mount in Medici's
favour, in some cases causing the Florentine government a great deal
of embarrassment. If the overtures made by Ambrogio Traversari,
the venerable Vicar General of the Camaldolese monks, could be
safely ignored, the same could not be said of the requests made by the
Marquess of Ferrara and less still those made by the Republic of Ven-
ice. The pro-Albizzi party did not take kindly to Venice's offer that
Cosimo spend the duration of his exile in their city, since they didn't
want to help their rival by giving it access to the Medicis' banking
and commercial network. Yet Venice was still a very important ally
for Florence, as it was the only state in northern Italy capable of
curbing Filippo Maria Visconti's territorial ambitions. Furthermore,
Rinaldo was obliged to contend with moderate elements in his own
faction, like Palla Strozzi, who, while in favour of the recent coup
d'état, insisted that Cosimo's life be spared. Some among these mod-
erates were chiefly concerned with hanging on to their golden goose
for as long as they could. (Cosimo would later mock his enemies,

affirming that the sums of money he'd spent to protect himself had been only a tiny fraction of what he would have been willing to pay.)

In any case, Rinaldo was determined to destroy Medici power, and he consented to shelving the plan to murder his prisoner in exchange for harsher sentences for the condemned: ten years of exile for Cosimo and Averardo, while the rest of the Medici family, save for a couple of notable exceptions, were declared *grandi*,[65] and therefore barred from holding public office. What Albizzi failed to do was ruin his enemies financially: the plan the caretaker government had hatched to gain possession of the capital the Medici had deposited at the Monte Comune (the public debt), was never implemented, given that it would have considerably reduced the amount of capital available to the Monte, much to the detriment of those citizens—many of whom were Albizzi supporters—who'd invested their money in it. In a display of false generosity, the Medici were promised that their property would be respected, so long as they respected the terms of their exile. Cosimo began his life in exile on October 3, heading to Padua as he'd been instructed. On December 16, the Florentine government gave into the Serenissima's pressures and allowed Cosimo to take up residence in Venice, but they nevertheless forbid him from establishing any kind of contact with his fellow citizens. It wasn't easy to ensure he observed this rule, since it was impossible to keep citizens under strict surveillance despite the ample power that the caretaker government had conferred on the Otto di Guardia (Eight on Public Safety) and on the Capitano del Popolo (Captain of the People) to go after anyone who was deemed politically suspect. In fact, and despite the extensive review of the electoral rolls, only a

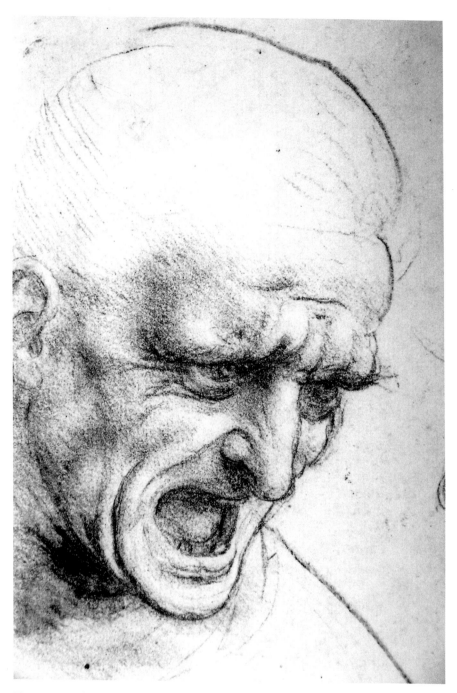

The scream and the anxiety. The human expressions found in Leonardo's studies for the mural *The Battle of Anghiari* (this particular example being Study of Two Warriors' Heads, in the Museum of Fine Arts, Budapest) displays the distinctiveness of Renaissance Art.

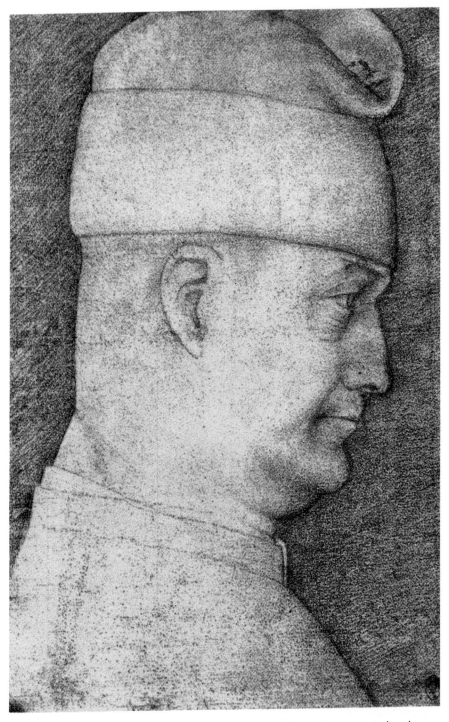

A talent for ruthlessness. Filippo Maria Visconti, the Duke of Milan, a devious, cynical, and super-stitious man, could have taught Machiavelli's Prince a thing or two.

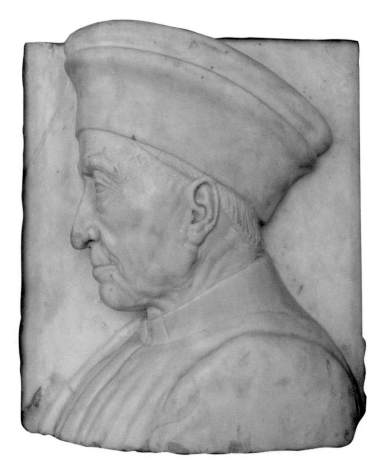

'States can't be governed by means of prayers.' Cosimo 'the Elder' de Medici, a consummate politician and a skilled businessman, also had unsurpassable taste when it came to the arts.

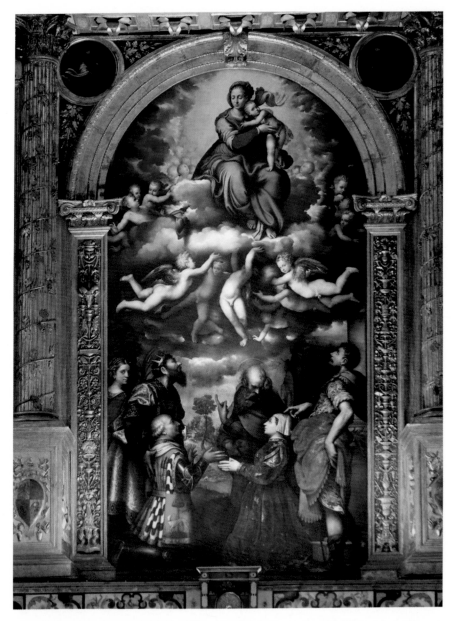

From the gutters to the stars. Francesco Sforza (kneeling in front of his wife Bianca Maria Visconti, here depicted in Giulio Campi's *Madonna and Child*, found in the Church of St. Sigismund in Cremona) hailed from an old family of wealthy landowners in the Romagna, would finally become Duke of Milan in March 1450.

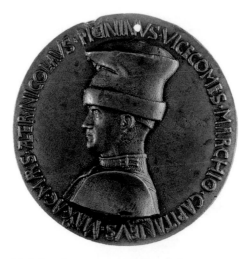

The cripple of Perugia. Made lame by a war wound, Niccolò Piccinino never managed to establish his own independent lordship, despite devoting his life to that effort.

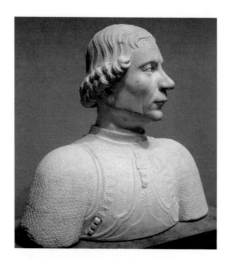

Warrior and Statesman. Astorre Manfredi, like many minor lords in central Italy, practiced the art of war simply to guarantee his independence.

The man from Cotignola. An experienced, cautious soldier, Micheletto Attendolo was one of the prestigious condottieri on the Italian military landscape for almost three decades.

A pillar of the Church. Martin V flew into a rage when he heard Florence's street urchins singing that he wasn't 'worth a dime', but those urchins' parents should have thought it over when it came to the pontiff's political value.

Peter amidst the waves. Eugene IV devoted his pontificate to unscrupulously fighting to impose the papacy's spiritual authority and reaffirming its policies.

The sword and the purple. More of a soldier than a cleric, Giovanni Vitelleschi was Eugene IV's right hand man until he was ruined by his own boundless ambitions.

The Lucullan Cardinal. Aside from his skill as a politician, Ludovico Trevisan had a taste for pomp, which he could amply afford as the Camerlengo of the Holy Roman Church. He is also commonly, yet erroneously, known as Scarampi Mezzarota.

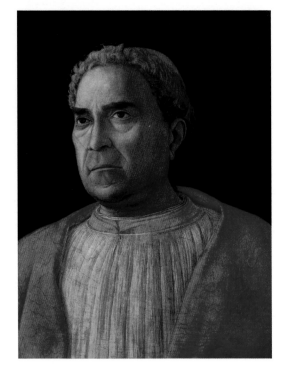

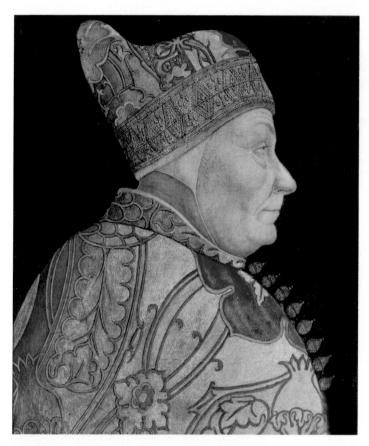

The Serene warmonger. Throughout his long tenure as Doge, Francesco Foscari argued for the need for Venetian expansionism in northern Italy.

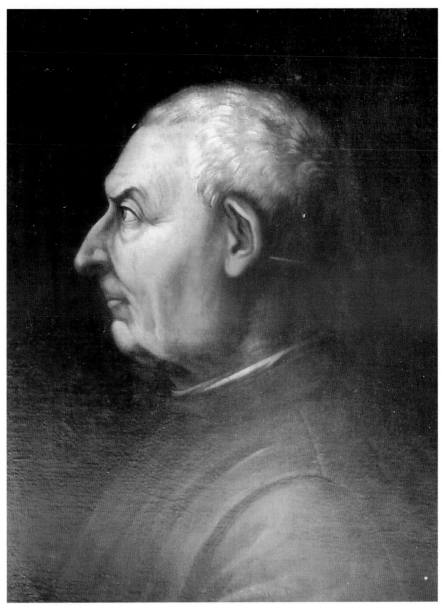

Commissar par excellence. Even when he came into conflict with Cosimo de' Medici, Neri Capponi, an historian and politician, always supported the alliance between Florence and Venice.

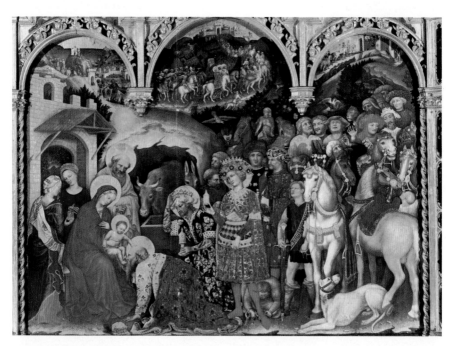

The Adoration of the Magi by Gentile da Fabriano. Palla Strozzi (depicted as the falcon trainer) commissioned the painting from Gentile da Fabriano in 1423, and it is now considered the culminating work of International Gothic painting in Florence.

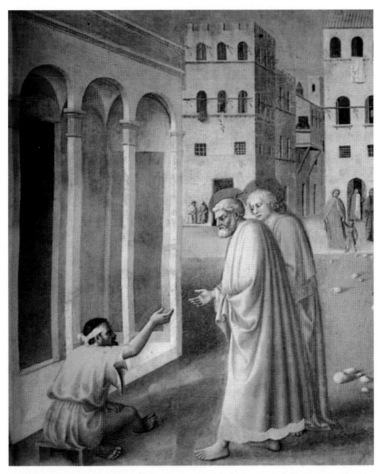

The Healing of the Cripple and the Raising of Tabitha by Masolino da Panicale. The stereotyped figures, typical of the International Gothic style, can still be seen in this fresco, which is housed in the Brancacci Chapel in the Church of Santa Maria del Carmine, in Florence.

The Expulsion from the Garden of Eden by Masaccio. In this painting, also housed in the Brancacci Chapel in the Church of Santa Maria del Carmine, Masaccio inaugurated a new style that focused on the authenticity of the characters' faces instead of stereotyping them.

Detail of *The Expulsion from the Garden of Eden* by Masaccio (left).

Saint George and the Princess by Pisanello. In this fresco, which is located in the Pellegrini Chapel of the Church of Santa Anastasia in Verona, one is struck not only by the poetic sophistication of the characters and the natural elements, but also by the blunt, brutal vision of reality: contrast the idealized features of Saint George and the Princess of Trebizond with the grotesque image of the two hanged men in the background.

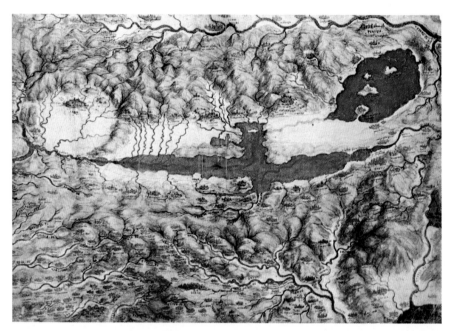

A bird's-eye view. In this map of the Val di Chiana, a work completed by Leonardo in 1503 and now housed in the Royal Library (n. 12278) close to Windsor Castle, one can spot Piccinino's operational area in 1440. Sansepolcro and Anghiari can be seen in the middle, at the top. Also present are Arezzo, Cortona and Perugia, the latter being key to Piccinino's quest to establish his own independent lordship in central Italy.

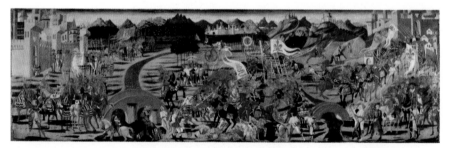

Prized family heirloom. The so-called 'marriage chest of Anghiari', currently housed in the National Gallery of Ireland in Dublin, was commissioned by Neri Capponi's son to honor his father's role in the battle.

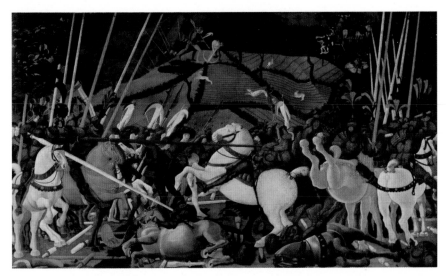

Known as *Bernardino della Ciarda Unhorsed* (housed at the Uffizi Gallery in Florence), a detail from Paolo Uccello's triptych, *The Battle of San Romano*, this frame probably depicts the unhorsing of Astorre Manfredi at Anghiari.

The Dynasty's Triumph. *The Cavalcade of the Magi* is a famous cycle of frescoes housed inside the chapel of the Palazzo Medici Riccardi in Florence that was painted by Benozzo Gozzoli in 1459. The paintings stand not only as a testament to the power of those who commissioned it, but also to their role in maintaining the peace after the Treaty of Lodi in 1454. Piero 'the Gouty' de' Medici can be seen astride a white horse in the foreground, with his father, Cosimo, beside him on a mule. Then, slightly to the side, one can see Galeazzo Maria Sforza, the heir to the Dukedom of Milan and Sigismondo Pandolfo Malatesta, the lord of Rimini. One can spot a very young Lorenzo de' Medici in the third row, slightly to the right, amidst a group of illustrious humanists. Right at the back of the procession, next to the character wearing the blue cap, one can easily recognize Pope Pius II's scowling face, a red bonnet on his head. Given the bad blood between the Medici family and Pius II, this can be considered an artistic spin on 'stick that in your pipe and smoke it'. The pervasive impact of realism on this cycle embodies the assertive triumph of the Renaissance style.

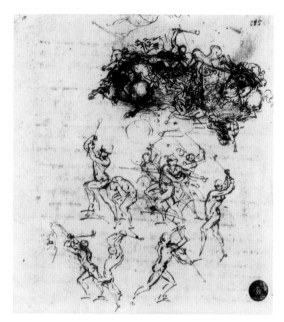

Flesh and blood. Leonardo's prepara-
tory studies for *The Battle of Anghi-
ari* (this panel above being the 'Fight
for the Flag', housed in the Gallerie
dell'Accademia in Venice) sum up
the master's thoughts on pictorial
representations.

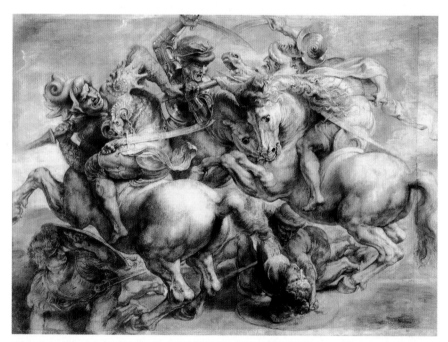

Filtered memories. Peter Paul Rubens's copy of *The Battle of Anghiari* stands as a testament to both the
grief caused by the loss of that painting as well as of the hope that it might one day be rediscovered
behind a wall in the Palazzo Vecchio in Florence.

minority of Florence's population endorsed the pro-Albizzi party, and its many moderates within the *balìa* itself. The government was clearly on its last legs.

Rinaldo needed the support of his fellow citizens more than ever, as there was another international crisis looming on the horizon. The pope had dispatched Giovanni Vitelleschi, the Bishop of Recanati, to govern the March of Ancona, but the prelate's brisk—if not fierce—methods of maintaining public order had brought the region to the brink of outright rebellion. These commotions hadn't eluded Filippo Maria Visconti, who jumped at the chance to reshuffle the cards of Italian politics. The condottiere Francesco Sforza had inherited some feuds in Apulia from his father Muzio Attendolo, and under the pretext that a few of the castles there had rebelled against him, he officially asked the Duke of Milan to go and reconquer them, to which the duke consented. The suspicion that Sforza and Visconti were plotting something seemed to be confirmed by the size of the army the condottiere was busy assembling, which was deemed too large for the task at hand. Since Sforza began crossing the Romagna in early November, having secured the Pope's consent, Florence became nervous, and Niccolò da Tolentino was promptly dispatched to its north-eastern borders to repel any likely incursions into its territory. But Sforza had different aims in mind. Having sent his pack mules and equipment ahead to Ancona via sea routes, the condottiere waited in Forlì until he received word they'd arrived, and then sprang into action with breathtaking speed. By December 7, he was under the walls of Jesi, at which point he decided to drop the act: he announced that the Council of Basel had hired him

to restore law and order in the March of Ancona, to do away with the abuses perpetrated by Eugenius IV's mismanagement of the region, and he invited local leaders to submit to the authority of the conciliarist priests. Jesi came to terms almost right away, and such was its hatred for Vitelleschi's government that Sforza's advance through the March more closely resembled a triumphal parade than a military campaign. City after city promptly flung its gates open for him. The condottiere only encountered stiff resistance at Montolmo, which was nevertheless besieged and plundered. By the beginning of January 1434, the entire March of Ancona was under Sforza's control, leaving Vitelleschi to flee to Rome and take the treasures of the Sanctuary of Loreto with him.

The Pontiff's misfortunes proved to be a blessing for Rinaldo degli Albizzi, who around the middle of the previous December had begun scheming to bring Eugenius—who'd been forced to deal with the numerous riots in Rome sparked by the Colonnas—to Florence. Rinaldo believed the Pope's visit would prove advantageous to both the city and the Albizzi government. The banishment of the Medici had caused a significant drop in public funds (Cosimo had on more than one occasion lent the Commune considerable sums in order to help it cover urgent expenses), the costs of the recent war hadn't yet been amortised and the economic recovery in the wake of peace agreements was taking its time. Albizzi emphasised that the Pope's visit would 'be good for this city, and useful for the merchants and artisans, not to mention our honour.'[66] Rinaldo had worked it all out: acquiring the bulk of papal finances would counteract the loss caused by the Medicis' banishment; in addition, it would strengthen

the Albizzi government, since it was well known that there was bad
blood between Cosimo and the Pope. One could imagine that the
ploy was also a means to placate the Venetians, whose suspicions had
been aroused by the insistent rumours that Rinaldo and Niccolò
Piccinino had met, which suggested Florence was looking to change
allies, swapping Venice for Milan.

When the Pope hesitated over accepting Florence's invitation,
Rinaldo found himself in an embarrassing situation: many of his
wealthier followers were pushing for the abolition of the catasto, but
given the state of the economy, it was unthinkable that the lower
classes could put up with higher taxes. Moreover, Albizzi could only
rely on very feeble support from Florence's ruling class: approximately
a quarter of the members of the *balìa* was composed of confirmed Al-
bizzi supports, but at least a dozen of them were friends of the Medici;
the others were not affiliated with either party.[67] Eager to broaden his
political base, Rinaldo had tried to bring a considerable number of
the grandi over to his side, abrogating the ban that had barred them
from public office since 1293. The manoeuvre had been strongly op-
posed by the leadership, many of whom considered those tycoons the
time-honoured enemies of communal freedom. The solution they
struck upon, whereby the grandi could obtain administrative jobs
outside the city walls, didn't please anyone, and the tycoons for the
most part preferred to bide their time and wait for future develop-
ments. Besides, the *balìa* did not follow through with its overhaul
of the electoral rolls, which meant pro-Medici supporters remained
in their places. In fact, the only serious measure to strengthen the
Albizzi regime had been to decide that the government in charge

throughout September and October would nominate its successor; nevertheless, the new gonfalonier of justice turned out to be Bartolomeo Ridolfi, who was friends with the Medici and Rinaldo. The Albizzi had clearly had a difficult time imposing their will.

Over the course of the following months, the transformation of the Italian political landscape would have major implications for Florence. Given Sforza's success in the March of Ancona, Eugenius IV had decided to bring the condottiere over to his side. At the end of March 1434, the Pontiff and the condottiere concluded an agreement at Calcarella, whereby the condottiere committed his loyalties to Rome, and received the title of Marquis of the March of Ancona for life—on top of his *condotta*. Sforza's sudden switch of allegiance ruined the Duke of Milan's plans and caused Florence's government a great deal of embarrassment. Both Florence and Venice had been invited to contribute to the expenses of Sforza's *condotta*, but the Albizzi regime was hesitating, due to the financial constraints it faced, as well as to the threats made by Niccolò da Tolentino—who was preparing to leave the Commune's service to defend his native city, which Sforza aimed to conquer, and who'd meanwhile asked for a salary increase. The Albizzi regime was niggling over the attitude it should adopt towards Sforza and was also contending with serious internal problems. The efforts to suppress the opposition had had somewhat limited success: the only illustrious victim they'd claimed had been Agnolo Acciaioli, a die-hard Medici supporter, who'd been imprisoned, tortured and banished to Cephalonia in February 1434 for having stayed in touch with the Medici during their exile. As his biographer Vespasiano da Bisticci reported, Agnolo had managed to

destroy the incriminating correspondence before being arrested,[68] but rumours nevertheless circulated that Rinaldo had intercepted a letter from Acciaioli to Cosimo in which he not only described the situation in Florence rather critically, but also advised Medici to make friends with Neri Capponi 'because I don't know a better man than him, and he will suit your purposes perfectly.'[69] Regardless of whether these rumours were true or false, they summed up the widespread feeling in Florence; besides, Rinaldo already knew Neri Capponi posed a great danger. Yet Albizzi's attempts to have Capponi indicted came to naught when the *priori* (governors) refused to incriminate him, a sign that Rinaldo was slowly losing control of the situation and that most Florentines also feared the consequences of using force against Capponi. The Capponis were a large and tightly knit family based in the quarter of Santo Spirito (Oltrarno), which had a different political landscape to the one in Florence: in 1343, its citizens had threatened to 'tear down the bridges and establish our own city'[70] in order to secure greater political—and fiscal—equality.

Increasingly cornered by their enemies, the Albizzi were ready to take extreme measures. In November 1434, Niccolò Barbadori appeared in front of the magistrates and confessed to having been involved in a plot masterminded by Rinaldo the previous spring to kill Neri Capponi, in addition to other prominent officers of the army who, while not necessarily pro-Medici, were nonetheless opposed to the Albizzi. Even Luca di Maso degli Albizzi had been interrogated, as he was now at odds with his brother Rinaldo. In addition, the Albizzi conspirators intended to reach an agreement with the Duke of Milan and abandon the alliance with Venice.[71] Given that the timing

of Barbadori's confession was rather suspect, its truthfulness is questionable. In any case, Rinaldo's attempts to cause him legal troubles—combined with the threats of violence made against him by hardened Albizzi supporters—resulted in Neri Capponi going over to Cosimo's side. On May 24, Giovanni di Marco Strozzi wrote to his kinsman Matteo di Simone Strozzi to inform him that Capponi had gone over to the Medici, and that sooner or later he would have to pay the consequences.[72] Having researched the family's papers, the historian Francesco Guicciardini still argued that Neri Capponi's switch had been a long time coming: '[Piero Guicciardini] bided his time alongside a few others, among them the heads of families that included Neri di Gino, who was a very close friend of his, as well as Alamanno Salviati and Luca di Maso, who wanted to have Cosimo pardoned.'[73]

The events that would eventually lead to the Medicis' return were already in full swing. Overburdened by the expenses of Sforza's *condotta*, the Pope was finding it difficult to pay the other important condottieri in his service, like the celebrated Erasmo da Narni, a.k.a. 'Gattamelata', which explains his reluctance to take up arms to defend Bologna, which had rebelled against papal control and which had always been one of the main objects of Visconti's territorial ambitions. The Venetians were seriously concerned by the situation, given that the conquest of Bologna by Milan would give Filippo Maria an outlet to the Adriatic sea, and would also cut the Serenissima off from its allies in central Italy. To ward off the blow, the Venetians hired Gattamelata, but this led Eugenius IV to suspect the Serenissima had its own designs on Bologna. What's more,

the Pope was having his own problems with Niccolò Fortebracci, who, while supposedly loyal to the Council of Basel, had spent the previous winter devastating the Roman countryside with the Colonnas. Under pressure, Eugenius tried to strike an agreement with the Duke of Milan, also involving the Florentines in his efforts. Rinaldo degli Albizzi was well disposed to this initiative, since an alliance with the Milanese would benefit his regime and would also free the Commune from the heavy financial commitments it had made with Sforza. Rather predictably, the Venetians refused to let themselves be dragged into any negotiations, having decided that it was nothing more than a typical example of Filippo Maria's *divide-and-conquer* strategy. The Serenissima now stood to gain a great deal from fostering political change in Florence.

In any case, Filippo Maria pursued both violent and peaceful options with the same determination. Sforza's about-turn had ruined his plan to create a 'defensive chain'—to employ the duke's definition—of dominions ruled by his condottieri in central Italy.[74] The tactic might have worked in the case of Piccinino and Niccolò Fortebracci, who both relied on Visconti to satisfy their own territorial ambitions, but as far as Francesco Sforza was concerned, the situation was different. It was common knowledge that the Attendolis were well entrenched at Cotignola, and Muzio Attendolo had also managed to obtain several fiefs in southern Italy, which served as decent logistical bases. In other words, Francesco had greater freedom of movement than the other condottieri in the duke's service, and Filippo Maria had tried to keep him close with the promise of his daughter's hand in marriage. Seeing that he'd also made the same

promise to Niccolò Piccinino, Sforza's invasion of the March of An-
cona and his subsequent defection to the papal purse should be un-
derstood as his attempt to strengthen his political base to improve his
negotiating position with the duke.

Since the Sforza–Piccinino–Fortebracci chain had been broken,
Visconti was busy trying to forge a new one. The Milan–Florence–
Rome axis was a viable option, since it would give the duke a free
hand to move against Venice in northern Italy. However, the Pope
was still a Venetian—his surname was Condulmer—and Florence's
political instability was a cause for concern. In addition, Filippo Ma-
ria had to deal with the ambitions of both Piccinino and Fortebracci,
not to mention that the consolidation of papal territories would not
favour his aims. Meaning the duke risked having to confront Venice
with unreliable allies (the pro-Venetian party in Florence was very
strong) and with condottieri whom he couldn't bribe with prom-
ises of fulfilling their lust for fiefs. Moreover, if Filippo Maria had
actually married his daughter to one of his condottieri, he would
have lost a key incentive to guarantee his captains' loyalty. Therefore,
Filippo Maria opted for a bold course of action, which, while not de-
void of risks, promised to deliver greater advantages in the long run.

Compelled by necessity, Eugenius IV had to come to terms with
the Council of Basel, withdrawing his decree that the assembly be
dissolved and recognising certain points of doctrine that the concili-
arist priests had put forward, while holding firm on his prerogatives
as Pontiff. The move didn't succeed in stemming the advances of
Fortebracci and the Colonnas, who by then had been joined by the
powerful Savelli clan, and the Pope had been forced to leave the

Vatican and retreat to the Castel Sant'Angelo, before moving to San Lorenzo in Domaso and subsequently to Trastevere. Having already used the Council of Basel as a fig leaf to further his own interests, Visconti was keen to exploit the Pope's difficulties. On May 29, a popular uprising, incited by Visconti's agents, broke out in Rome and was immediately followed by the proclamation of the Roman Republic. Castel Sant'Angelo remained under papal control, but word that Fortebracci's forces had been reinforced by those of Niccolò Piccinino (who had first gone to Pozzuoli, supposedly to take the waters) caused Eugenius a great deal of anxiety. On June 4, he disguised himself as a monk and boarded a boat waiting for him on the banks of the Tiber, but he was recognised during his journey downriver and forced to protect himself from stoning by stretching out on the bottom of the boat and hiding under a shield. Arriving unscathed at Ostia, he sailed on a galley that brought him to Pisa and he finally arrived in Florence on June 23. He had brought little more than his personal possessions and on July 4, the Commune granted him 4,000 florins so he could meet immediate expenses.

The news of Eugenius's flight had direct consequences. Bologna rebelled against papal rule, and the rebels, led by the rich and influential Battista Canetoli, imprisoned the papal governor and the Venetian ambassador. Venice demanded that its representative be released immediately, and when Canetoli tried to exchange him for his brother Gaspare, who was languishing in a Venetian gaol, the Serenissima ordered Gattamelata to devastate the Bolognese countryside. Faced with that show of strength, Canetoli was forced to capitulate, but this didn't stop Gattamelata: the Venetians had received reports

that Piccinino (who'd agreed to a five-month truce with Sforza, himself in no rush to assist the Pope because his salary was in arrears) was advancing towards Bologna. Seeing Visconti's *longa manus* behind the Bolognese insurrection, the Venetians were convinced Canetoli was trying to buy some time with useless negotiations while awaiting Milanese reinforcements.

Canetoli's position was stronger than it might have seemed at first, in that the Pope was reluctant to allow the Venetians to move against Bologna, fearing that once the Serenissima conquered the city, it would never give it back. In turn, Rinaldo degli Albizzi was reluctant to send troops over the Apennines, worrying that riots might break out in Florence. Besides, an attack against Bologna would leave the city open to Visconti, while on the other hand a negotiated settlement would restore Bologna to papal rule, denying Piccinino an important re-supply base. In the end, negotiations with Canetoli were wrecked when the Bolognese leader refused to back Vitelleschi as the city's new governor, and furthermore insisted that his brother be released and that Gattamelata withdraw. The Venetians turned him down, and forbade the Pope and the Florentines to carry on any negotiations with Visconti's emissaries, even though the duke had let it be known that he was willing to withdraw his troops from papal territories so long as Bolognese demands were met. Given that he'd already established himself as duplicitous, the Serenissima believed Filippo Maria couldn't be trusted.

Piccinino's advance forced Florence to opt for a defensive strategy against the Milanese condottiere's likely incursion into Tuscany. In view of the Albizzi regime's unwillingness to dispatch Niccolò da

Tolentino to the Romagna, Pope Eugenius suggested a renegotiation of Sforza's *condotta*, and this time both Venice and Florence supported his proposal for a few defensive alliances. The Serenissima agreed to cover half the costs, so long as Florence paid for the rest. Florence's counterproposal was that each signatory should contribute a third of the total sum, and on August 9, Rinaldo degli Albizzi appeared before the Consulta to present a plan outlining an expenditure of 8,000 florins a month. The suspicion that Rinaldo wanted to use Sforza to entrench his power—possibly with Visconti's assistance—led to the rejection of his plan, causing him serious embarrassment with the Pope and the Venetians. Cosimo de' Medici seemed to have played a crucial role at this juncture: Marino Sanuto the Younger testified that when the Pope's secretary Flavius Blondus arrived in Florence to negotiate the request for the money to pay Sforza, Cosimo 'went to the Collegio and offered the Signoria a loan of 15,000 ducats.'[75] Thus, Medici both ingratiated himself to the Pope and also became friends with Sforza, forging a bond that would solidify over the years and not only lead to a change in Florence's pro-Braccescho policy, but also redraw the map of Italian politics. In the meantime, Cosimo had worked his way into the Venetians' graces, while they openly distrusted Rinaldo.

Albizzi continued to oppose sending troops to the Romagna, arguing that dispatching Niccolò da Tolentino's company, which had been stationed between Arezzo and Cortona to guard the passes of the Apennines, would leave Florence undefended. The pro-Venetian party, headed by Neri Capponi, nevertheless managed to secure a compromise: Tolentino would remain where he was until there was

some certainty that Piccinino intended to continue marching north; at that point, Niccolò would be free to go to Bologna and join his forces with Gattamelata's. Apart from mollifying Florence's allies, Capponi's plan was also calculated to ensure that Rinaldo wouldn't attempt another coup, perhaps this time with Piccinino's help. The Milanese condottiere didn't try to enter Tuscany, and instead opted to march his troops along the Via Aemilia; but in his refusal to accept the political defeat he'd been dealt, Albizzi and his followers continued to oppose sending troops outside of Tuscany, arguing that it would be more advantageous to continue talks with Canetoli, who, as it happened, had promised he would not lend Piccinino any assistance. These delaying tactics had the sole effect of enraging both Venice and the Pope, both of whom threatened to sever their alliance with Florence if Tolentino didn't head to Bologna right away. Having been seduced by the Pope with secret promises of rich rewards, the Florentine captain added his voice to the chorus asking that immediate action be taken, and Rinaldo was forced to give up in the end. However, Niccolò was ordered to avoid battle, and to limit himself to cutting off the supply lines to Piccinino, who by then had reached the walls of Imola. Conversely, Tolentino had received secret instructions from the Pope to do his utmost to join up with Gattamelata and attempt to defeat the Milanese.

Niccolò reached the allied camp near Castelbolognese on August 27, when, to his bitter surprise, he discovered that he would have to share his command with Vitelleschi. In spite of everything, the situation seemed to favour the allies, whose forces outnumbered the Duke of Milan's. Yet Piccinino's renown for being one of the

ablest captains of his time wasn't undeserved, as his enemies would soon learn. Apprised of the divisions in the enemy camp, Piccinino launched a feeble attack on their positions the following day. The ease with which it was repelled emboldened the allies, who leapt into hot pursuit of the Milanese despite Tolentino urging them to stay still, since he suspected that Piccinino had a dirty trick up his sleeve. Niccolò wasn't wrong, and Piccinino sprang his trap at exactly the right moment, dispatching a strong contingent of soldiers to engage the enemy's rear. Surrounded and with no way out, Tolentino was captured alongside many other condottieri and the allies lost almost half their army to death, injuries and—most of all—imprisonment. Vitelleschi and Gattamelata managed to escape along with Niccolò's sons, but Piccinino gained the upper hand.

News of the disaster at Castelbolognese caused fears that ducal troops would attempt a lightning strike against Florence, given that the only soldiers left at the Commune's disposal were the battered remains of Tolentino's company. But the Albizzi were chiefly tormented by internal problems: not only did the citizens blame the recent military debacle on the regime, but the elections for the next government, due the following September and October, had returned an overwhelming pro-Medici majority. Considering the bad turn of events, Rinaldo's immediate response was to resort to the old trick of convening a new parliament to nominate another *balìa*. He was dissuaded by his confederates, chief among them Palla Strozzi, who were afraid that any resulting disorder would encourage Piccinino to march on Florence. Having never reached a consensus, the Albizzi hadn't had the opportunity to rid themselves of their rivals through

a drastic reform of the electoral rolls. The exiled Medici only needed to bide their time until they could make their comeback.

In Venice, Cosimo had continued to take care of Sforza's financial needs, which amounted to 30,000 ducats, and earned the gratitude of the Venetians, who promised him their assistance should he ever need it.[76] With their pockets full of Medici money and their commands coming from Micheletto Attendolo (a friend of Cosimo's), Sforza's troops reached the borders of Tuscany around the middle of September, thus allowing the remainder of Tolentino's company to leave Bologna, ready to intervene and protect the Florentine government if need be. Nevertheless, Medici was in no hurry to leave Venice: throughout the duration of his exile, Cosimo had been respectful of the terms and conditions attached to his sentence, and he had no intention of allowing his enemies to claim he'd broken the law. Thus, he was ready to wait until the government green-lighted his return to Florence.

Rinaldo degli Albizzi had realised Cosimo's return would be inevitable unless he resorted to drastic measures. He had left Florence in early September to recruit peasants in the city's surrounding countryside, and had returned to Florence with several hundred armed ploughmen sometime around the twentieth of that month. His agents had also made their own preparations, meaning that between acolytes and hired hands, the Albizzi could count on several thousand fighters. Likewise, Medici supporters had made arrangements of their own, and the government had recruited 3,000 foot soldiers from the Mugello and the Romagna, while awaiting Tolentino's company: 'The whole city was teeming with boorish peasants, who

lusted after other people's goods and bayed for their blood' as Cavalcanti vividly put it.[77] The situation took a turn for the worse when the *priori* summoned Albizzi stalwarts Ridolfo Peruzzi and Niccolò Barbadori to the palace. Convinced that Peruzzi and Barbadori would suffer the same fate that had befallen Cosimo de' Medici the previous year, and having been warned that the government intended to convene a parliament for September 29, on September 26, Rinaldo and his followers began to spill into Piazza Sant'Apollinare—now known as Piazza San Firenze—with the intention of taking over the city's key strategic points. By four o'clock in the afternoon, there were roughly a thousand of them 'and their numbers kept growing';[78] but when recourse to arms seemed inevitable, Rinaldo was abandoned by some of his most influential acolytes, like Palla Strozzi, since the thought of actual violence made his stomach turn.

The refusal of Strozzi and others to provide Rinaldo with military assistance shook the Albizzis' confidence, making them think the enterprise was unlikely to succeed. While he was pondering what needed to be done, Giovanni Vitelleschi arrived, having been dispatched by the Pope to urge all the parties to seek a peaceful resolution. Albizzi was well acquainted with the Bishop of Recanati and was easily convinced to confer with Eugenius, who was lodging at the Convent of Santa Maria Novella. It was dark and raining when the crowd of Albizzi supporters arrived at the Duomo, and Rinaldo barely managed to prevent the nearby houses of the Martelli family—who were overtly pro-Medici—from being set on fire. Over the course of their meeting, Rinaldo acknowledged his defeat, and when the *priori* promised that none of the protesters would be prosecuted,

he agreed to lay down his arms and place himself under the Pope's protection. This latest development did not escape the citizens' notice; many had remained by their windows, waiting to see how events played out, and the ranks of pro-government supporters swelled hour after hour. Two days after, the *priori* felt they were in a sufficiently strong position to convene a parliament, which voted for the creation of a *balìa* of 350 individuals. One of the new magistracy's first acts was to rescind the Medecis' exile, and Cosimo (who left Venice on September 29 after receiving the necessary assurances from the government) returned to Florence on October 7, without much pomp and accompanied only by his brother Lorenzo and a few relatives. As the political situation was still unstable and the Albizzi were still capable of causing them problems, the Medici thought it best to keep a low profile.

How to deal with the defeated had in fact been the subject of ongoing debates. The *balìa* deemed itself free from any and all promises the government had made, but Rinaldo nevertheless enjoyed the Pope's protection, and the Pope was opposed—if only out of gratitude towards the person who had offered him sanctuary—to the idea of Rinaldo being executed. In the end, Eugenius was forced to admit it would be impossible for the Albizzi to remain in Florence, and on October 2, Rinaldo, his son Ormanno, and Donato and Ridolfo Peruzzi, along with their sons, were condemned to an eight-year exile, to be spent at a location of their choosing, so long as it was at least one hundred and sixty kilometres away from Florence. All the Albizzi that stayed—with the exception of the pro-Medici branch of the family, led by Luca di Maso—were declared *grandi*, and therefore

forever barred from public offices. The 'medicine' that everyone had prayed for years ago to restore a sense of political unity to the Commune was now about to be administered, but as far as Rinaldo was concerned—he had used such an analogy himself—these doctors were more like executioners than physicians.

The millstones of revenge began to grind the following November, when the *balìa* decreed not only that citizens should go to the polls again, but that the new government should be handpicked by members of the previous executive and the *accoppiatori* (election officials), who would then select a limited number of names that would appear on the rolls. As was to be expected, the outgoing Signoria was entirely made up of men who looked favourably on this new direction, and on November 1, a small meeting of the Consulta, attended by Cosimo, Neri Capponi and Luca degli Albizzi, issued punitive measures for all the most influential members of the enemy faction. The fear of anti-government conspiracies sped up the creation of these blacklists and over the following couple of weeks, around seventy of the city's most eminent citizens followed Rinaldo into exile; others were allowed to remain in the city, but were permanently—or at least for a long period of time—deprived of their political rights. Among the exiled were Felice Brancacci, who by then had already been one of Masaccio's patrons, and Palla Strozzi, who was banished to Padua for ten years. Strozzi's fate had been the subject of heated debates, but Cosimo had managed to have him exiled, arguing that anyone who'd dithered over supporting a friend was likely to do the same to someone else in the future. As far as the new government was concerned, allowing such a wealthy

and influential man as Palla to remain in the city posed too great a risk.

The political revolution of 1434 not only eliminated the vast majority of the oligarchy that had ruled Florence for half a century, but also marked a major ideological departure. The importance of this fact should not be underestimated. The ruling class that came to power with Cosimo de' Medici, while not composed of people hailing from humble backgrounds, was still largely made up of individuals and families who'd existed on the periphery of power. It required a new language and a new culture in order to distinguish it from the previous regime. It is therefore significant that over the course of the following decade, Florence's artistic scene took on a totally different perspective—to employ a modern concept—more markedly in keeping with the Renaissance style. The sharp turn taken by the new Medici politics coincided with the propagation of a new style, which had already been heralded by artists like Masaccio and the young Donatello. International Gothic, which had been associated with the old oligarchy, disappeared from the city's panorama, or, as in the case of Beato Angelico (Fra Angelico), assumed a different form better suited to what was referred to as 'the real'. But artists were closely linked to their patrons, and there was no certainty that new patrons wouldn't enter the picture, or that they would share the same taste as their predecessors. In this sense, the constant transformations of the Italian political landscape did not inspire much hope.

5

A CARDINAL PROBLEM

The bearded man had reasons to feel dissatisfied. His patrons had been very generous, so to speak, in furnishing him with enough cardboard and flour for the adhesive mixture he needed to cover a surface of more than 250 square metres. He was eager to begin work and the city's rulers were pressing him to start immediately. He had shown them a scaled-down version of the project, which he'd executed punctiliously, employing materials of the highest quality. It was warmly received, and everyone wanted the painting to be completed as soon as possible; so much so that he'd managed to secure permission to finish the first part of the work before finalising the other drafts. The painted surface would be extensive, and naturally the figures would be life-size. After all, the epoch during which the battle of Anghiari had taken place had been a time of great personages, individuals capable of shaping the course of events with intelligence, and sometimes genius. A time of sudden changes and uncertainties—much like our own times. This was why the bearded man was sketching the outline of the fresco in a room called the Pope's

Chamber, inside a convent in the city, which had been named after a Pontiff who'd been forced by events to reside there for more than five years. It was a very ample room, ideally sized for the dimensions of his illustrations. The Pope in question had used it as his throne room, and it had witnessed the comings and goings of people hailing from all parts of Europe and the Mediterranean—even a Byzantine emperor and a patriarch of Constantinople.

As for the Pope . . . although he didn't feature in the drafts for the fresco, his presence loomed large; and not only due to the depiction of ecclesiastical banners, or the praying, combative figure of the Patriarch of Aquileia. The Pontiff had been the catalyst of all the events that had led to the clash of Anghiari, and his own political survival had rested on the outcome of the battle. Perhaps more than any other state in Italy, the Church had been prey to sudden changes, depending on whoever happened to be in charge; the bearded man knew this, since he'd also once worked for a Pope—or rather, for the son of that particular Vicar of Christ. Changes could happen as rapidly within the papal entourage; intrigues, nepotism, betrayals—and even acts of physical violence—could lead to the rapid elevation of outsiders, or the abrupt downfall of men who'd been extremely powerful just a moment earlier.

There was a character missing in the fresco, who summed up this fluid and unstable state of affairs; a man who might have made a difference had he been present at Anghiari.

To describe Giovanni Vitelleschi as a man of action would be like comparing him to Sardanapalus. Born around 1395 at Corneto

(present-day Tarquinia) into one of the most influential families of the region, he had studied canonical law at Bologna, cutting his teeth serving as secretary to the condottiere Angelo da Lavello, who'd been nicknamed Tartaglia due to his stutter.[79] Vitelleschi had followed Tartaglia in all his battles, alternating between administrative duties and diplomatic missions on his employer's behalf. At some point, he was noticed by Pope Martin V, who took him into his service in 1420, making him Protonotary Apostolic and entrusting him with the command of the fortress of Bologna and thus using him whenever he needed to negotiate with the Commune of Florence. Giovanni's career truly took off with the election of Eugenius IV, who simultaneously made him the Bishop of Recanati and the governor of the March of Ancona. The ink on his nomination hadn't even dried by the time Vitelleschi started to bring the rebellious local lords back to the papal fold, imposing martial law on the area's communities. His campaign against the Malatestas of Pesaro allowed him to recover various territories for the Pope and in September 1433, he managed to capture and execute Pier Gentile da Varano, the Lord of Camerino. His toughness and rapaciousness made him universally hated, and by the time Francesco Sforza had barely invaded the March of Ancona at the end of the year, a general uprising forced Vitelleschi to run for the hills. Whatever his flaws, Eugenius IV deemed him a valuable asset, and following the crucial role Giovanni played during Florence's political crisis in September 1434, the Pope entrusted him with the task of retaking Rome.[80]

Ever since the Pope had fled, the Eternal City had been plunged into total anarchy, and each new day brought further violence and

robberies. Nevertheless, Castel Sant'Angelo was still in papal hands, and its castellan Baldassarre da Offida had shown a determination only rivalled by his inventiveness: he'd even spread a rumour that he'd been imprisoned by mutinous soldiers of his, and by employing this ruse, he'd managed to capture several rebel leaders who'd run into the castle on hearing the news. Meanwhile, the Capitoline government had turned out to be completely incapable of addressing the city's problems, and many Romans were starting to think that they'd been better off when they'd been worse off. When Niccolò Fortebracci withdrew from the surroundings of Rome—under pressure from Micheletto Attendolo and Leone Sforza, the Perugian condottiere deemed it more salubrious to retire to Città di Castello to marry the daughter of Count Francesco Guidi da Battifolle—he deprived the Capitoline government of crucial military support. On the 25th of that month, the Bishop of Recanati entered the city at the head of Sforza's troops and was heartily welcomed by the locals. The reconquest of Rome was a crucial turning point for Eugenius, since it gave him the political autonomy he needed to negotiate with the Council of Basel. However, the Pontiff preferred to remain in Florence, wary of Rome's changeable nature, and entrusted Vitelleschi with the task of restoring order to the Lazio. Which was like unleashing a horde of fleas on a stray dog.

Although known for being heavy-handed when it came to military matters, the Bishop of Recanati had a deserved reputation as a skilled diplomat, and instead of allowing himself to get caught up in a gruelling series of sieges, he preferred whenever possible to bring the rebellious papal feudal lords to heel by signing treaties with

them. Throughout the entirety of 1435, Vitelleschi successfully nego-
tiated the return of the Orsinis (who'd backed Eugenius from the
very start), the Colonnas, the Savellis and the other barons of the
area into the papal fold. Having distributed the requisite number of
carrots, Giovanni decided that it was time to use the stick: Jacopo da
Vico, the Lord of Vetralla, was the last of a race who'd never stopped
giving the Pope serious headaches, and the da Vicos had managed
to extend their domains all the way to Orvieto and Corneto. It is
therefore understandable that Vitelleschi bore a grudge against the
rulers of Vetralla, and following a fierce siege, Jacopo was forced to
surrender at the end of August, and the bishop had him decapitated a
month later. He had already been appointed Patriarch of Alexandria,
in partibus infidelium, the preceding February and his successes on
the battlefield led to his elevation to the Archbishopric of Florence
the following October.

Vitelleschi's appointment to the Florentine see had been backed
by his friend Cosimo de' Medici, who wanted to strengthen his own
standing with the Pope. Indeed, the Pope had many reasons to be
grateful to the Medici regime, given that just a few months earlier a
plot had been uncovered, whereby Visconti's agents and some Flo-
rentine agitators had schemed to kidnap him and take him to Lucca.
The plan had also envisaged the takeover of one of the city's gates,
which would be accomplished by a small force led by Count Fran-
cesco Guidi, as well as the return of the exiled Albizzi.

The plotters were captured and either executed or condemned to
long prison sentences; at the same time, all the exiles who'd broken
the terms of their banishment were denounced as rebels by the *balìa*,

chief among them Rinaldo degli Albizzi, who, although he'd resided in Naples for a decade, had eventually moved to Milan and worked his way into the graces of Filippo Maria Visconti. Thus, the plot of February 1435 had, in all likelihood, been the brainchild of a few friends of the Bishop of Novara, Bartolomeo Visconti, who'd been present in Florence at the same time as the Duke of Milan's ambassador to the Pope. Even Guidi's involvement in the plot is dubious, given that the count was busy trying to curry the favour of Florence's new rulers. Nevertheless, conspiracies of this sort were useful to the Medici regime in that they allowed them to prolong the state of emergency.

The permanence of these extraordinary measures was justified by the internal situation, given that the political forecast for the first months of 1435 predicted hail. Queen Joanna II of Naples had died in February, just a few months after her nephew and designated heir Louis of Anjou. In accordance with the provisions left behind by the dead queen, the crown should have passed to Louis's brother, René, who was being held prisoner by the Duke of Burgundy at the time. Filippo Maria Visconti had followed these developments in southern Italy with great interest, and saw the imminent clash between the Angevins and King Alfonso V of Aragon as an opportunity to make a move against his rivals in northern and central Italy. The Duke of Milan initially supported René's claim, promising his wife Isabella the support of the Genoese fleet.[81]

As Anjou was backed by both Florence and the Pope, Filippo Maria's decision might seem incomprehensible at first glance, given that Piccinino's actions in the Romagna risked compromising the

fragile peace of Ferrara. But Visconti had thought the situation through, and he was determined to keep Genoa—which had been in conflict with its Aragonese rulers owing to commercial rivalries since the fourteenth century, and more recently for the active support Aragon had lent to anti-Genoese rebels in Corsica—firmly in his camp.[82] The Aragonese had come to power in Sicily at the end of the thirteenth century and the Genoese didn't want to run the risk of seeing them in Naples too. Furthermore, Niccolò Fortebracci was still keeping Sforza's forces busy in central Italy, while Sforza himself was too focused on defending the March of Ancona to help the Venetians in the Po Valley. However, it was well known that the Pontiff had granted Sforza the March of Ancona as a feud, even if only because he'd had his back to the wall, and was waiting for the right moment to rid himself of this inconvenient vassal. Under these circumstances—and in light of later events—Visconti's policy must be interpreted as an attempt to bring the Pope over to his side, distancing him from his alliance with Venice, and thus allowing Filippo Maria to create a strategic axis between Naples and Milan. As both Piccinino and Fortebracci aimed to create their own independent states in central Italy, it was in Filippo Maria's interest to support the Bracceschi against the Sforzeschi. Far from being mere supporting actors or thorns in Italy's side—as certain humanists would have us believe, Machiavelli chief among them—mercenary companies, and especially condottiere schools, played a fundamental role in the peninsula's political game.[83]

In the summer of 1435, Alfonso besieged the stronghold of Gaeta, which was protected by a Genoese garrison, with the idea of using it

as a springboard for his planned conquest of Naples, and the ground operations were supported by a large Aragonese fleet, to prevent the beleaguered Genoese from receiving help via sea. But the king's plans were literally wrecked when his fleet encountered the Genoese fleet, which was determined to break the siege of Gaeta, in the vicinity of Ponza on August 5. Cornered by their enemies' superior seafaring abilities, the Aragonese suffered a crushing defeat, losing at least 600 men and thousands of prisoners, among them Alfonso and his entourage. News of the battle reverberated throughout Italy, leading the various governments of the peninsula to ponder the political implications that would arise in the wake of Ponza.[84] The Genoese seamen had captured a king in order to help one another, and they were hoping Filippo Maria would support their plan to conquer Sicily. But pieces on the political chessboard of fifteenth-century Italy had the tendency to move according to their own rules and logic.

At first, the duke wanted to profit from the strategic advantage he'd secured after the victory of Ponza, but the Sicilian endeavour had to be abandoned due to lack of available men and resources. What's more, several significant changes in international politics led Filippo Maria to reconsider his priorities. On August 23, Niccolò Fortebracci was defeated and killed at Fiordimonte, near Camerino, by Alessandro Sforza, who'd been entrusted to defend the March of Ancona by his brother Francesco; Carlo da Montone, Braccio's son, managed to escape along with a few hundred men. Following this rout, many fortresses in the Val Tiberina were restored to papal control; only Assisi, held by Carlo da Montone, and Borgo Sansepolcro, which was held by Count Francesco Guidi, Braccio's

father-in-law, had refused to surrender. Lacking any other valuable allies south of the Apennines, the duke agreed to negotiate with his enemies, showing he was open to compromise, which in hindsight now seems like a clever gambit. Filippo agreed to withdraw from Bologna and the Romagna, consenting to his enemies' request that several Milanese-occupied fortresses should be returned to the Pope, who was also given those fortresses conquered by the Venetians. Assisi surrendered soon afterwards, and Braccio's son was given the coveted castle of Montone as a reward for not having opposed the negotiations. Shortly after, having just returned from reconquering the Lazio, Vitelleschi had gone to the Casentino to force Francesco Guidi to loosen his grip on Borgo Sansepolcro. Isolated, Battista Canetoli agreed to give Bologna back to the Pope, and the representatives of Eugenius IV moved back into the city on October 6. As far as outward appearances went, Visconti looked as though he'd been defeated, but he had a serpentine knack for slithering his way out of unfavourable situations and still profiting from them.

Visconti's request that Alfonso and the other prisoners captured at Ponza be delivered to him quickly was greeted with a mixture of surprise and anger, since the Genoese were being enraged to see their chance to secure a rich ransom for the king and his entourage slip out of their fingers. The Ligurians' anger reached a boiling point when news went around on October 8 that the king and the duke had signed a treaty of alliance and mutual assistance, whereby Alfonso won his unconditional freedom, as well as 3,000 knights to conquer the Kingdom of Naples. In a single blow, Filippo Maria had turned the Italian political landscape to his advantage, forging a large link

in his 'chain'. The Genoese asked the duke to reconsider, but it was in vain: Visconti, who'd meanwhile recovered the fortresses of Lerici and Portovenere from Alfonso, having ceded them in the wake of a treaty he'd signed with the Aragonese in 1426, ordered the Superba's ambassadors to abandon their Angevin alliance and rally behind his new friend. Both their pride and their purse seriously injured, the Genoese began to ponder whether the Milanese game was worth the candle: what was at stake wasn't only the ransom money they'd lost, but also, more important, Genoa's commercial survival, as well as its dominion over Corsica. The final provocation occurred when Alfonso hired nine Genoese boats to transport him and Visconti's troops to Naples.[85] On December 27, the Genoese rose up en masse, slaughtering the Milanese governor and restoring the city's republican institutions.

Filippo Maria had predicted that his actions could have unwelcome repercussions, so much so that he'd reached an agreement with the Aragonese for their military support in the event that Genoa caused him any problems. Yet the universal support and success the rebellion enjoyed didn't allow Visconti to immediately retake the city, even though the fort at Castelletto had remained in Milanese hands. The duke no longer had access to an important outlet to the sea and he therefore dispatched Niccolò Piccinino to reconquer Genoa, also counting on Alfonso of Aragon's naval support. Led by Doge Tommaso Campofregoso, the Genoese put up a stiff resistance to Piccinino's advances, holding the Milanese troops for several days on mountain passes with just a few thousand ramshackle troops, most of whom were crossbowmen. Forced to fall back due to the

enemy's superior numbers after they'd suffered roughly two hundred casualties, the Genoese went on an all-out offensive and managed to storm the fort at Castelletto. Piccinino decided not to engage his forces in a protracted siege, opting for the strategy of cutting off all communication routes to Genoa and thus starving it into surrender. After systematically looting the city's outskirts, in March 1436 the condottiere besieged Albenga while awaiting the arrival of Aragonese reinforcements. Meanwhile, Alfonso had managed to conquer Gaeta and was putting pressure on the Aragonese Corts to obtain the necessary funds for his military campaigns.

The Milanese–Aragonese alliance was causing the other Italian states not a few worries, and Florence feared that if Visconti managed to reconquer Genoa, it would find itself squeezed in a vise that would be difficult to slip out of. Consequently, the Florentine government gladly agreed to surreptitiously dispatch a contingent of troops to aid the Genoese, since overt assistance would be a violation of the recent peace treaty. In addition, Florence lent its support to a pro-Genoese revolt in Pietrasanta, Lucca's most valuable port. The Florentines hadn't forgotten the humiliation they'd suffered a few years earlier during the war against Lucca, and besides, Cosimo de' Medici had every reason to prolong the state of emergency in the city. Although the electoral emergency established by the Medici *balìa* should have had a limited duration, at least in theory, the successive Signorie had extended the powers of the Accoppiatori to handpick governments— using the excuse that the *balìa*'s new decree for counting ballots had delayed the electoral rolls.[86] As a matter of fact, the reigning government wished to make provisions for any unpleasant surprises, like

the one that had occurred in September 1434, which had led to the rise of the pro-Medici party.

In the end, Alfonso of Aragon didn't budge from southern Italy, focusing on the conquest of the Kingdom of Naples, but the spring of 1436 nevertheless saw him busily assembling a fleet to aid Visconti: Alfonso had too many military commitments, and insufficient funds to finance both a naval and a land campaign. The Aragonese Corts had granted him 250,000 florins, but one should remember that Alfonso's military commitments didn't extend only to Genoa and Naples, but also to Aragon (where there were constant problems on its border with Castille), as well as Sicily and Sardinia.[87] The danger of Aragon landing on the Ligurian coast led Venice, Genoa, Florence and the Papacy to sign a treaty of mutual assistance in May 1436, which, while not a formal breach of the peace treaty concluded a few months earlier, led to a serious straining of relations, since the duke could not—if only for reasons of prestige—look idly on while half of the Italian peninsula joined forces against him. While militarily impressive, at least on paper, the alliance wasn't that at all solid. The Florentines weren't interested in Venice's main strategic objective, which was to expand to the west at the expense of a weakened Milan, which would inevitably lead to Venice reaching Florence's doorstep. After all, Cosimo de' Medici hadn't lost sight of who would succeed Filippo Maria, and he intended to favour Francesco Sforza's ambitions. This wasn't only due to their friendship, it was also part of a long-term plan to redraw the map of Italian alliances to benefit both Florence and the Medici. Nevertheless, like any self-respecting statesman, Cosimo exploited situations to his favour

rather than creating them, making do with the cards he'd been dealt.

Filippo Maria certainly had no intention of idling about while his enemies went on the offensive, and he thus decided to parry the blow by sending troops led by Luigi dal Verme, whom he'd recently poached from Venice, to help Lucca recover Pietrasanta. The Milanese troops were accompanied by Ormanno degli Albizzi as well as other Florentine exiles, who were waiting for the right moment to return to the city. They received further encouragement from the humanist Francesco Filefo, who as an inveterate opponent of the Medici had had to flee Florence after their rise to power. In contrast to the stereotype of the bookish humanist, Filefo was an intellectual who didn't hesitate to get his hands dirty, at least figuratively speaking. When Cosimo had been captured by the Albizzi, Filefo had insisted that the prisoner be executed. Having removed himself to Siena in 1434, Filefo had been the target of an assassination plot by the Medici, and he'd paid them in kind by sending a hired assassin to murder Lorenzo de' Medici, as well as other followers of the new regime (including a few professional rivals of his). Following the failure of the physical attack, Filelfo began work on a verbal assault of the Medici and their supporters, the *Oratio in Cosmum Medicem ad exules optimates Florentinos*, in which he argued that the Albizzi needed to use the Duke of Milan to bring freedom back to Florence.[88] Filefo's invectives didn't fall on deaf ears: there was no shortage of Albizzi supporters in Florence, and the Medici were constantly on the alert due to their fear of internal upheavals.

Italy had once again wound up in the warm embraces of Mars.

Milan's operations in Lucca and Liguria had been followed up by
Vitelleschi's manoeuvres against the Aragonese in Naples and rebel-
lious barons who supported Alfonso in the Lazio. The Archbishop of
Florence put his renowned talent for swiftness on display once more
when he seized a number of castles and executed their defenders, like
Antonio da Pontedera, who was summarily hanged from an olive tree
'wearing his shirt, but not his trousers, and he was not administered
the last rites by the Church,' as the Florentine diarist Giovanni Mo-
relli commented with thinly disguised glee.[89] Palestrina, the Colon-
nas' main stronghold, was stormed in August, and Vitelleschi had it
razed to the ground a few months later. Meanwhile, the Pontiff had
gone to Bologna to better follow Francesco Sforza's campaign against
the Ordelaffis of Forlì, at which point the condottiere would move
to Tuscany to aid the Florentines against the Milanese at Lucca. Ab-
sorbed by the task of containing Venetian troops in the Po Valley
and kept busy by the rebellion in the Liguria, the Milanese could do
little to help Lucca; even Piccinino's offensive into Tuscan territory
had produced disappointing results, and the condottiere had eventu-
ally been forced to withdraw due to a lack of victuals and fodder.

It's likely that the allies' claims had more significant repercus-
sions than one might have initially assumed, given that a Milanese
success at Lucca could have triggered a series of consequences that
would imperil the survival of the Medici regime in Florence. Archi-
val documents discovered a few years ago suggest that Filippo Maria
had tried to encourage the city of Arezzo to rebel, having attempted
the same trick in 1431. Back then the conspiracy had been uncov-
ered and Visconti's agents were repelled, but this time, the duke was

planning an insurrection that would engulf the entire Aretino and
the Val Tiberina—where a few local lords, in particular the dreaded
Anfrosina da Montedoglio, the Lady of Monterchi, resented Floren-
tine rule—and this coincided with Siena entering the fray. There
had been many anti-Florentine plots in Arezzo, but the suspected
involvement of the Commune's chancellor, Leonardo Bruni, makes
this particular affair pregnant with meaning: Bruni had been in ca-
hoots with the old Albizzi oligarchy, and thus the conspiracy in the
Arezzo was also calculated to appeal to the Medicis' enemies within
Florence.[90] Cosimo thus had quite a few reasons to be grateful to
both Francesco Sforza and Vitelleschi.

Florence was safe, at least for the time being; but it was also clear
that the Medici needed to widen their support base, pitting them-
selves as the defenders of civic liberties against the despotism of Vis-
conti and his allied Albizzi exiles. These acts of propaganda didn't
only take place on a political and literary level—whereby the regime
used intellectuals of the highest calibre to rebut the accusations lev-
elled by its enemies—but also spilled over into the world of art. Back
in 1433, when the regime had been dominated by the Albizzi, the
Commune had launched an open competition for a painting to com-
memorate the English condottiere John Hawkwood, in an attempt
to whitewash the military failures of the previous years. Although
Hawkwood had been dead for forty years, the city still remembered
him as a successful captain who'd been loyal to Florence and had
repelled Gian Galeazzo Visconti's forces on more than one occasion.

A character like Hawkwood was quite useful to the Medici given
the climate of anti-Milanese hostility that prevailed in the city;

hence, on May 30, 1436, the painter Paolo Uccello, was commissioned to execute an equestrian portrait, which he completed within a month. Nevertheless, once the work was finished the Operai of Santa Maria del Fiore, the institution charged with overseeing the work on the Duomo, ordered the artist to repaint the horse and the knight because they hadn't been 'painted properly'. Uccello thus only completed the portrait in August. There had been much speculation as to what had led the Operai to order Uccello to redo the entire painting, but it's quite likely that they had taken a dislike to the realist perspective that Uccello embraced. If that was indeed the case, the order to change the portrait would also have had a political meaning, given that classical realism was a style highly prized by Cosimo and his inner circle, which clashed against the more traditional tastes of many Florentines, even if the latter were not completely averse to modern flourishes. *In cauda venenum*, however, given that the inscription above the caption "PAULI UGELLI OPUS" is essentially the same as the one on the tombstone of the Roman general Quintus Fabius Maximus; thus, the monument to John Hawkwood is as much an epiphenomenon of the Renaissance as of the Medicis' new political order.[91]

Although favoured by fortune, the allies were encountering difficulties that did not bode well. The Venetians were struggling to make any headway against the Milanese, and in November 1437, the Consiglio dei Dieci (Council of Ten) ordered Francesco Sforza to bring his troops back to the north. Naturally, the Florentines saw this as a move to neutralise the advantages they'd obtained to the detriment of Lucca up until that point. Meanwhile, Sforza was focused

on defending the March of Ancona, had no intention to leave it, and argued that he was receiving contradictory orders from Florence and Venice. In response, the Venetians decided to cease deliveries of their quota of Sforza's pay, which he was rightfully owed. The condottiere subsequently withdrew from the Luccan countryside and threatened to switch over to Visconti's side once his contract expired the following month. Given that the Serenissima refused to loosen its purse strings unless Francesco decided to cross the Apennines, Cosimo de' Medici decided to play a trump card that would allow him to salvage the situation insofar as he could: employing Sforza as an intermediary, Florence signed a three-year truce with Milan in March 1438 in exchange for a promise that the duke would consent to marry his daughter Bianca Maria to Francesco, and that on Filippo Maria's death, he would be succeeded by his son-in-law. Visconti gladly accepted, given that he would thus be able to split his enemies' ranks, and what's more, he ordered the Luccans to cede a large slice of their territory to the Florentines. The duke was now free to focus on the second link in the enemy chain.

The Pope's Italian problems were of little consequence compared to those caused by the Council of Basel, which was by then becoming increasingly radical. Having forced Eugenius to accept their authority, the conciliarist priests had grown determined to increase it at the expense of papal prerogatives, including those he wielded *ab immemorabile*. Emperor Sigismund had tried to curb the angered conciliarists' more extreme demands, complaining, among other things, about their decision to grant Filippo Maria Visconti the title of Vicar Apostolic for the whole of Italy, which would allow the Duke of

Milan to carry out his expansionist politics against ecclesiastical do-
mains under the protection of a legal fig leaf. The council and the
Pope also clashed on the issue of the reunion between the Western
and Eastern Churches, which had existed in permanent schism since
the thirteenth century (not since 1055, as is often stated). The Council
of Basel insisted on being the chief interlocutor in the negotiations
with Constantinople, blocking Eugenius's efforts in every way that it
could. In order to cripple the Pope financially and bring him to his
knees politically, on June 9, 1435, the conciliarist priests decreed the
abolition of papal annates. This decree unleashed a barrage of pro-
tests from some of the less radical conciliarists, but the assembly at
Basel had by then been taken over by extremists backed by European
sovereigns who wished to control the clergy in their own countries
and simultaneously profit from their incomes.

In March 1436 the priests of Basel decreed that future papal
elections would not be recognised if the new Pontiff did not first
recognise the supreme authority of the council, simultaneously im-
posing strict limitations on the investiture of cardinals. When the
ecclesiastical council claimed the authority to grant indulgences, it
seemed it would only be a matter of time before it came to a com-
plete break with Rome, and the papal delegates withdrew from the
council. Among other things, there was a widespread impression
that the French representatives were doing all they could to cause a
split in the Church, since France had never gotten over losing control
of the Papacy after having enjoyed influence there for much of the
fourteenth century. The Bishop of Tours was very clear in this sense:
he stated that the Papacy needed to be prised out of Italian hands or

else stripped of so many of its powers that the question of who owned it would no longer matter.[92]

The definitive break between Eugenius and the council occurred over the question of the Eastern Church, after the majority of the fathers of Basel decided that the assembly should relocate to Avignon to continue discussions with the Orthodox priests there. It was obvious that the French wanted to obtain control of the council and the Papacy, but instead the Pontiff approved the choice of either Udine or Florence over Avignon, paying heed to the minority's wishes. Eugenius enjoyed the support of the Greek delegation, who were opposed to going to Avignon, and who furthermore questioned the legitimacy of certain decrees issued by the conciliarists. Eugenius's diplomatic victory triggered the extremists to rebel, leading increasing numbers of moderates to leave Basel; on July 3, 1437, the extremists asked the Pope to appear before a tribunal established by the council. In response, the Pope dissolved the assembly and stipulated it should reconvene at Ferrara the following January. The extremists declared the papal dissolution decree to be illegitimate and continued along their path undeterred. The schism had taken place.

Filippo Maria Visconti was determined to bend the Pope's will to the wishes of the Synod of Basel (one is obliged to call it by this name now), as it fitted into his strategy to achieve hegemony over Italy. It was thus crucial to hinder the council convened at Ferrara at all costs. An overt attack against the Pontiff would have almost certainly led to the strengthening of the anti-Milanese coalition, but the duke enjoyed a deserved reputation for his ability to devise plans as subtle as they were effective.

In March 1438, Eugenius IV was approached by the agents of
Niccolò Piccinino with an enticing offer: the condottiere was now on
bad terms with Visconti, due to the favouritism the latter had shown
to Francesco Sforza; hence, Piccinino proposed that the Pontiff hire
him to recover the March of Ancona, in exchange for being granted
Perugia, Assisi and Città di Castello as feuds and the title of Gonfa-
lonier of the Church. Eugenius gladly accepted, eager to rid himself
of Sforza, who at that time had been busy fighting in Naples for René
of Anjou—recently freed from prison—against Alfonso of Aragon.
With the Pope's backing, Piccinino took possession of various locali-
ties in the Emilia and the Romagna, among them Imola and Forlì,
but then, in a sudden volte-face, and in collusion with the anti-papal
faction of the city, he captured Bologna in June in a lightning attack.
One of Niccolò's first acts was to install an Albizzi exile as *podestà*,
and the Bolognese branch of the Medici bank was systematically
and meticulously looted. Piccinino had played his cards masterfully
and now the Pope was faced with a cordon of Milanese fortresses
perilously close to Ferrara; in addition, there was no certainty that
Niccolò III d'Este wouldn't also go over to Filippo Maria's side, even
though the Marquis of Ferrara was just as worried by Milanese ex-
pansionism in the Po Valley. Therefore, under the pretext that the
plague was raging in Ferrara, the Pope decided to relocate the Coun-
cil to Florence.

Piccinino's military initiative had triggered a chain reaction.
Venice had been put on the alert when the Milanese condottiere
had attacked Ravenna, which was held by the pro-Venetian Osta-
gio da Polenta. The Serenissima decided to open hostilities after the

Marquess of Mantua, Gianfrancesco Gonzaga, entered the fray on Milan's side, driving a dangerous wedge deep into Venetian territory. But Visconti had the strategic initiative, and throughout the summer and autumn of 1438, Piccinino and Gonzaga repeatedly defeated the enemy forces, occupying several castles and placing Brescia under siege. The heroic defence of the city and Gattamelata's skilful harrying prevented its fall, but it was only a matter of time before the whole of Lombardy and the western Veneto wound up in Milanese hands. There could only be one solution: salvaging the alliance between Florence and the Pope, and re-hiring Francesco Sforza.

The alliance between Florence, Eugenius and Venice was signed on February 19, 1439, and granted Sforza a *condotta* of 5,000 knights and 2,000 foot soldiers, further recognising his claim to the March of Ancona, and giving him full discretion over the use of his troops as well as a guarantee that he could hold on to any territories he conquered.[93] In March, Francesco took over Foligno, where he arranged for his brother Leone to marry Marsabilia, the daughter of the local lord, Corrado Trinci, in a union destined to have short-term repercussions. Travelling through the March, Sforza went to Forlimpopoli, which he captured after a siege that lasted barely half a day. Neri Capponi reached the allied camp shortly after and advised Sforza to go north and help the Venetians, who were experiencing difficulties. Capponi was a notorious friend of the Serenissima, but he also saw the advantage of focusing the war effort on the Po Valley, far from Florence's borders.

After trying in vain to conquer Forlì, Sforza moved on to the Ferrarese, and sailed for Venice. Joining up with Gattamelata, Francesco

managed to send reinforcements to Brescia, to ease the pressure the Milanese were exerting on Verona, and to defeat Piccinino at Tenno. But while the victorious Venetians were marching towards Brescia, they received the news that the Milanese had taken Verona with a surprise attack and were forced to turn around. It was Gattamelata who turned the tables on the situation by taking his soldiers on a daring march through the mountains to fall suddenly upon Visconti's troops, who were still busy looting the city, and take thousands of prisoners. Piccinino and the other Milanese commanders had no choice but to retreat to Lombardy, slowing the enemy down by fighting a rearguard action.

The Venetians' successes exerted a determining influence even on the Church's internal affairs. Pushing the war away from Florence's borders had allowed the council to devote itself to its work with tranquillity, and at the same time augmented Cosimo de' Medici's prestige and lined the pockets of the local merchants. The union with the Orthodox Church was the subject of long discussions, especially when it came to subtle—but nevertheless important—theological questions. However, it was in both parties' interest to reach an agreement: the Pontiff for reasons of prestige, besides reaffirming his own position as the spiritual leader of Christianity, which the Synod of Basel had jeopardised; and on the other hand, the Orthodox priests, above all the Byzantine Emperor, hoped that the union would bring military advantages with it, which they desperately needed to stop the Ottoman onslaught. The agreement that marked the end of the schism was signed on July 5, 1439, and it was formally proclaimed the following day. The Pope hastened to inform

all European governments to that effect, and while there were many outstanding points of contention, what mattered was that the schism had come to an end.

Watching the Eastern priests and the court of Constantinople parade through the streets of the city was something new and fascinating for the Florentines, while hearing the divine liturgies recited in Greek gave them a window to another aspect of the Christian world, about which they'd previously known nothing. The veneration for the golden icons held solemnly aloft during the procession dazzled the spectators, just like the iconostases set up inside the Churches during liturgical celebrations. The impact these had was significant, considering their echoes in some of Beato Angelico's paintings, which belonged conceptually to the Renaissance, while their forms were profoundly Eastern. There was another artist—employed in the workshop of Domenico Veneziano at the time—who was also indelibly marked by Orthodox gestures and spirituality: Piero della Francesca. His works are iconic, and he genuinely rose to the challenge of allowing the tangible world of nature to seep through the hieratic incorporeity that looked out onto infinity.

Eugenius IV's successes with the Church were as much of a nuisance to Filippo Maria as the Venetians' military triumphs. Having failed to put a spanner in the council's work, Visconti decided to switch his efforts to the field of doctrine. The progress achieved at Florence had caused the Synod of Basel not a few annoyances, to the point that, in a last-ditch effort to stop the Pontiff, the Synod deposed him on June 26, freeing the faithful from any obligations they'd had towards him. But there was still need for a Pope, and

so, on November 5, a cardinal and a handful of dissident bishops elected Amadeus VIII, the Duke of Savoy, as Eugenius's successor. This move had been engineered by the cunning Visconti: Amadeus, coincidentally, had been his father-in-law, since Filippo had taken Marie of Savoy as his second wife. (That marriage was not only never consummated, but the duke also kept his unhappy consort under lock and key.) Having a Pope to whom he was closely related suited Filippo Maria very well, since it increased his authority and he could furthermore claim to act in the Church's name in his capacity as Vicar Apostolic for Italy. However, Amadeus didn't seem very inclined to accept this dubious honour, and only gave his consent a couple months later, taking the name of (Antipope) Felix V. That aside, Amadeus was careful not to leave his residence at Rapaglia, on the shores of Lake Geneva, where he kept a very low profile.

Having a Pope's nominal backing was of little consequence without the assurances of military support. In order to break through the enemy's front, Filippo Maria had tried his usual trick of promising his daughter to Francesco Sforza, who immediately took care to warn his employers of the offer without interrupting his campaign against the Milanese. But Visconti hadn't yet been defeated, and he was still certain that he'd found the weakest link in the enemy 'chain'. Florence was badly defended, surrounded by potentially hostile states, and it hadn't yet grown accustomed to Medici rule. In fact, Rinaldo degli Albizzi thought that in the event an army appeared at the gates of the city, it would trigger an insurrection against the Medici. This was an enticing prospect for the duke, who was nevertheless interested in a broader strategy: shifting the war to central Italy would

threaten the March of Ancona, and therefore force Sforza to leave Lombardy in order to protect his dominions. In addition, a direct attack on Florence could bring the council's work to a premature end, all to the advantage of Visconti and the Synod of Basel. It was a simple but well-considered plan, which on paper promised great profits against a relatively modest investment.

On March 4, Milanese forces led by Niccolò Piccinino and Astorre Manfredi, the Lord of Faenza, who had quite a few reasons to fear Florence's expansionism, converged on Bologna. Rinaldo favoured a swift advance before Florence had the time to recall Sforza or recruit more troops. But the seasoned Piccinino preferred to wait for the ice in the Apennines to melt before making a move: his horses needed fodder, and, besides, he needed to watch his back. Having relocated to the Romagna, the ducal condottiere took possession of Forlì and Imola, as had been agreed, and after the Milanese conquered Meldola and looted it, Domenico Malatesta of Cesena and Sigismondo Pandolfo Malatesta of Rimini sided with Visconti, with Domenico allowing Milanese garrisons into various fortresses in his possession, including Cesena. After conquering Modigliana, Piccinino found himself at the doors of Marradi at the beginning of April. Marradi was the gateway to the town of Mugello, a town that wasn't surrounded by walls, but that guarded the only bridge that crossed an otherwise impassable valley. Defending the area could have been an easy task, even with just the few simple peasants at the disposal of the Florentine commissioner Bartolomeo Orlandini; but Orlandini was no hero, and as soon as he saw the enemy army approach, he took off for the hills, and didn't stop until he'd reached

Borgo San Lorenzo. Piccinino tore through the Mugello, preying on livestock and taking prisoners, while hundreds of scared peasants sought refuge behind the walls of Florence. Stories of mass rapes committed by Milanese soldiers made the rounds of the city, but after having questioned several refugees 'among the youngest and most eye-catching', Cavalcanti came to the conclusion that a few beatings aside, Visconti's troops had on the whole behaved themselves with great decency and respect towards the women of the Mugello.[94]

Although it was normal for rural populations to seek refuge in fortified cities in cases of danger, for Piccinino to have allowed the massive influx of peasants to flow into Florence was part of a well-thought-out strategy: the sudden increase in population would inevitably create considerable logistical problems, including a flare-up of social tensions and an increased likelihood of revolts. Around April 10, Piccinino set up camp right outside the castle of Pulliciano, in the Val di Sieve, but despite repeated attempts, he failed to storm it. At the same time, he continued to pillage the surrounding countryside, managing to get to within five kilometres of Florence and occupying several small, undefended communities. The reasons why the ducal condottiere lingered in the Mugello are easy to guess: he was short of victuals and fodder and he furthermore needed his troops to recover, since after their march through the snowy mountains 'not only men-at-arms had died of cold, but also the horses.'[95] The ducal condottiere was also waiting for the hoped-for insurrection in Florence, and it is more than likely that he was also waiting for help from another front. But, in this case, his hopes would be dashed.

Eugenius was having problems with Vitelleschi, whom he had

elevated to the rank of Cardinal on August 9, 1437. The prelate hadn't interrupted his repressive campaign against the Roman barons, and he was still waging war against Alfonso of Aragon. His campaigns in the Neapolitan region had alternated between victories and defeats, even though he had almost managed—in a dishonourable violation of a truce—to capture the king while he was attending Christmas mass in 1437. But Vitelleschi's relationships with Venice and Florence were fast deteriorating, at least in part because of the favouritism that the two republics had shown to Francesco Sforza. Vitelleschi had never forgotten that he'd been forced to flee the March of Ancona due to the pressure of Sforza's troops, and this resentment had been further fuelled by the fact that Leone Sforza had married Marsabilia Trinci. A blood feud between the Trinci and the Vitelleschi had persisted through several generations, and besides, Corrado Trinci had rebelled against papal authority on a number of occasions. Vitelleschi had tried to conquer Foligno in 1438, but had been forced to withdraw by the arrival of Francesco Piccinino; he had attempted the conquest again the following summer, and this time it proved successful, with Vitelleschi occupying the city and capturing Trinci. Meanwhile, having noticed René of Anjou's scant progress in southern Italy, Vitelleschi had opened peace talks with Alfonso; he had by then come to a complete break with the Angevins due to his territorial claims and the constant habit of conquering localities in the name of the Church rather than in René's.

Vitelleschi was probably being sincere when he declared he'd only acted for the good of the Church, but it was a shame that he had a tendency to claim victories in his own name. In January 1440,

Vitelleschi had managed to take over the important fortress of Spo-
leto, prising it away from one of Alfonso of Aragon's allies. The Pope
decided to grant it to his relative Amorotto Condulmer, but the new
castellan was forced to bend his knee to the cardinal, who made
it very clear that it had been he, and not the Pope, who'd granted
Spoleto to Condulmer. The extraordinary power that the cardinal
exercised over the Pope was beginning to be a cause of major con-
cern. He was detested by the Roman curia, where rumours circu-
lated that Vitelleschi wanted to supplant Eugenius; and he was also
not looked upon kindly by the Venetians or Florentines because he
was suspected of having a secret relationship with Visconti. On Feb-
ruary 29, the Florentine Antonio Serragli wrote from Modena to his
fellow citizen Iacopo Ridolfi, captain of the mountain of Pistoia, 'I
warn you that Niccolò Piccinino and the patriarch (Vitelleschi) are
plotting together, and the same goes for the Duke of Savoy (Felix
V).'[96] The fears of a possible betrayal by Vitelleschi appeared to be
confirmed when the Florentines intercepted a few letters purportedly
written by Vitelleschi to Piccinino, even though the content of these
letters was inscrutable, as they'd been written in cypher. Still, the
message was abundantly clear: if Vitelleschi defected to the Milanese
camp, the March of Ancona and other papal territories would be in
danger, and the Synod of Basel would also acquire a formidable mili-
tary presence in Italy, which would consequently risk the survival of
the Council of Florence.

In view of the evidence, the Pope decided to take his time; forg-
ing incriminating letters was an old trick, and besides, the Pontiff
needed Vitelleschi for a possible future campaign against Sforza

in the March of Ancona. However, the Medici regime could not afford the luxury of waiting, and the Florentine government dispatched Luca Pitti, Cosimo's henchman, to Rome with the task of ordering Antonio da Rido, the governor of Castel Sant'Angelo, to arrest Vitelleschi at the earliest opportunity. On March 18, while the cardinal was readying to leave the castle, Rido delayed his departure under the pretext that he needed to speak to him urgently. The governor waited until all the soldiers had left the fortress, and after he gave a predetermined signal, a heavy iron grate suddenly slammed down over the entrance, separating the cardinal from his men. Vitelleschi immediately understood what had happened and spurred his horse as he tried to clear the way for himself, sword in hand. Rido's followers pulled him down from his horse, inflicting injuries all over his body. While the bloody cardinal was being carried inside the castle, Rido went up the battlements and waved a document to the cardinal's acolytes below, claiming it was an arrest warrant for the cardinal that had been signed by the Pope himself.

In all likelihood, Eugenius had been kept in the dark about the move against Vitelleschi, a hypothesis that seems to be confirmed by the letter Rido sent to the Florentine government the day after the cardinal's capture. In this missive, the castellan claimed he'd acted on his own initiative, given that the cardinal had long 'used his wiles and tricks to try to wrest the castle out of my hands', adding that he was 'an enemy of Pope Eugenius'. Rido had thus been unable 'to overlook such wickedness from so evil a man', and asked the Pope for his forgiveness 'for having acted with Our Lord's approval,

not having had the time to notify him' and concluding 'that he did
to him what he was certain that [Vitelleschi] would to do to [the
Pope].'[97] The Pontiff contented himself with the explanation, since
the matter seemed nothing more than a blood feud between two of
his underlings. The following year the Pope issued a bull clearing
Rido of all blame, and in that document he even appropriated the
version of events that his castellan had furnished to him.

Rido had given assurances that Vitelleschi was being 'treated
well and kept safe at Pope Eugenius's request', but his enemies
couldn't run the risk of the cardinal escaping. This was something
that Bartolomeo Vitelleschi, the prisoner's nephew and Bishop of
Corneto, was also well aware of, and on March 26, he sent a let-
ter from Siena, where he had taken refuge, to Cosimo and Lorenzo
de' Medici, reminding them of all the help they'd received from his
uncle and imploring them for aid: 'You are those who can decide
the monsignor's fate and pry him from the hands of those assassins.
Act now: this is the time and before long those traitor dog assas-
sins will kill him.'[98] Bartolomeo clearly saw the long hand of the
Medici at play behind his uncle's misfortunes and he knew that it
would only be a matter of time before he was dead. The cardinal was
also well aware of this, since whenever anyone tried to comfort him
over his bad luck, he would reply: 'Anyone who doesn't deserve to be
caught also doesn't deserve to be released.'[99] On April 2, Vitelleschi
passed away under mysterious circumstances, even though Floren-
tine historians attributed the blame to Luca Pitti, who, while clean-
ing a wound the cardinal had suffered on his head, 'stuck his hand
into his brain, and he died right after.'[100] In fact, the identity of the

man responsible for Vitelleschi's murder was of little consequence, given that the cardinal's fate had been decided the moment he was arrested.

It's possible that the Florentines had planned Vitelleschi's death after Neri Capponi and Giulio Davanzati sent their ambassadors to Venice the previous February. The two diplomats had gone to ask that Francesco Sforza move his troops south of the Apennines, since the concentration of Milanese troops in Bologna had caused them to worry they might soon invade Tuscany. Sforza was equally concerned over the March of Ancona, and was further of the opinion that if he didn't march his troops to Florence's aid, the city would either fall or be forced to conclude a separate peace treaty, which would bring the anti-Visconti coalition to an end. On the other hand, the Venetians believed that Sforza's presence in Lombardy was the best deterrent to protect Florence, in that it would force Visconti to concentrate all his troops there. In order to persuade the condottiere, the Venetians offered him 80,000 florins as a gift, on top of a salary increase of 40 florins per lance, and in a coup de théâtre, they threatened to enter into negotiations with Filippo Maria in the event that Sforza and the Florentines persevered with their demands. In fact, the Venetians were well aware of the dangers threatening Florence, which could have been easily avoided if Sforza's troops in the March of Ancona moved to Tuscany; but this would have been impossible so long as Vitelleschi was able to roam free, which is why it became necessary to cut him out of the picture.

The cardinal's death gave the allies some respite, and as a compromise between the Florentines' requests and the Venetians' needs,

a thousand troops under the command of Bosio Sforza, Francesco's brother, crossed the Po on April 18 and headed towards Tuscany. Concurrently, Micheletto Attendolo left the March of Ancona with 800 knights and made for Florence. The Florentine commander in chief, Pietro Giampaolo Orsini, came down from the Romagna with an additional 600 knights, managing to elude the Milanese troops in the area: when Domenico and Sigismondo Pandolfo Malatesta had sided with Visconti, Orsini had pretended to do the same, thus managing to keep his little army intact, and he fled at the first available opportunity. Nevertheless, they stayed on the defensive: the scant allied forces converging on Florence were not up to the task of fighting against Piccinino's soldiers on an open battlefield, and having an army in itself was crucial to keeping the internal situation in the city under control.

The danger of popular uprisings was very real, so much so that some individuals in the Medici faction were pushing for the immediate arrest of all those deemed politically suspect, but there were many Florentines who instead argued that there was a need to allow the exiled Albizzi to return to the city, in the hopes that this would convince Piccinino to withdraw. There was also much uncertainty over the reliability of the troops defending Florence; Orsini himself was considered by many to be a potential traitor, in light of his recent behaviour. At the height of the crisis, Cosimo de' Medici declared that he was willing to opt for life in exile for the good of his birthplace. His offer was rejected, but the situation was serious enough for Neri Capponi to order Orisini to have a cavalry unit ready to escort Cosimo to a safe location. Despite the internal and

external pressures, the Medici regime was nevertheless determined to resist to the bitter end, and it began a propaganda campaign to restore its followers' confidence. During a public debate, Puccio Pucci, a close collaborator of the Medici, articulated the reasons why the Florentines couldn't give up: Florence was equipped with strong walls—so strong that Piccinino had never dared to launch an all-out assault on the city—and Rinaldo degli Albizzi was a coward and had betrayed his native city, which had given him glory and power. What's more, how could the exiles hope to win given that Florence's military forces were growing day by day?[101] Pucci's arguments weren't purely rhetorical. Florence had already capitalised on Piccinino's prolonged presence in the Mugello, while the hoped-for anti-Medici revolt hadn't yet materialised. Meanwhile, the Florentines were starting to react, and Neri Capponi left the city at the head of a few cavalry squadrons to chase the enemy away from the city's outskirts.

Indeed, Piccinino's wait-and-see policy seems rather inexplicable, given that he'd earned his fame for his ability to make lightning-fast manoeuvres. A keen observer such as Poggio Bracciolini could argue that Piccinino's stubbornness in capturing 'tiny castles' of little importance had lost him the opportunity to take Florence by surprise. 'But few are the times when the counsel of men leads to good fortune: and fewer still know how to use it to their own benefit and to recognise it when it shows itself prosperous in front of wide-open eyes.'[102] The more logical explanation is that the ducal condottiere was waiting for Vitelleschi's arrival, so as to catch the city in a lethal vise. But in order for that to work, Filippo Maria's strategy relied on

the military and political pieces at his disposal to fall into place at the same time, and with Vitelleschi out of the picture, Visconti had lost a crucial pawn. Nevertheless, the game was still far from won, and the capable Duke of Milan still had more than one ace up his sleeve.

6

HORSES CAN'T EAT STONES

The bearded man was closely observing his assistants, who were staring intently at the cartoon on the wall in the great hall. He took a few steps back to gaze at the entirety of his composition, which was now beginning to take shape in the dimensions the artist had envisioned. It wasn't just the end of the first phase of a large job (even though the city wasn't paying him as generously as the princes he'd previously worked for); it was also a kind of revenge against the painter who'd been tasked with decorating the opposite wall. A fine fellow, that chap! The sort of man who would have tried Job's patience in a single day. Which was why a colleague of his had broken his nose with a well-aimed punch. But it didn't seem as though he'd learned his lesson. To this day, he did nothing but speak badly of the art of painting while glorifying sculpture, and, perhaps not without reason, he'd also become famous for his statues. One wondered exactly what he was trying to achieve with all those naked bodies, which, as the story went, he had included in his cartoon for The Battle of Cascina, *a painting with which the city intended to celebrate*

another victorious campaign that had taken place a hundred and fifty years earlier. The bearded man was convinced that all that flesh on display was nothing but the transposition of a sculpture into a wall, and that it was still essentially a sculpture. At heart, this shortage of ideas was nothing other than the reflection of that abject, ungrateful land in the Casentino from which it was said the other artist hailed. For that matter, it had been precisely his adventure in the Casentino that had caused Niccolò Piccinino, whose likeness appeared in the middle of those cartoons he'd just hung on the wall, so many troubles.

No, painting was the art that could embrace and accommodate everything the eye perceived, something the deficiency of sculpture found it impossible to replicate: colours, perspective, the intensity of bodies and objects . . . the sort of completeness that couldn't be found in any statue. Furthermore, when it came to depicting a battle, how could sculpture reproduce the effects of the dust, the clouds, the rain and the chaotic mass of fighters locked in fierce hand-to-hand combat? Of course, not all painters were capable of creating such uniform and harmonious compositions; truth be told, most of them could do little more than superimpose one layer of expressiveness atop another, without paying much attention to the distortions this created for the outside eye. That being said, the vastness of the hall didn't allow him to create a perfect perspectival view according to the criteria of the great Leon Battista Alberti, and one therefore had to employ a series of visual tricks to try to reproduce the feel of an open-air countryside inside the four walls of that council room, regardless of how large it was. Even if the four windows that had been recently opened on the western side of the hall gave little light, it would be exactly that feeble luminescence which would emphasise the shapes and

colours of those paintings. As for The Battle of Cascina . . . Well, the
artist with the broken nose would have to adapt his pictorial technique
to the circumstances of the great hall; then and only then would one be
able to determine which of the two artists had managed to triumph over
the limitations of the physical environment in which they'd had to work.

Since the hoped-for anti-Medici insurrection in Florence hadn't
come to pass, and with Cardinal Vitelleschi dead, Piccinino dithered
over which strategy to adopt. The quickest, and perhaps most effec-
tive, recourse would be for him to leave the Val di Marina and march
his troops between Florence and Prato all the way to the Arno so as
to stop victuals from Pisa from being delivered to Florence. Rinaldo
degli Albizzi was in favour of this approach, and he was furthermore
pressing the condottiere to focus on Pistoia, hoping that the forth-
coming arrival of a large army would prompt the Panciatichi fac-
tion to rise up against its centuries-old enemies, the Cancellieri, who
were then in power and backed by the Florentine government. Once
they'd conquered Pistoia, Visconti's forces, with the backing of the
Panciatichi, could then proceed to occupy several important loca-
tions in the lower Valdarno and control the routes of communication
to the Val di Nievole. This would inevitably force the Florentines to
seek battle on unfavourable footing, and their defeat might be able to
reinvigorate the courage of pro-Albizzi elements in Florence.

However, Niccolò realised the risks that such a strategy entailed,
not least of which was getting embroiled in a civil war in Pistoia. In
addition, both the Panciatichi and the Cancellieri had numerous

strongholds alongside the mountain of Pistoia, whose communities
were fiercely opposed to the enemy faction. Thus, once he'd captured
Pistoia, Piccinino would be subjected to a campaign of sieges, which
would eventually bleed him dry, especially since he'd been led to
believe that those castles wouldn't give up so easily. There was also
the matter of provisions, and a city of roughly 6,000 inhabitants
like Pistoia wouldn't have been able to meet the needs of more than
5,000 soldiers for very long, particularly since those soldiers had had
to reduce their loads in order to move more rapidly. Visconti's squad
leaders were well aware of these difficulties, and they'd made their
needs clear to their captain: 'we need to eat, and we can't eat the
hours of the day or the sound of trumpets; no, we eat bread, meat,
milk and all the other things that other captains give their men'.
Giovanni Cavalcanti, who gave us the previous report, also tells us
that Niccolò intended to occupy the hills of Fiesole and San Miniato
al Monte, as well as capture the castle of Lastra a Signa in order to
prevent supplies from Valdarno and Pistoia from reaching Florence.
Thus, the city's logistical situation would rapidly deteriorate thanks
to the added pressure of thousands of refugees within its walls, trig-
gering insurrections, despite the presence of the troops that had ar-
rived with Neri Capponi, and forcing the Medici regime to come to
terms.[103] It's likely that Cavalcanti was reporting the fears circulat-
ing Florence vis-à-vis the action Visconti's forces might take rather
than Piccinino's real intentions. Piccinino must have realised that he
couldn't successfully bring the siege to an end quickly, as he did not
have the necessary forces to conduct a prolonged blockade: it would
take 35,000 men and ten months to force Florence to surrender in

1530. One also needed to account for the possibility of Micheletto Attendolo's troops arriving from the south, and if he'd undertaken a siege, Piccinino would risk finding himself caught between the hammer of Florence and the anvil of its reinforcements. Furthermore, although he still hoped to secure a regime change in Florence, Piccinino's main objective was not to threaten the March of Ancona so as to force Francesco Sofrza to leave Lombardy. At this point, the greatest problem Visconti's forces faced was the lack of an adequate logistical base, and Piccinino thus experienced a great deal of joy and relief when he received a letter from Francesco Guidi da Battifolle, the Count of Poppi, inviting him to come to the Casentino. The reasons for the invitation were Guidi's hatred towards Florence for certain wrongs he'd suffered in the past and the fact the Florentines were planning to turn his lands into a curacy. He also added that, besides offering Piccinino a refuge in the Casentino, he would also be placing all his provisions at his disposal.

The roots of the Count of Poppi's decision ran deep. Francesco Guidi hailed from one of the most illustrious Tuscan families, whose progenitors, according to legend, were the beautiful Gualdrada, the daughter of Bellincione Berti dei Ravegnani, and Guido, to whom the Holy Roman Emperor Otto IV had given the Casentino as a fief. The Emperor had also given Guido Gualdrada's hand in marriage, after she disdainfully refused to surrender her virtue to the august sovereign in exchange for material benefits for her impoverished clan. As it happens, Gualdrada dei Ravegnani did in fact marry a Guidi, but her husband's family had already ruled the Casentino as a fief for at least a century and a half before Otto's arrival in Florence.

The Guidis' relationship with the Commune had oscillated be-
tween conflicts and alliances, and in turn the Commune had always
viewed the presence of such a large fief so close to the city with both
suspicion and apprehension. Throughout the course of the century,
Florence had whittled away the Guidis' possessions by way of wars
and treaties, and in 1357 had forced them to become vassals in per-
petuity to the Commune. Although they'd seen their autonomy
radically curtailed by this act, the Guidis had the advantage of being
inserted into the political-territorial system, and this paradoxically
allowed them to build up a network of personal contacts and pre-
serve their lands by appearing loyal to their new masters.

Despite the fact that the Guidis generally served Florence faith-
fully, from time to time dispatching military contingents to aid the
Commune and entertaining friendly relations with some of Flor-
ence's most prominent personalities, there were still tensions be-
tween the two camps. In March 1398, Count Roberto Novello was
arrested and imprisoned for a few months in the Stinche gaol under
suspicion of having conspired with the Commune's enemies. Once
he was released, Roberto did actually ally himself with Gian Gale-
azzo Visconti, out of either spite or self-interest. There was a wide-
spread belief among the lords of the Apennines that the Duke of
Milan would ultimately prevail in the fight against Florence, and as
a Florentine once wrote, 'presuming that we would have to submit to
him,'[104] they had tried for years to join the side that would most likely
win, to help them preserve their territories.

Roberto Novello succumbed to the plague in June 1400, leav-
ing his under-age son Francesco as his heir on the condition that

he renew his loyalty oath to Florence. This was probably why the Commune did not immediately try to annex the Casentino; besides, with Gian Galeazzo at the gates of the city, the Florentines needed all the allies they could get. Nevertheless, the fact Francesco Guidi was a minor allowed the Commune to exercise strict control over his territories, and Florence acquired the habit of dispatching civic and military plenipotentiaries there. Even when Francesco came of age, Florence's guardianship over the Casentino showed no signs of relenting, forcing the count to conduct himself carefully and to try to widen his network of personal contacts as much as possible. Closely linked first to Maso and then to Rinaldo degli Albizzi, Francesco also succeeded in working himself into the inner circle of Florence's Bracceschi. Moreover, Guidi had the chance of coming into contact with Braccio da Montone and a few of his captains, probably during the condottiere's stay in Tuscany in the summer of 1415, or when Braccio reconciled with Pope Martin V in Florence in February 1420. It's also possible that Francesco had fought with Braccio da Montone when he had served Florence during its war against Ladislaus of Naples, and he certainly fought alongside Braccio's nephew, Niccolò Fortebracci, during the Volterra rebellion in 1429. The importance of having the Count of Poppi as a friend couldn't have been lost on Montone: the Casentino was criss-crossed by important routes of communication that led to the Adriatic coast, the Romagna and Umbria; therefore, it wasn't in the Lord of Perugia's interests to have Guidi as an enemy. On the other hand, Guidi could consider his close relationship with the Bracceschi a means to loosen Florence's suffocating grip on his affairs, so

much so that in October 1434 he married his daughter Ludovica to Fortebracci.

Unfortunately for Francesco, the marriage took place at the wrong moment. Cosimo de' Medici's return to Florence in September of that year, followed by Rinaldo degli Albizzi's exile a few weeks later, triggered a reshuffling of political cards in Florence, and inspired the Count of Poppi to work his way into the graces of the Commune's new leader, and to deny the rumours that implicated him in a plot to help the exiles return to Florence. In February 1435, the Count of Poppi voiced to Cosimo his complaints regarding the arrogance of the Florentine commissioner to the Casentino, despite having already made himself clear to Luca degli Albizzi, Rinaldo's pro-Medici brother, and Piero Guicciardini, one of the Bracceschis' representatives in Florence, who'd been dispatched by the Commune to determine where Guidi's allegiances lay.[105] Guidi even tried to propose himself as an intermediary between Francesco Sforza, who was friends with Cosimo, and Fortebracci, who'd been waging an aggressive campaign against Pope Eugenius IV in central Italy at the time. The count's mediation efforts failed, as did his attempt to marry one of his daughters to Piero de' Medici, Cosimo's eldest son. At first, Medici hadn't looked unfavourably upon the match, but he had been dissuaded by his allies, the most authoritative of whom had been Neri Capponi, despite the fact that Capponi was on good terms with the count, in addition to being one of the principal exponents of the Bracceschi in Florence. Capponi had obviously borne his father's warning in mind: 'Every lord who is close to you, no matter how petty, is your enemy, so long as he doesn't need to be your friend: so

beware of joining forces with them because they could take a knife
to your throat and do whatever they like with us and our posses-
sions.'[106] By marrying into the Guidi family, Cosimo, already bound
to the powerful Bardi clan, the feudal Lords of Vernio, would have
compromised his standing in the city, and so, much to the count's
disappointment, he decided that the game wasn't worth the candle.

Acquainted with the wheeling and dealing of politics, Francesco
Guidi grudgingly swallowed this defeat. What proved more difficult
for him to accept was the Commune's behaviour in the events that
took place shortly thereafter. Niccolò Fortebracci was killed in battle
in August 1435, and the count took advantage of the situation by try-
ing to pull off what he thought was a masterstroke. Without wasting
any time, he seized control of the papal city of Borgo Sansepolcro in
the Val Tiberina, which was already held by Fortebracci, with the
excuse that he needed to protect his daughter's dowry, given that
she was now a widow. Knowing full well that Florence longed to
strengthen its border with Umbria, Guidi offered Borgo Sansepolcro
to the Commune, a proposal that was nevertheless flatly rejected:
the Florentines did not want to incur the Pope's wrath and they in-
formed the count that he better not dare hold on to Borgo Sanse-
polcro as a personal fief. Thus scorned, Francesco subsequently tried
to secure himself a hefty compensation from Eugenius IV, always
claiming it was part of his daughter's rightful dowry; but once again
his proposal was rejected outright and his Florentine friends warned
that he could in no way expect to receive the Commune's military
backing in the event of a conflict with the Pope, which was exactly
what occurred shortly thereafter when Vitelleschi arrived in the

Casentino at the head of many soldiers. Having quickly conquered Pratovecchio, the prelate offered it to the Florentines, who accepted it only after Vitelleschi threatened to torch it, and once they'd secured the Pope's permission to give it back to Guidi at a later time. Although Francesco immediately agreed to forsake Sansepolcro, he would have to wait another two years before regaining possession of Pratovecchio, and was furthermore subjected to the humiliation of going to Florence with his sons to personally defend his claim and to solemnly renew his oath of fealty to the Commune; and in addition to the conditions that had already been imposed on his father and grandfather, Francesco also had to promise not to give sanctuary to the anti-Medici agitators who'd been banished in 1434.

Suspicions linger that Guidi had renewed his relationship with Rinaldo degli Albizzi for some time, as Machiavelli would later sum up: 'Nevertheless (so powerful in men is the love of party) no benefit and no fear could make him forget the affection he had for Messer Rinaldo and the others who were important in the late government.'[107] If this was true, this claim would cast a different light on the letter the count had sent to Piccinino: in other words, Francesco would have already gone over to Visconti's side prior to his invasion of Tuscany, having been prompted to do so by his old friendship with the Perugian condottiere as well as by his resentment towards the Florentines. Nevertheless, the facts tell us that Guidi's decision to ally himself with the Milanese had been a by-product of the situation at hand, and not the result of a master plan. When Piccinino arrived in the Romagna in the spring of 1440, Florence hastened to nominate Francesco as the commissioner for the Casentino, and the count diligently

carried out his duties at least until the end of April, keeping the Dieci di Balìa apprised of the movements of enemy troops. But the count's belief that Visconti would ultimately prevail led him to join forces with them, even though his son Luchino had advised him to be cautious. For the sake of appearances, Guidi resigned his post as commissioner of the Commune and prepared to welcome his new allies.

The count's defection proved to be a blessing for Piccinino: not only had he at least temporarily found a solution to his supply shortages, but thanks to his new base in the Casentino, he could also threaten Florence from both the east and the south, and obstruct the flow of victuals from the higher Valdarno. Moreover, the presence of a large Milanese army in the vicinity might have induced Arezzo to rise up against Florence's hated domination, the failed conspiracy of 1436 having inspired hopes in that regard. Niccolò aimed to wreak as much havoc as he could in Florence's territories, relying as usual on the assumption that the Medici regime would implode, thus leading, among other things, to the dissolution of the council that had been convened there. But Piccinino also had other objectives. He had never disguised his own territorial ambitions, and Perugia was less than a hundred and sixty kilometres away from Poppi. As the heir of Braccio da Montone—at least in his mind—and a native of that city, Niccolò could still hope to become its lord and create his own state in the same way Francesco Sforza had done with the March of Ancona, especially considering the hostility that most Perugians felt towards the papal government. In the end, controlling the southern access routes to Florence would have allowed the condottiere to halt the progress of both papal troops coming from the

Lazio and Micheletto Attendolo's from the March of Ancona, which was why he dispatched a strong contingent of soldiers to the Aretino and the Val Tiberina. But Attendolo was already a step ahead of him, and Piccinino could now only hope to stop the advances of the papal armies, which were led by Eugenius's new commander in chief, the energetic and ambitious papal legate and Patriarch of Aquileia, Lodovico Trevisan.

Trevisan was in many ways cast in the same mould as the deceased Cardinal Vitelleschi. Born to a Venetian physician in 1401, Trevisan had followed in his father's footsteps and had become the personal doctor to Cardinal Gabriele Condulmer shortly before the latter ascended to the papal throne. Nominated as the new Pope's *cubilaricus* (chamberlain), Trevisan opted to give up his medical practice for the far more lucrative career of a clergyman. Made canon of Padua's cathedral and then Bishop of Traù (present-day Trogir in Dalmatia, a see which he was careful to avoid taking up personally, choosing to let a vicar rule it in his stead) in 1437, Trevisan was appointed Archbishop of Florence, and became one of the most influential members of the papal court. A learned man with refined tastes, Trevisan was friends with humanists such as Niccolò Niccoli, Francesco Barbaro and Cyriacus of Ancona, but politics was the field in which he excelled. Closely linked to Cosimo de' Medici, Lodovico was the privileged interlocutor between Venice and the Papacy, and in December 1439, he became the Patriarch of Aquileia, a seat which had been left vacant a few months earlier, for the express reason that the Venetians considered him a persona grata. Nevertheless, the Serenissima was not willing to cede territorial jurisdiction of

the Friuli over to the new patriarch, even though it was his by right, and thus on February 13, 1440, the Venetian Senate offered him the spiritual-temporal *podestà* of Aquileia, San Daniele and San Vito, in addition to an indemnity of 3,000 scudi to compensate him for the lost income of other territories. Despite Eugenius being rather vexed by Venice's actions, as Trevisan had other fish to fry, he decided to bide his time and not defend his claim. Appointed Camerlengo of the Holy Roman Church in January, Trevisan had taken over the imprisoned Vitelleschi's role as the papal legate for the Church's territories by the end of March.

The patriarch was no soldier, but it didn't take him long to cut his teeth on that front. As soon as news spread that Cardinal Vitelleschi had died, the city of Corneto, the cardinal's place of birth, fell prey to civil unrest, leading Pietro and Bartolomeo Vitelleschi, the cardinal's nephews, to seek refuge in Civitavecchia, together with some rebels from Corneto, taking with them approximately 300,000 scudi and precious stones which had formerly belonged to their uncle. Trevisan came to terms with the city—although he wasn't able to prevent his soldiers from looting it—but the citadel held out until the end of the year. In any case, the patriarch had no intention of getting mixed up in a strenuous siege of Civitavecchia, and so, having left a few hundred soldiers to keep the situation under control, he headed north to Tuscany. He had taken care to come to terms with Count Everso dell'Anguillara, who'd already been loyal to Cardinal Vitelleschi, allowing him to keep all of the property he'd been able to snatch in the wake of the latter's death, worth approximately 1,445 scudi, to make up for the balance of the salary he was owed. Trevisan

knew how to go about things, given that it would have been very dangerous to leave a hostile Anguillara behind in his fortress of Ronciglione (Viterbo), as the powerful condottiere was well-placed to block communication routes between Rome, Umbria and southern Tuscany, or even cause considerable problems in case the patriarch decided to settle his scores with the Cornetanis. Indeed, there were rumours that the camerlengo intended to do just that, in the manner Vitelleschi would have done, and on this note, the Venetian diarist Marin Sanudo observed, not without apprehension: 'People kept saying that the Patriarch of Aquileia had gone with the people paid by the League to Corneto, just as though he was Cardinal [Vitelleschi] at Foligno. May God help us.'[108]

However, Trevisan had to tackle several problems more important than bringing the Cornetani to heel. He had received pressing invitations from the curia in Florence to come to the aid of the Florentines, and even though we don't know which route he took to get to Tuscany, it's quite likely that he would have gone by way of Arezzo. Crossing Siena's territories would have been risky: Siena was always on the verge of joining Visconti's side, and there had also been a dispute between the Sienese republic and the Papacy for the hospitality it had given to Bartolomeo Vitelleschi, who'd managed to flee Civitavecchia, taking part of his uncle's treasury with him. By using the road along the Tyrrhenian coast, Trevisan had also had to contend with the hostility of the Lord of Piombino, Iacopo II Appiani. The fact remains that Trevisan avoided a clash with Piccinino's troops and reached Florence with a sizeable army by June 13. But by that date, Visconti's condottiere was no longer in the Casentino, hav-

ing begun a new campaign to satisfy his own territorial ambitions.

Piccinino's campaign in the Casentino hadn't fared all that well. He had easily captured the feebly defended castles of Bibbiena, Borgo alla Collina, Pitiano (near Vallombrosa) and Romena, but he had gotten bogged down under the walls of Castel San Niccolò, held by the fierce constable Morello da Poppi, with his company of 120 foot soldiers. The Milanese suffered due to the lack of heavy artillery at their disposal: Piccinino's army was an agile force, suitable to moving rapidly and carrying out conquests by simply deploying its forces or issuing lightning-fast attacks. Yet when faced with a castle determined to resist, there was little Piccinino's locally built catapults could do compared to the destructive power of the defenders' bombards. Visconti's forces spent almost a month under the walls of Castel San Niccolò, with Piccinino's frustration becoming more palpable by the day, exacerbated by the defenders' constant sneering at the besiegers from their ramparts. Even though he'd had plenty of opportunities to personally verify what little truth there was to the alarmist rumours circulating in Florence, Giovanni Cavalcanti writes that whoever was captured trying to flee the castle would be interrogated and then blasted out of a *briccola* (catapult), 'getting smashed up until mothers could no longer recognise their children, nor wives their husbands.' Neri Capponi tells us that this torturous treatment had only been applied to Bartolomeo del Bolognino, a corporal from Pistoia captured at Romeno, but the information gathered at the time by Florentines tells us of a few more people subjected to the *briccola*.[109] Piccinino's atrocities had actually formed part of his retaliation for the massacres the Florentines had perpetrated against

the defenders of the Torre di Vaglia, who'd been put to the sword after having surrendered. When Piccinino had learned the news, he'd taken the soldiers he'd captured at Romena and sentenced those who belonged to the Cancellieri faction to hang, while freeing those of the Panciatichi faction. Far from being gratuitous, these acts of revenge served a psychological purpose: by executing the followers of the Cancellieri, Piccinino—and above all Rinaldo degli Albizzi—wanted to send the people of Pistoia a very specific political message.

Despite Piccinino having proceeded to capture and loot other castles in the Casentino, the Milanese shortage of supplies was beginning to reach critical proportions once again. After little more than a month, Visconti's army had eaten its way through all the produce of the area, and once Castel San Niccolò finally surrendered on May 24, the castle was found devoid of all munitions and foodstuffs. Castel San Niccolò's resistance had, however, allowed the Florentines to obtain abundant stocks of victuals to reach the city, and also to strengthen their army. On May 21, many veteran soldiers and 400 crossbowmen sent by Genoa entered the city, where they were greeted by jubilant crowds. The troops were crucially important reinforcements (the Genoese were deemed to be the finest crossbowmen in the world). Micheletto Attendolo's company had also just arrived from the March, its numbers having swelled thanks to a few of Sforza's contingents. Although the allied army could do little to curb the advances of the Milanese and aid Castel San Niccolò, now that the allied army's numbers had increased, it could still act as a deterrent against any eventual Milanese attempts to push towards the lower Valdarno.

Now, aside from the presence of Visconti's forces on their ter-
ritory, the Florentines' greatest problem was the rivalry between
Micheletto Attendolo and Pietro Giampaolo Orsini; as Orsini had
been Captain-General of the Commune a few years previously, he
was quite displeased to be under the command of a representative of
the Braccescho school, and given recent events, there was reason to
doubt his loyalty. Under these circumstances, organising offensives
in the Casentino became a very difficult task for the Florentine com-
missioners Neri Capponi and Piero Guicciardini. As though that
weren't enough, Capponi had also had to contend with the Floren-
tine government's indecision about the best strategy for dealing with
Piccinino. Capponi wrote earnestly to the Dieci di Balìa to persuade
them not to abandon Arezzo, which, he wrote, 'I judge to be at the
top of your priority list when it comes to Florence'; still, he added,
'you should let me know your opinion, and I will follow it.'[110] Mind-
ful of the failed rebellion that had taken place four years earlier, Cap-
poni knew full well that once the Florentine garrison left Arezzo,
its inhabitants would waste no time in opening the gates of the city
to Piccinino, and at that point, Siena would hasten to do the same.
The Florentines were aware of the preliminary meetings that had oc-
curred between Siena and Milan, thanks to the fact that a messenger
from Siena was captured while on his way to the Milanese camp.
In the meantime, Neri Capponi continued to ask for victuals and
money for the soldiers, thereby hoping to help Castel San Niccolò.

Administrative and political delays frustrated Capponi's ambi-
tions, and thus Castel San Niccolò was abandoned to its own fate. To
top it off, the League's troops took advantage of their commanders'

weakness and looted Florentine lands just as the Milanese had, often causing more damage than the latter. Their motivation wasn't violence so much as basic, immediate needs: the soldiers' pay was in arrears, so much so that Micheletto Attendolo had to threaten, on more than one occasion, to withdraw from the campaign if he wasn't paid what he was owed.[111] The only one who seemed able to maintain discipline among his soldiers was Niccolò Gambacorti, a condottiere from Pisa, who, besides keeping his men under control, also organised a few harrying sorties against the Milanese. All this offered little solace to the Florentines, who'd meanwhile learned the news of another defection in their camp. The Commune had sent Agnolo Acciaioli with 15,000 florins to hire the mercenary company of Borso d'Este, the illegitimate son of Niccolò III d'Este, Marquess of Ferrara (whose numerous offspring had given rise to the saying: 'Everyone had a kid with Niccolò / on either side of the river Po'). However, as soon as Borso pocketed his money, he had switched to Filippo María Visconti's side, 'claiming that the Republics didn't pay well and were always late, and that it therefore wasn't in his troops' interest,'[112] and justifying his misappropriation of those funds with the excuse that his father boasted of substantial credit with Florentine banks. As Giovanni Cavalcanti would bitterly comment: 'And so our enemies' forces grew thanks to our money; and he [Acciaioli] showed just how far back the betrayals of the House of Este went.'[113] But the Florentines only had themselves to blame for their intrinsic weakness when it came to matters of war, and as for Borso, his decision to throw his lot in with Visconti, who at least that time appeared likely to emerge as the winner, was a means

to safeguard Ferrara's independence from Venice's expansionist aims.

Piccinino had in the meantime started to tire of having to pull the count's chestnuts out of the fire in a campaign that was starting to prove mostly favourable to Guidi. Consequently, Piccinino announced his intention to leave the Casentino in early June so as to head towards the Marche, which had been his declared goal from the start. When Guidi tried to dissuade him, promising him that new conquests would restore his supplies and telling him that without Visconti's military backing he would be left exposed to the Florentines' inevitable reprisals, 'as Niccolò had looked at the country and the places' he'd replied with ineffable logic: 'Count, Count, my horses can't eat stones.'[114] Thus, after conquering the castle of Rassina, Piccinino took the road to the Val Tiberina, ravaging the Arezzan countryside along his way, and then, in the vicinity of Borgo Sansepolcro, he reconnected with the troops he'd sent ahead in a vain attempt to bar the path to Trevisan and Attendolo's forces. From the Borgo, one could see the fortified village of Anghiari from a distance, and perhaps Piccinino had spared a thought for the defeat the Florentines had suffered under those very walls fourteen years earlier when he'd been in the service of his present enemies.

Despite the fairly disappointing results, Piccinino had nevertheless managed to divert a good number of enemy troops away from the Marche, and an attack in that direction could therefore prove successful enough to force Francesco Sforza to leave Lombardy to save his own possessions. However, Piccinino had even more immediate goals in mind, which, although they culminated in the

conquest of the March of Ancona, had their roots in a strong personal interest. Any future campaign would require good re-supply bases, and Piccinino had one in mind which could above all help satisfy his ambition to rule a state of his own. As previously stated, Perugia was perfectly suited to those logistical and political needs, and the condottiere's aims were strongly favoured by the fact that since 1438, there had been a strong pro-Visconti contingent in the castle of Montone, forty kilometres to the north of Perugia, led by the young but determined Carlo Fortebracci, son of Piccinino's old teacher, Braccio da Montone. Over the course of the previous summer, Carlo had successfully repelled Cardinal Vitelleschi's attempts to retake the castle and his devotion to the Braccescho cause made him a valuable ally for Piccinino.

Piccinino arrived before the gates of Perugia on June 9, announcing that he wanted to travel through the city to reach Foligno, and that he would return the following day to confer with the city's rulers in regards to this. The *priori* and the papal governor Gaspare de Diano, Archbishop of Naples, were forced to agree to his request given the scantiness of the local garrison, not to mention the popularity that the condottiere enjoyed among Perugia's citizens, many of whom had gone to visit him in his camp eight kilometres to the north. Piccinino entered the city on the afternoon of the 10th at the head of 300 men-at-arms with their retinue, all of whom were armed to the teeth and preceded by six buglers, and, while he arrived as 'though he were at home and like a citizen of Perugia,'[115] he quickly made his real intentions known. That very evening, the condottiere ordered the arrest of the papal treasurer, the Florentine Michele

Benini, whom he accused of embezzlement; the next morning he went with the *priori* to command the governor to go to Florence with a message for Eugenius IV: the Pontiff should keep to spiritual affairs and not get mixed up in matters that concerned the Duke of Milan, or Venice or Florence, and if the Pope agreed to do so, Piccinino would return Bologna and other territories that already belonged to the Church, as well as help him reconquer the March of Ancona. In the event of a refusal, Piccinino threatened to conquer Rome as well as any other ecclesiastical territories that fell within his range. Piccinino's political strategy clearly aimed to detach the Pope from the League and nevertheless allow the condottiere to take possession of Perugia in the same manner in which Francesco Sforza had become master of the March of Ancona. Furthermore, by sending the governor away, Piccinino wanted to rid himself of a nuisance within the walls of the city. *Obtorto collo*, the Archbishop of Naples had no choice but to agree, and he left Perugia on June 14 along with a group of his fellow citizens, who were evidently averse to the new political direction the city appeared to be taking.

On the same day, Piccinino busied himself with consolidating his power: to begin, he forced the *priori* and the *camerlenghi* to cede their prerogatives to the Dieci Commissari (Ten Commissars), a magistracy that had recently been created and to which an eleventh member was personally nominated by the condottiere. Following his orders, the commissioners asked for forced loans, with variable interest rates of 0 to 10 per cent, according to how quickly individual citizens yielded to the request. Thus, in just a few hours, they were able to collect thousands of ducats, but Piccinino's hurry in collecting

all that money, which risked turning the Perugians against him, illustrates just how insecure he felt. Despite the rather warm welcome he'd received from the city, the surrounding lands largely eluded his control. Milan's presence in Tuscany and Umbria was like spots on a leopard, and the position of the spots kept changing. Once the Milanese had arrived, various squires in the Val Tiberina—among them the Lady of Monterchi, Anfronsina Schianteschi—went over to Filippo Maria's side. Notwithstanding, while Città di Castello had done much the same, Perugia decided it would be more worthwhile to remain under Florence's guardianship once the Milanese forces had withdrawn. And although the majority of Perugians were against papal rule, they showed no hurry in openly siding with the ducal condottiere, preferring to wait while the situation developed. Niccolò needed to score a success to stir the hearts of his fellow citizens, and so on the night of June 15, he left Perugia and headed for Cortona. He had had a few preliminary meetings with some of Cortona's citizens who were dissatisfied with Florentine rule and promised him that they would open one of the city's gates for him. Unfortunately for Niccolò, the plot was uncovered, the conspirators were decapitated, and the Milanese forces found the gates of the city shut.

Humiliated, Piccinino decided to recoup his losses by conquering Città di Castello, entrusting his son Francesco with the task of conquering its adjacent fortresses, certain that the previous year's bad harvest would prevent its inhabitants from holding out for long. But the Florentines had already sent the city help in the form of Troilo Orsini da Rossano and Paolo della Molara, the latter having just

returned from Lombardy, where he'd triumphed in battle. Niccolò
had managed to set up camp in order to block access to Città di
Castello, but the two condottieri didn't take this lying down: they
exploited Piccinino's overconfidence by sending a few handpicked
men on horseback through the Milanese camp at a gallop. The men
managed to break through to the inhabited areas of the city and,
though they suffered the losses of several soldiers, they captured
around seventy knights and took them prisoner while they followed
the trail of their more fortunate colleagues. Given the situation, it
was inevitable that Piccinino would retreat to Perugia. Nevertheless,
events had started to take a turn destined to bring Niccolò back to
places with which he was well acquainted, but would probably not
enjoy revisiting due to the bad memories associated with them.

As has been explained, Milan's incursion into central Italy had
at first been a source of serious worries for Francesco Sforza, who
in April had asked his employers for leave to go defend his territo-
ries in the Marche—which was exactly what Filippo Maria Visconti
had wanted. The refusal of the Serenissima's rulers, as well as that
of Neri Capponi and Cosimo de' Medici, to grant this request had
proved prescient, and once the League's position in Tuscany had
been consolidated, Sforza felt sufficiently confident to go on the of-
fensive. While Milanese forces manned the bridges over the Mincio
river, on June 3, Francesco extended a bridge of ships across the river
in order to funnel his army to Lombardy right under the noses of
the Milanese. Making use of the fleet that the Venetians had set up
on Lake Garda under the command of Stefano Contarini, Sforza
rapidly conquered a series of strategically important castles, before

sending a strong contingent to besiege Salò. With nothing barring his way now, Francesco headed towards starving Brescia, which he nevertheless avoided, wary of getting trapped; instead, encouraged by Francesco Barbaro, the stalwart defender of Brescia, he headed in the direction of the Oglio river so as to bar the road to Milan to Visconti's armies, led by Ludovico dal Verme and Taliano Furlano, who'd taken up position at Bassano Bresciano. The duke's captains understood the danger they were in and retreated towards Orzinuovi, blocking the bridge over the Oglio, which was part of the road that led to Soncino.

Reinforced by the troops that had joined up with his army after he'd stormed and looted Salò, Sforza set his wits to trying to flush the enemy out: having reached the vicinity of the enemy's positions, he sent his loyal acolyte Sarpellione da Parma ahead with a few squadrons to engage battle, and, as he'd foreseen, the Sforzeschi were pushed back by Visconti's superior forces and chased right up to the camp, despite the efforts of Ludovico and Taliano, who, having understood Sforza's ploy, had tried to hold their men back. This was exactly what Sforza had been waiting for: as soon as the Milanese were in sight, they were hit by a volley of arrows and gunshots, which, besides causing considerable damage, also broke the enemy's ranks, allowing Francesco to hurl the majority of his cavalry against them. Having been repulsed, the Milanese could have attempted to regroup near the bridge and stood their ground, but panic spread through their ranks, leading to an all-out stampede. Exploiting his advantage, Sforza fell on Soncino, not only capturing the little town, but also Visconti's stores of munitions and the biggest prize

of them all, Borso d'Este. Dal Verme managed to retreat to Crema, while Furlano was forced to hide among the reeds of the Oglio to avoid being captured. The Milanese lost several hundred men—both wounded and killed—in addition to a few thousand soldiers and horses which were taken prisoner. The Florentines had probably grinned at the news of the 5,000 Milanese who'd been captured—Borso d'Este among them—which seemed an apt punishment after Ferrara's betrayal.

With Sforza steamrolling his way through Lombardy, the same turns of events that had taken place earlier in Tuscany happened once again. The terrorised inhabitants of the populous countryside spilled into the cities, taking household goods and livestock with them and causing critical shortages. As though that weren't enough, Filippo Maria Visconti was forced to leave his western and southern borders undefended so as to reinforce his garrisons in the Milanese region. While he watched his troops file past his windows, Visconti dictated an urgent letter to Piccinino, ordering him to return post-haste and defend Lombardy. Piccinino's army was the only intact force still at the duke's disposal, but it was hundreds of kilometres away, and we can well imagine the duke's couriers furiously gallop-ing off to Umbria. As often occurred in these circumstances (which was why several copies of the same letter were usually sent along dif-ferent roads), Filippo Maria's letter was intercepted by the allies, who thus learned that Visconti's masterstroke had not only failed but had also backfired against him.

Piccinino reacted to the duke's orders with the greatest chagrin. He needed time to consolidate his power in Perugia and to conquer

other lands in order to create a sufficiently large state to guarantee his army's upkeep. For this very purpose, he had taken care to begin creating a citizen's militia, issuing a public decree on June 20 that 'all citizens should be at the ready and equipped with their own weapons so that they can immediately go wherever they are commanded to.'[116] Five days later, the Archbishop of Naples returned with the news that the Pope and the Florentines were ready to discuss the terms that Piccinino had asked for previously. Piccinino was too wise not to realise Florence and the Pope were simply trying to buy themselves some time, and their willingness to negotiate would vanish the moment he decided to leave Perugia. Besides, the arrival of an embassy from Siena gave rise to the hope that the latter would join Visconti's side in the near future, thus creating an extended territory that would cut off the major routes of communications running through Italy. But with only Perugia and a few adjacent villages in his possession, Piccinino didn't have the necessary financial resources to strike out on his own, and he couldn't afford to disobey the duke. What's more, several of his Lombard commanders had expressed serious worries over what was happening in Lombardy—not so much out of loyalty to the duke, but due to their fears that Sforza would do as he liked with their possessions. Thus, Piccinino was forced to bow his head, and he very reluctantly left Perugia on June 27 with the entirety of his army, starting on what promised to be a long and, due to the loot they'd captured during their campaign, slow march towards the north. Soon enough, Piccinino's march would proceed far more quickly than he could have imagined.

7

THE LEOPARD'S LEAP

The bearded man laid down his brush and stepped off the scaffolding.

He took up position in the middle of the hall to better observe the fruits of his labours, his nearly completed polychrome composition, which stretched across the entire wall. The enemy condottiere's red cap stood out amidst the tangle of human bodies, and his wide-open mouth was venting a furious scream, seemingly strengthening his raised hand, which brandished a falchion. His wrath was fuelled by despair as he savagely tried to defend himself and the battle standard in his left hand. His opponents appeared just as determined to pry it from his clutches, their frenzy leading them to ignore the risk of being felled by his cutting blows. In the midst of the melee, nobody seemed to notice the two men lying prostrate beneath the horses' bellies as their riders fought over the banner, and even those two didn't appear interested in what was happening above their heads: the first, on the left, was slowly plunging a dagger into his enemy's neck with the greatest calm, while keeping him pinned to the

ground with his steel elbow-pad as life left the victim's mouth, accompanied by an agonising death rattle.

The painter silently recalled all the texts he'd studied, as well as the conversations he'd had with the few greying veterans who'd survived the battle, all of which had proved crucially important in reconstructing the scene as he'd painted it. The enemy's banners were still hanging in the room where he'd been working, a constant reminder of the victory that had helped consolidate a regime that had so fiercely opposed the one that had followed it in both word and deed. There was a touch of irony to the fact that this government had tried to legitimise itself through something to which it was only vaguely linked; still, the continuity between the past and the present couldn't be ruled out entirely, given that the artist's patrons were dealing with similar situations involving different enemies, and they nevertheless considered themselves the heirs of the very liberty that had been saved on what, by then, was a distant summer's day.

Throughout the course of his life, the bearded man had seen too many political upheavals to experience much surprise; besides, who had commissioned the painting didn't matter as much as the possibility of testing out an ancient technique. If his patrons considered themselves the heirs of ancient Rome's civilization, it was now up to him to prove this assumption through his pictorial practice. The regime which had hired him wanted to celebrate a victory from the good old days, but the artist's true triumph would lie in bringing the past back to life in the present.

All in all, one couldn't say that Visconti's campaign in central Italy had been much of a success. Although Piccinino had caused considerable damage to his enemies' territory and reaped a rich booty,

he had nevertheless failed to accomplish the main goals he'd set himself. The presence of Milanese troops in its rural domains had undoubtedly caused Florence ample inconveniences, but there still hadn't been a single anti-Medici uprising to bring about the change of government that Filippo Maria had wanted. Worse, Sforza hadn't taken Visconti's bait when Piccinino had marched down towards the March of Ancona, meaning Francesco had shrewdly decided to keep warring around the Po Valley. But Piccinino wasn't the kind of person to so easily abandon a campaign when the arrival of the harvest season would allow him to extend it (during his siege of Città di Castello the condottiere had ordered all the wheat to be mown from the surrounding fields). Thus, Piccinino had begun his march to the north extremely reluctantly, loath to concede defeat and to let the opportunity to permanently install himself as Perugia's lord vanish before his very eyes.

Somewhere between Città di Castello and Borgo Sansepolcro, Piccinino received word that the allies had pitched their camp beneath the walls of the Florentine fortress of Anghiari. In light of this new development, Niccolò decided to convene a war council, which would later turn out to be a harbinger of momentous consequences. Piccinino offered his commanders two choices: they could either march towards Lombardy or give battle. Retreating was the simplest and least hazardous option, as the Milanese had intercepted the letters that the Dieci di Balìa had sent to the Florentine commissioners Neri Capponi and Bernardetto de' Medici, in which they'd been ordered not to engage the enemy but to follow them from a safe distance until they had left Tuscan soil. In addition, some of Piccinino's captains were troubled by their lack of victuals and were worried that

the Milanese army was about to enter lands that had already been stripped of all supplies by anti-Visconti forces in order to hasten their retreat. They also added that while they were wasting time conquering castles of little importance, Sforza's advances in Lombardy were endangering their families and possessions. Hence, they insisted that Piccinino either first procure all the necessary supplies or else lead his troops back across the Apennines.

On the other hand, Astorre and Guidantonio Manfredi were pressing for a pitched battle, fearful that the allies' army could wreak vengeance on their lands, which lay on Florence's borders, as retribution for the damage done to Florence. The 'devastation' that the allies had inflicted on the countryside around Borgo Sansepolcro and the 'lands of Madonna Anfronsina' had been only a taste of what could happen to Faenza.[117] As the two Manfredis were among Visconti's main allies in the Romagna, their opinion on the matter could not be underestimated; furthermore, the group of exiled Albizzis, who had everything to lose and little to gain should they fail to return to Florence, could only favour a continuation of the campaign. The two lords urged the Milanese commander to seek open battle with enemy forces, stressing the existing divisions in the allied camp. It was a well-known fact that there was bad blood between the commissioners Neri Capponi and Berndetto de' Medici, and that there were also reciprocal jealousies among the various allied commanders, particularly between Micheletto Attendolo and Pietro Giampaolo Orsini, which would undoubtedly worsen with the arrival of the papal armies under the command of Trevisan. A victory by Visconti's armies would weaken the Florentines' position in their rural domains, sparking defections along the lines of Count

Poppi's, and would also probably stir a desire for regime change in Florence and open the road to Rome for Piccinino. If the Perugian condottiere prevailed in battle, it would imply both the success of Filippo Maria's plans and the option to create an independent state of his own in central Italy, meaning Piccinino would triumph where his old teacher, Braccio da Montone, had failed. Piccinino had ulterior motives urging him to consider going into battle, despite the duke's orders to the contrary and the risks that such a decision would entail: the Milanese army was proceeding slowly, burdened by the rich booty they'd reaped in war; if Sforza managed to move rapidly, Piccinino might run the serious risk of being crushed by two of the League's main armies.

The solution the Perugian condottiere proposed was typical of his *forma mentis*, and justifying his fame as a bold commander, he decided 'not to tarry and settled on waging war against the Florentines.'[118] In order to convince his men, Piccinino told them that the enemy camp was well stocked with victuals and there was a good chance they could catch their enemies unawares. To confirm this, on June 28 Piccinino personally led a feeble attack against the allies' camp, which was easily repulsed: 'four lances were smashed, and everybody retreated', as the Florentine commissioners present at the time commented.[119]

Nevertheless, this skirmish enabled Piccinino to test the waters and probe his enemies' defences, even though he had simultaneously put them on alert. But even this had been part of Piccinino's plan, which relied on the assumption that the enemy commanders wouldn't be able to keep their men in a constant state of alert. Niccolò planned to strike the following day, a holiday, when he knew

that the enemy would be off their guard. Another advantage Piccinino enjoyed was that the saccomanni would not be in the allied camp, as they were usually sent to forage for provisions in the mornings, a mission that could lead them several kilometres away from their base and would prevent them from hurrying back in case of need. Still, a full-frontal attack on the enemy camp necessitated a perfect balance between the element of surprise and the speed of execution; without these factors, the allies could exploit their higher ground and their field fortifications, while the Milanese would find the Tiber obstructing their line of retreat.

Arriving at Borgo Sansepolcro on the evening of June 28, Piccinino set up his headquarters and was favourably welcomed by the local people. While the presence of Milanese troops in the city could certainly have been seen as a source of inconvenience for its citizens, it was also a good opportunity to engage in profitable transactions with the needy soldiers. Moreover, the city was coveted by Florence, the Pope, the Vitelleschis and the Dukes of Urbino, so throwing their lot in with Filippo Maria Visconti was also a means for the inhabitants of Borgo Sansepolcro to preserve their independence, at least pro tempore. In addition, there was atavistic and reciprocal hatred between Borgo Sansepolcro and Anghiari, and Piccinino therefore had little trouble recruiting a great number of inhabitants as auxiliaries.

Piccinino's plan was as simple as it was clever, owing to his long experience as a soldier. The majority of his men-at-arms and a small force of handpicked infantrymen would assail the enemy camp, while part of his light cavalry would try to intercept the allied saccomanni

and prevent them from rushing back to their base to help. The most interesting aspect of Piccinino's plan was that the Milanese infantry comprised 'a great many musketmen,'[120] about forty of whom were Germans whom Francesco Sforza had sent to the Florentines and who'd been captured during the operations around Città di Castello. Generally considered to be among Europe's best in their use of firearms, these Germans had joined Visconti's side to save their lives, Italians being capable of just as much brutality as foreigners when it came to outsiders. The musketmen are crucial to understanding Piccinino's plan. Once they'd come into range of the enemy camp, his foot soldiers would fire a volley, and the resulting noise and smoke, coupled with the impact of his men-at-arms, would help to confuse and disperse the enemy's forces.

While gunpowder weapons had yet to become a decisive factor in combat, Piccinino's tactics were part and parcel of the aforementioned 'military revolution'. More significant, perhaps, is that they were a telling sign of Piccinino's innovative spirit. Anghiari and Borgo Sansepolcro were separated by roughly nine kilometres of road, a distance that a foot soldier moving at a rapid pace could cover in just a little over two hours. However, this would considerably reduce the element of surprise, as well as the infantry's operational abilities, which had already been put to the test by marching under the scorching summer sun. One must furthermore add that there was no chance that the Milanese army could slip out of Borgo Sansepolcro unnoticed, as a crowd of several thousand men would raise a cloud of dust that would be spotted from a great distance. But Piccinino had also accounted for this factor. In order to take the

road to the Romagna, Piccinino would have to reach the Bridge delle Forche, which was three kilometres away from Borgo Sansepolcro and was a site for public executions. Therefore, anyone who spotted the Milanese troops on the move would assume that they were heading north, an impression reinforced by the cloud of dust raised by the light cavalry as it split off from the rest of the army. But the Bridge delle Forche was also the starting point of the road that led to Anghiari, which was six kilometres away, the equivalent of an hour and half's march, but which would still take too long for Piccinino's plan to work. The only logical solution, confirmed by the large number of horses present at the battle, was for Piccinino to put his musketmen in the saddle. This was hardly an innovation in itself, since putting foot soldiers on horseback had been a widespread military practice at the time whenever an army needed to move quickly. The use of mounted musketmen also wasn't unusual, as the English archers that belonged to John Hawkwood's company in the fourteenth century had also moved on horseback while on marches, and would simply dismount in the event of a battle. Piccinino's real stroke of genius lay in recognising the true potential of using firearms; by combining his musketmen's destructiveness with mobility, he anticipated the development of the dragoon unit by more than a century, given that tradition holds that it was invented by the Florentine Piero Strozzi around the middle of the sixteenth century. Piccinino's plan was a glaring indication of how warfare in fifteenth-century Italy was in a state of constant evolution, far from a staid repetition of antiquated and predefined patterns.

Having made his preparations, Piccinino waited to leave until the

hottest hour of the day, which occurred around one-thirty or two in the afternoon, when he was certain that his enemies would have succumbed to the midday heat. Ready to do battle, the Milanese troops struck an impressive and colourful sight. The shining suits of armour and groomed horses were draped by tabards and caparisons emblazoned with heraldic themes. Prominent among these was the *radia magna*, the sun in its full splendour, Filippo Maria Visconti's personal emblem, also worn by his lances fournies and the armigers who served the duke's family. Even the individual captains the duke had hired wore their own personal insignia, which the troops assigned to them also wore. Astorre Manfredi's soldiers proudly displayed their *salasso*, the blood-letting instrument that the lords of Faenza had adopted as their symbol at the end of the fourteenth century (given the penchant for burdensome taxation among the Italian states of the time, one could attribute this choice to their twisted sense of humour). The Milanese troops were preceded by their war banners: the Viscontis' child-eating snake, the duke's radia magna, and finally Piccinino's crouching leopard, which had once been used by Braccio da Montone's army. Piccinino could lay a strong claim to the speed and cunning of the beast displayed on his banner.[121]

Everything had been readied, but a thought kept nagging Piccinino at the back of his mind. He had noticed something strange a little earlier, which he hadn't paid much attention to at the time, but which was now making him reconsider his plan. During the march to Borgo Sansepolcro he had seen a large snake leap from one tree to a fig tree, which was then popularly known as 'St. Peter's fig tree'. While making that leap, the snake had impaled itself on a sharp

branch and died on the spot. Beholding the great Visconti banner with its coiled snake, Piccinino asked himself whether that vision wasn't warning him to avoid giving battle on June 29, an ordained holiday in honour of saints Peter and Paul. Yet Piccinino had a justly deserved reputation as a heathen, renowned for having on several occasions compared excommunication to being tickled: some people are ticklish, while others aren't. For that matter, the strategic specifics of this situation had left him little choice, and so, feast or no feast, he could by that point no longer avoid giving battle.

Trumpet calls relayed the order to the Milanese troops, who started to spill out of the walls of Borgo Sansepolcro slowly, so as not to tire out the men and beasts. They most likely took an hour to reach the Bridge delle Forche, and following the commander's orders, the army split into two. Spurring their steeds, the light cavalry headed south-west in the direction of Citerna to hunt for the enemy saccomanni, leaving the heavy cavalry and the infantry to cross the Tiber and trot towards Anghiari. Up until that moment, everything had gone according to plan for Piccinino. Visconti's condottiere expected he would encounter the enemy in roughly half an hour, and he was certain of victory; unfortunately for him, and he should have been well aware of the fact that one couldn't dine at the Tavern of War and reckon without one's host.

The League had pitched its camp in a strong defensive position, on a sloping hillside with the fortified village of Anghiari at its back and a small stream over which lay a little stone bridge that was part of the road that led to Borgo Sansepolcro. In itself, this moat, which was only a few metres wide and roughly a hundred metres away from

the foot of the hill, did not represent a substantial obstacle for any attacking force, as one could easily wade through it at certain points, especially during the dry summer season. Mindful of this, the allies had taken care to steep up its shores, except for a spot alongside the bridge, which served as a passage for livestock and carts. This type of field engineering, while not entirely obstructing infantry movements, could prevent the enemy cavalry from performing an envelopment manoeuvre. The allies had simultaneously levelled out the ground in front of their camp by filling in the irrigation ditches fed by the Sovara stream, but had left those on the other side of the bridge as they were. In this way, while the League's army had the necessary space to form its ranks, the cavalry of any attacking force would find itself boxed in on the only flat terrain available to it, the road, which was only a few metres wide. Furthermore, the allied camp was entrenched behind a stockade of sharpened poles, with a few gaps to allow things and people through, and in some cases, to allow the artillery a clean field of fire. In other words, the way the allies had organised and structured their camp allowed them to feel relatively confident.

Piccinino had played his cards well up to a certain point. Despite the fact that military logic and common sense required that a commander secure himself against any foreseeable risks, one could well say that on that sultry day in June, the allies' army was truly slacking off. The saccomanni's departure had deprived the camp beneath Anghiari of its eyes and ears, and thus to avoid danger the other troops had been prudently lined up in front of the camp for the entire morning. After lunch, the soldiers had been allowed to remove

their armour and retire to the coolness of their tents, since it was deemed unlikely that the enemy would attack on that day, due to the intense heat. Therefore, unburdening themselves of kilos of steel, the allied soldiers settled down to what they rightly thought was a welcome and well-deserved rest.

However, some people weren't sleeping; on the contrary, they kept their eyes peeled, fully aware of how clever and capable the enemy commander really was. Neri Capponi and Micheletto Attendolo were on the alert, their suspicions raised by how easily Piccinino had given up the previous day's skirmish. To play it safe, Attendolo had kept one of his squadrons armed and at the ready. He had definitely spotted the cloud of dust raised by the Milanese troops as they'd left Borgo Sansepolcro, and had probably deduced that Piccinino was trying to buy himself an hour or two by marching against his enemies at that hour. Nevertheless, it didn't take him long to realise something had gone wrong: instead of getting smaller, the cloud of dust was growing visibly. Attendolo immediately understood the peril they were in and reacted swiftly. Together with Capponi, he sounded the alarm, stirring the allied soldiers from their afternoon siesta, then left his distinguished Florentine colleague to ensure all the men had woken up, while he took some men with him and galloped towards the moat, waving the banner of his native Cotignola, which featured blue and white waves on one side and golden quinces on a bed of red on the other. Having reached the little stream, Attendolo blocked off all access routes with some of his men and arranged the others, some of whom were mounted, along its banks to prevent the enemy infantry from breaking through. In any case, if the

rest of the allied forces hadn't arrived, Attendolo would have been quickly overwhelmed since he could not resist the enemy onslaught indefinitely.

Considering the way the battle was unfolding, one could deduce that the allied commanders had had time to settle on a plan of action before Attendolo had left the camp; in fact, Flavius Blondus mentions a secret meeting on the bridge while the allies were already 'within arrow range of the lightly armoured enemies,'[122] which might be a reference to the mounted infantry troops. However, given the speed with which the Milanese were drawing near, at the pace of roughly a kilometre every four minutes,[123] it's far more likely that Micheletto hadn't had time to take part in a war council and had instead reached an agreement with Capponi about how to deploy his soldiers, placing his trust in the Florentine commissioner's authority. The allies had probably simply followed the plans they'd adopted that morning when awaiting the enemy's attack. However, in the midst of the inevitable confusion caused by the alarm, the absence of a guiding hand could have led to complete chaos. We can well imagine the feverish activity in the allied camp, with squires breathlessly sliding armour atop their men-at-arms and tightening it around them, foot soldiers helping each other with their cuirasses and brigandines, while the artillerymen anxiously and carefully loaded their bombards with gunpowder, the clank of steel on steel mixing with screams, curses, whinnies and the sounds of trumpets and other musical instruments.

As soon as Piccinino came in sight of the Bridge delle Forche, he realised, much to his annoyance, that he could no longer count

on the element of surprise, and that, as is often the case, his well-conceived plan had been the battle's first victim. 'While his spirit had been ready to fight at first and had then cooled somewhat,'[124] the Perugian condottiere still wasn't the sort of man to throw in the towel, so he changed his attack plan on the spot, exploiting his numerical advantage. The Milanese army counted approximately 3,500 to 4,000 horses and 2,000 foot soldiers. Only 700 to 800 of his mounted troops were in full armour, and furthermore, part of his light cavalry—an unspecified number, but probably around 1,000 to 1,500 men—had been dispatched to intercept the enemy saccomanni. The same applied to the infantry, since we know that a substantial number of foot soldiers remained in Borgo Sansepolcro to protect the wagons and the war booty that had been accumulated throughout the course of the campaign. Hence, it is reasonable to suppose that Piccinino had roughly 2,500 to 3,000 knights at his disposal, as well as a thousand foot soldiers, most of whom were musketmen. To these one should add a few hundred citizens of Borgo Sansepolcro, who'd been recruited as auxiliaries or manual labourers. The chronicles mention that roughly 1,500 citizens were present at the battle, but this figure seems to have been exaggerated. A century after the battle, the city of Borgo Sansepolcro had just slightly over 5,000 inhabitants, and adult males couldn't have accounted for more than a third of that total. Given that a great many of them would have been too old, or simply didn't have the stomach for battle, we can safely assume that the number of Borgo Sansepolcro's male citizens at the battle would have been around 500 (to which one could perhaps add a few dozen women who'd been employed to provide logistical

support), a number confirmed by the Florentine commissioners in a letter to their government.[125]

But the allies capitalised on the scant forces at their disposal by repelling the first wave of Piccinino's attack, with only a couple of knights sufficient to block the bridge. At that moment, Piccinino had fifty men on horseback and perhaps as many on foot. Time, however, was not on his side, and if he hadn't been able to break through the enemy's ranks quickly enough, matters might have taken a turn for the worse, especially given that not all of the allied troops had completely removed their armour, and thus could rapidly prepare themselves for battle. In addition, it was roughly three-thirty in the afternoon by then, and while summer days were long, the coming of night after a prolonged battle would nonetheless put the Milanese army in a difficult situation, preventing it from exploiting any eventual advantages or, in the case of defeat, making a retreat fairly difficult.

Piccinino launched his knights on the offensive, sending his son Francesco's troops and those of Astorre Manfredi ahead, as they were probably his strongest squadrons. The tactic Piccinino employed was the one that Braccio da Montone had pioneered, which involved rotating his squadrons rapidly in order to keep constant pressure on the enemy with fresh troops. Well aware that Braccio had defeated Carlo Malatesta at Sant'Egidio by exploiting his enemies' thirst—warring being one of the most dehydrating experiences known to man, especially in the summer heat—Piccinino had deployed a number of women, including some from Borgo Sansepolcro, at his rear, to carry barrels of water to provide some refreshment for the soldiers.

Attendolo's men bore the brunt of the Milanese army's formi-
dable assault. The collision of the two forces produced a cacophony
of lances being shattered and metal plates being struck. Attendolo
bravely resisted the impact and also managed to repel his assailants.
It's quite likely that Piccinino had foreseen Attendolo's moves (in the
poem *The Captain's Flight*, the ducal condottiere tells his son Fran-
cesco to 'use every skill, my man / to lure him from the bridge if you
can'[126]), since when Attendolo tried to move through the heat of the
battle, he found himself assailed by other Milanese squadrons and
was forced to retreat, repulsing the enemy until he'd reached the foot
of Anghiari's hill. Piccinino managed to quickly take over the bridge
and the ford, but by this time the papal troops of Simonetto da Cas-
tel San Pietro had arrived to lend Attendolo a hand, and thanks to
them, the allies were able to avoid their weak defensive lines being
breached. Piccinino hadn't had sufficient time to shift enough troops
to the other side of the stream, and Simonetto's arrival forced him
to retreat back over the bridge. Meanwhile, small groups of allied
foot soldiers entered the fray to support their comrades-in-arms, who
were already engaged in a fierce battle with their enemy counterparts
on the banks of the stream. The newcomers featured a few of Ang-
hiari's inhabitants (who'd been drawn to the fight by their hatred for
the citizens of Borgo Sansepolcro rather than by their loyalty to Flor-
ence), among them the blacksmith Renzino di Menco della Valle,
who is said to have killed and wounded many enemy soldiers using
only a spontoon, and 'who was thus thereafter known as Renzino the
Spontoon' and enjoyed his fellow citizens' respect and esteem for as
long as he lived due to the valour he had shown on that day.[127]

Piccinino redoubled his efforts, sending additional squadrons to help Manfredi and his son, simultaneously increasing his own troops' efforts. This move achieved the desired effect: the Milanese managed to cross the moat and outflank their enemies. Simonetto and the newly arrived Pietro da Bevagna moved their troops to address this new peril at the cost of creating a breach in the allies' ranks. Niccolò immediately exploited this advantage, launching fresh troops into the fray and managing to recapture the passages over the stream as well as the allied condottiere Niccolò Gambacorti. Attendolo was nearly taken prisoner himself and was only saved by Pietro Giampaolo Orsini's timely arrival. Orsini's intervention temporarily stabilised the situation, with the allies even managing to free Gambacorti, but the Milanese offensive proved too strong and the allies were obliged to retreat step by step back to their camp. The attackers' frenzy was such that they pummelled one another with their steel gauntlets once their swords, lances and war hammers broke—a detail that left a profound impression on the historians and chroniclers of the time.[128]

Having crossed the moat in full force, the Milanese could now deploy their troops on the ground that had been drained and levelled by their enemies, who now risked being crushed in a steely vise. Piccinino only had to keep up the pressure to carry the day, but, by this point, his troops had come into the deadly range of the Genoese crossbowmen, who were lined up on the slopes at the rear of the allied camp. A constant shower of bolts rained down on the Milanese, penetrating the infantry's light armour, piercing through body parts unprotected by steel, and wounding and felling horses. Shielded by

their tough cuirasses, the Braccheschi men-at-arms didn't suffer excessive losses, but the Lombard infantry and light cavalry suffered the heaviest casualties. The allies also managed to drag their bombards out of their camp, and although these were slow and imprecise, they proved devastating at short range. The cannonballs tore bloody breaches through the Milanese ranks; or, by shattering on impact, could send splinters of stone hurling through the air in all directions. There are descriptions of a single shot killing two or three armigers and their horses at once.[129] The devastating effect of heavy artillery against concentrations of troops would later be aptly described by a witness present at the battle of Ravenna: 'It was scary and terrible to see every artillery shot cut into those people, sending helmets with heads still inside them, pauldrons and torsos flying into the air.'[130] Even though sixteenth-century artillery had greater destructive powers than that of the fifteenth century, the battle of Anghiari presaged what war would soon have in store for mankind.

Crossbow bolts and cannonballs had the effect of slowing down the Milanese offensive, and the battle transformed into an exhausting melee. After throwing aside their lances, soldiers began fighting with swords, daggers, steel maces, and war hammers in a struggle that recalled the one depicted in Paolo Uccello's *The Battle of San Romano*. One of those strange phenomena that sometimes happened during battles also took place: the only sounds that could be heard were the clashing of weapons, while the fighters kept silent and 'onlookers thought it was a miracle that they couldn't hear the usual shouts and insults.'[131]

Trevisan had meanwhile succeeded in regrouping the remnants

of the papal forces, assisted by the Florentine commissioners. Reports written at the time give one the distinct impression that the responsibility for directing the battle fell upon their shoulders, which would be logical given the way in which the clash had started for the allies. Realising the gravity of the situation at the camp's gate, the Florentine commissioners, and in particular Bernardetto de' Medici, convinced the hesitant patriarch to send his troops into the fray after having arranged them into a wedge formation. The incline of the terrain increased the momentum of the papal charge, making it possible for the allies to push the Milanese back to the bridge. The gradual arrival of fresh enemy soldiers was neutralising Piccinino's numerical superiority, while exhaustion was beginning to infect his ranks. Another disadvantage Piccinino had to contend with was the inferiority of his horses, which, like all of Visconti's horses, were originally from Germany, and still hadn't sufficiently recovered their strength from the ordeal of seeing through the winter and spring; on the other hand, the allies' mounts were from Puglia and Calabria, meaning they were at the peak of their strength, and also better suited to warmer climates.

The outcome of the battle remained dubious. Both sides had employed most of their troops and were waiting for the right moment to send their reserves into the fray. The commanders constantly exhorted their men to make a last-ditch effort, and Flavius Blondus transcribed Attendolo's and Piccinino's incitements with verbal flourishes worthy of Livy's finest prose; but it's more likely that the various condottieri's instigations were peppered with obscenities in the Emilian, Perugian or Roman dialects. It was almost six o'clock

in the evening by then, and after three hours of fighting, both sides seemed on the verge of giving up. Piccinino decided that it was the right moment to make his final move: once he gave the sign, thirty trumpeters ordered the entire Milanese army to go on an all-out assault in an attempt to break through the enemy line. Piccinino had switched from the Braccescho system of rotating his squadrons to the Sforzescho large-scale assault, displaying not only his operational flexibility but also his troops' discipline. If the Milanese troops hadn't been so worn out, such an unexpected change of strategy would have led to fatal confusion among allied forces.

However, this time Piccinino had miscalculated. The allies not only withstood the brunt of the assault, but also managed to counter-attack. Given the situation, Astorre Manfredi moved forward on his own initiative to slow the enemy advance, thus forcing a breach in the Milanese lines: 'Astorre wanted to stop the enemy force / while sitting atop his horse' as the Perugian poet Lorenzo Spirito Gualtieri, who'd been fighting for Piccinino at the time, put it.[132] Piccinino would later claim, not without justification, that the Lord of Faenza's move had cost him the battle, because Astorre soon found himself isolated and surrounded by enemy troops: in this instance, the outcome of the battle had been decided by a loose horseshoe.

The battle turned into a furious struggle, with dozens of casualties. Fighting against a larger force, while personally assailed by thirty enemies, Manfredi continued to resist until a spear pierced him just below his groin—in what at first appeared to be a fatal wound—and the Lord of Faenza wound up being captured by Gambacorti. Thanks to his expert eye, Orsini deemed that the moment

had come to call up the reserves, and he hurled them against the Milanese's faltering lines and pushed them back over the bridge, the allied attack strengthened by the arrival of the saccomanni, which the light cavalry had failed to intercept. Despite their fatigue and the numerical inferiority of his troops, Piccinino managed to reorganise his ranks and to hold out for another half hour, aided by the fact that his auxiliaries from Borgo Sansepolcro had meanwhile managed to fill in the ditches on either side of the road as best they could. But now Piccinino also had to contend with the forces of nature, since while the wind had first blown in their favour, it had now suddenly changed direction, blinding them with a cloud of dust.

Niccolò could no longer ask anything more of his exhausted men; several of the Bracceschi veterans had concluded that sometimes bravery had to give way to prudence, and some had already started to slip out of the battle on the sly. The human trickle suddenly turned into a flood as the Milanese line collapsed in one fell swoop, with his soldiers beginning a headlong rush back to Borgo Sansepolcro shouting 'to the saddles, to the saddles!'[133] Alongside his son Francesco and Guidantonio Manfredi, Piccinino managed to rally some of the stragglers and organise a fairly orderly retreat, trying to save themselves—and above all, their banners. Possession of the banners had been the cause of the battle's final and most brutal clashes, and despite the Bracceschis' desperate attempts, the allies managed to capture Visconti's personal standard, while Attendolo took Piccinino's own. Fighting a rearguard action throughout the retreat, the ducal condottiere finally managed to find refuge behind Borgo Sansepolcro's walls, but the majority of his men were either captured

or felled by allied weapons. Among the casualties were about sixty women who had been assigned to transport water and were trampled by the allied horses as they gave chase. Piccinino and his squadron owed their deliverance to the coming of night, which was darker than usual due to its lucky coincidence with a lunar eclipse. Having arrived in the city, Piccinino found the light cavalry units he'd sent to intercept the enemy saccomanni, and fearing an allied attack under cover of night, he reinforced the sentries on the walls and at the gates, ordering them to keep him informed of all developments every fifteen minutes.

His fears turned out to be unfounded, insofar as the allies had neither the desire nor the willpower to undertake other campaigns. With Attendolo's support, the Florentine commissioners insisted (in vain) that they should exploit their advantage to the fullest, but by then both the mercenaries and Anghiari's citizens were purely interested in the enormous booty that had been abandoned on the battlefield, or captured during the Milanese retreat. Given that he'd been forced to abandon his wagons outside the walls of Borgo Sansepolcro, Piccinino had lost all the rewards he'd reaped during his previous raids. Attendolo himself would later complain of the allies' frenzy in accumulating all those spoils since it had led to a breakdown of discipline which could have led to disastrous consequences: there was a risk that Piccinino would take advantage of the mayhem to counter-attack, and in any case, 'roughly three hundred horsemen had been lost because some of them tried to drag three or four carts away from the enemy, and not only lost them, but were themselves captured in their turn.'[134]

In any case, the number of prisoners captured by the allies was impressive. Once the clangour of arms had abated, the Florentine commissioners took care to provide their government with a detailed account of what had transpired at Anghiari, emphasising the sheer vastness of the booty reaped—between 300 to 400 men-at-arms, 2,500 horses, 500 citizens of Borgo Sansepolcro (in addition to a few Perugians)—and the names of the most important prisoners: a virtual who's who of the greatest mercenaries of the time.[135] In his *Commentaries*, Capponi would later furnish even more impressive figures: 22 of the ducal army's 26 squad leaders; 3,000 horses; 400 men-at-arms; and a grand total of 1,540 'high-profile prisoners.'[136] It's quite possible that once the situation settled down, Capponi was able to make a more accurate assessment, but one cannot exclude the possibility that he made some exaggerations, as he wrote the account years after the events transpired. The prisoners became the subject of an animated dispute: Attendolo and the allies' civil representatives wanted to hang on to as many Milanese prisoners as possible, but the majority of the League's condottieri were only interested in those who could be ransomed for considerable sums; and even in those cases, they didn't necessarily need to keep them prisoner while waiting for said ransom, since it was commonplace for people to keep their word: breaking a promise could lead to ostracism in the circumscribed world of mercenary soldiers.

It was thus to the Florentine commissioners' great dismay that the overwhelming majority of Milanese prisoners were released the next day, after being stripped of their weapons and armour. When Piccinino's sentries spotted columns of their comrades-in-arms, they

at first thought that they were the enemy's advance guard. Not having expected his soldiers to be released, Piccinino sarcastically commented: 'If God had given them a brain, the Florentines wouldn't have freed those veterans.'[137] The Perugian was right: finding soldiers who were suitably experienced in a short amount of time could pose a considerable problem, but outfitting them with new weapons didn't. After the disastrous defeat at the Battle of Maclodio in 1427, Filippo Maria Visconti had managed to re-equip 4,000 knights and 2,000 foot soldiers in the space of a single week simply by drawing on his own personal stocks and those of Milanese blacksmiths. Even if hanging on to so many prisoners would have caused the allies quite a few logistical problems, letting them go had basically granted the Duke of Milan a new army.

The most prominent of the prisoners who'd been kept was Astorre Manfredi, whose life had hung in the balance for days—so much so that Capponi had given him up for dead—but who had actually made a full recovery thanks to his luck and toughness. Fate hadn't been so kind to others. Sixty Milanese men-at-arms lay dead on the battlefield and another 400 had suffered serious injuries. An additional eighty members of the light cavalry had died, many of whom succumbed to their wounds in the days after the battle; even though injuries inflicted by bladed weapons tended to heal better than those caused by projectiles, one can reasonably assume that the mortality rate hovered around 50 per cent. Given that more than 900 Milanese soldiers were killed or wounded during the clash, Piccinino must have lost around 30 per cent of his force, a sum that didn't include the prisoners taken, and which was comparable to some of

the bloodiest episodes of the Napoleonic wars. The exact numbers are impossible to calculate, even if lesions produced by cold resulted in less tissue deterioration than those caused by gunshots. As for the allies, forty of their knights were slain during the battle, while another 200 were wounded. Six hundred horses had been lost on both sides, and it's quite likely that warm tears were shed over them: aside from the indisputable fact that knights were very attached to their mounts, the capture or loss of a horse worth twenty ducats was a great financial loss for some, or a considerable gain for others. We know next to nothing about the infantry losses on either side of the conflict, given how the men who enlisted tended to be of little consequence both socially and financially, and therefore weren't notable enough to merit mention in official dispatches or chronicles.

Despite his defeat, Piccinino paved a successful path of retreat to the north. The loss of his wagons had relieved him of a considerable burden, and his army could now move faster. As a result, he quietly left Borgo Sansepolcro on the night of June 30 and marched towards the Apennines. The allies learned of his escape the following day, but showed no hurry in giving chase. To begin with, they had no idea where he was headed—Neri Capponi, for one, was convinced he'd returned to Perugia—and the victorious allies wanted to enjoy the fruits of their labours. Furthermore, the Florentines had lost interest in Piccinino now that he had left Tuscany behind: after all, there were other scores to settle.

8

THE TABLEAU OF POWER

The bearded man stepped off the scaffolding, which was another of his inventions, which could bend like an accordion to allow one a full view of the painted wall. Now that he had completed his final brushstrokes, the time had come to prove himself to all who'd accused him of being inexperienced when it came to frescoes. To be sure, The Last Supper *had begun to deteriorate almost as soon as he finished it, but this had been caused by the humidity of the wall rather than his technical incompetence. However, his current patrons were tough, unforgivin, and overly critical men, who would be difficult to impress and even more difficult to please. To avoid any surprises this time, the artist ensured he'd adequately prepared the foundation of the fresco, and up until that point the only setback he'd encountered had been when the cartoon had fallen off the wall during a storm.*

The creator had good reason to feel optimistic. He had spent a great deal of time studying the techniques of the ancients, and had especially taken cues from those passages in Pliny the Elder's Natural History,

which described the approaches employed by the old masters of antiquity, especially Apelles of Kos and Pausias. But he could imitate the classical greats only through the encaustic technique, which, despite its utilization by other painters in recent times, the painter still thought he alone had perfected—partly thanks to the way he mixed his pigments. The method required a great deal of heat in order to apply the beeswax to the surface, but the bearded man had already successfully experimented with the method on other occasions. The fresco he was painting would be as bright as an oil painting, but the wax would help preserve that effect forever. So much for those who'd accused him of wasting time over pointless experiments and not sticking to tried and tested methods.

The artist savoured the long-awaited moment as he gave his assistants their orders. Large braziers were brought into the hall and placed below the fresco. The burning coal began to produce an intense heat that climbed up the wall. More and more fuel was added to the flames and the growing artificial haze made the large painted figures look as though they'd sprung to life, almost as if they were trying to step off the wall. Everyone in the hall anxiously awaited the results, keeping their eyes firmly fixed on the fresco. Soon enough, a triumphant smile formed on the bearded man's lips: the colours had started to dry, exactly how he'd predicted they would.

As it happens, Piccinino didn't return to Perugia, but instead headed to Gubbio. He had previously held a preliminary meeting with Guidantonio da Montefeltro, the Lord of Urbino. Piccinino and Montefeltro had often found themselves on opposing sides, and,

among other things, Piccinino had inflicted several painful defeats on Montefeltro. Nevertheless, Montefeltro's illegitimate son was fighting for Visconti's army, and his father—who, following the conventions of Renaissance politics, kept his fingers in many pies—had been more than happy to welcome Milanese troops within Gubbio's walls and to lend them his assistance. All this despite his position as a vicar, as he was fully aware that his dominion's survival rested on the Papacy's military weakness. In addition, although the inhabitants of Città di Castello had submitted to Florence's guardianship, the question of the city's loyalties was still unresolved, and Montefeltro had no intention of seeing it fall permanently under Florence's sphere of influence. Thus, the presence of ducal troops in Umbria was reassuring, and it could prove useful in the event that Montefeltro tried to switch sides. In any case, Piccinino was in no condition to undertake another campaign given the state of his troops, and he therefore feverishly set himself to the task of re-equipping his army insofar as local resources allowed. Around July 7, Piccinino left Gubbio to head towards Gualdo Tadino where he would await the arrival of Sigismondo Pandolfo Malatesta and at the same time attempt to purchase horses through his agents in the Marche. But the Lord of Rimini switched sides, and the purchase of said horses was prevented by the energetic efforts of Alessandro Sforza, who threatened to unleash severe sanctions on anyone who aided the Milanese. Having failed in this attempt, Piccinino decided to go to Perugia, a perfect logistical base, dispatching some of his couriers to prepare the city for his arrival. Instead, the Perugians adroitly sent him 8,000 ducats to accelerate his departure for the Romagna. Piccinino had no choice

but to accept: he had few weapons and armour at his disposal, not to mention warhorses, and Trevisan's papal troops were only two days away; getting trapped in Perugia was the last thing on his mind, and besides, Guidantonio Manfredi was worried about the likely reprisals against Faenza. As soon as he was able to move, Piccinino headed north, and after leaving his son Francesco with Manfredi to hold the front in the Romagna, he hurried to Milan.

The Perugians welcomed the news that the Milanese had given up on returning to their city with relief, as they could now blame their defection on a few reckless types, and thus be welcomed back into the Pope's good graces. The citizens of Borgo Sansepolcro attempted a similar manoeuvre, by sending ambassadors to beg Trevisan's forgiveness, justifying their conduct on the grounds that they'd been foolhardy and had been forced to yield to the enemy's greater numbers. They were also in a hurry to find another protector, given that Troilo and Paolo della Molara had come from Città di Castello accompanied by their cutthroats and had already killed a few of their enemies from Borgo Sansepolcro, who welcomed the Florentine commissioners with cries of 'hooray for the Church.' But by that point the possession of Borgo Sansepolcro had become the subject of open contention between Florence and the Pope. The Count of Poppi had already offered Borgo Sansepolcro to Florence, but the latter had declined him so as not to antagonise the Pope. Although the Patriarch of Aquileia had nominally taken possession of the city, Eugenius IV was obliged to contend with the Florentine garrison still within its walls. In the end, both parties agreed to a compromise whereby the Pope would cede Borgo Sansepolcro to his hosts in

exchange for 25,000 florins, and a contract to that effect was signed on February 22, 1441. Constantly short of money, the Florentine government sourced the necessary funds by imposing a fine of 20,000 florins on the Jewish banker Salomone di Buonaventura, claiming he'd broken the laws forbidding usury—which was exemplary from a legal point of view, but fundamentally politically suspect. It seems that Salomone was one of Eugenius IV's protégés, and his sentence seems to have reflected a change in the relationship between Florence and the Papacy after the victory of Anghiari and the resultant waning of the Milanese threat.[138] Since they had already secured their guardianship over Città di Castello, the purchase of Borgo Sansepolcro allowed the Florentines to considerably increase their influence over the Val Tiberina.

These weren't Florence's only gains. Unlike the inhabitants of Perugia and Borgo Sansepolcro, many Florentines couldn't find any loopholes to justify their illegal actions, and in some cases, in admirable displays of dignity, they didn't even try. In the aftermath of the victory at Anghiari, Bernardetto de' Medici had forced Anfronsina Schianteschi to cede the castle of Monterchi, coupling his demand with a vitriolic comment: 'If you attended to your family like a woman should, then you wouldn't have lost your state.' In a manner befitting her lineage, the lady had replied: 'The lady did what the goodness of her soul asked of her, and she put her trust in her lord, the Duke of Milan, who had given her an annuity of fifteen hundred gold ducats, and thus had a right to the state which belonged to her and her daughters.' Enraged by this display of resistance, Medici had growled: 'I hope her daughters wind up like King Herod's sons.'[139]

But it was Neri Capponi who landed the biggest prey, an achievement that filled him with such pride that he left behind a detailed description of events. By allying himself with Piccinino against Florence, the Count of Poppi had lost his wager, and the Florentines didn't wait long before asking him to settle his debt. As the count had been one of Florence's vassals, his defection amounted to a betrayal, and he was thus subject to the punishment reserved for rebellious feudal lords. Besides, the Signoria was afraid Trevisan would beat it to the punch, in the style of the deceased Vitelleschi, a prospect that didn't allow Florence's rulers to sleep easily. Accompanied by Alessandro degli Alessandri, Capponi was immediately dispatched to the Casentino, where he rapidly conquered Bibbiena, Romena, Pratovecchio and Rassina—the latter won with the threat of hanging some of the prisoners captured at Anghiari. Subsequently, the Florentines reached the walls of Poppi, where they pitched two camps in order to block all access routes to the city. Given the castle's strong defences, Guidi could resist a protracted siege so long as he had sufficient supplies; but since all his stocks had been depleted by the Milanese, it would have been foolish to hold out. Capponi knew this, and he'd written to the Signoria: 'You should place more trust in hunger than in our bombards'; but as he was nevertheless conscious of the numerous opportunities that his fellow citizens had failed to grasp, he hurriedly added: 'You should ensure the Count of Poppi doesn't prevail over us.'[140]

It's likely Guidi was hoping to reach an agreement with Capponi, relying on the fact that he was one of the most distinguished representatives of the Braccescho faction in Florence. He didn't take

THE TABLEAU OF POWER

long to realise that negotiations would be impossible: the Florentine commissioners refused to grant his ambassadors safe passage to the Signoria, and instead threatened to sack the castle if he didn't surrender immediately and 'give ten thousand ducats to those men-at-arms who are still alive and fifteen thousand to those taken prisoner, or who lost a son.'[141] Accordingly, the count went down to the bridge over the Arno below his keep to exchange words with Capponi:

> The first thing he [the count] said was: 'Can it really be that your lords won't let me keep this house, which has been in my family for nine hundred years? I suppose you'll do as you like.' At which point I replied: 'Consider this instead: that you did not keep to your oath, and that my lords want to keep you close. They would be very pleased to see you become a great lord in Germany'. Angered, he replied in turn: 'And I will rather see you go there.' And I laughed. Reaching the end of our discussion, I asked him to surrender Poppi and all his goods, as well as to free all the prisoners.[142]

Thus, Guidi had to pull up stakes and leave his ancestral castle at the end of July. He took with him his family and his household furnishings—which were borne by no less than thirty-four mules—in addition to his retinue. Guidi headed to Bologna where he would take up his friend Annibale Bentivoglio's hospitality, haunted by the sarcastic comment that Capponi had sent to Florence's rulers: 'And he can try to trick the bloodhounds, finding out what it means to betray Your Lordships, thus becoming an example for all others.'[143]

The entire Casentino was thereafter directly governed by Florence, which allowed the city to control not only the passes over the Apennines and a series of strategically important castles but also the woodlands that had been one of Guidi's chief sources of revenue. Florence greeted the news of Poppi's capture with jubilation, adding to the joy already prompted by the victory at Anghiari. After all the thrashings the Milanese had inflicted on them over the years, the Florentines could finally boast of a success of their own, which, as Micheletto Attendolo put it in a letter to Cosimo de' Medici, 'didn't come about every day.'[144] Despite their proverbial parsimony, the Florentines spared no expense in celebrating this victory and handing out rewards.

As soon as the battle had ended, Neri Capponi and Bernardetto de' Medici had taken care to ask Cosimo de' Medici to do something for their 'honour' (Bernardetto added that the 'burden' was weighing him down, as the Commune had resorted to forced loans), emphasising that 'discord in the camp' would have led to the defeat of the allies if they hadn't been there at the time.[145] The two commissioners were offered knighthoods, honours which they both refused, perhaps out of modesty or maybe because it wasn't worth much in the first place. As it happens, the Commune customarily handed out knighthoods to all their ambassadors in order to elevate their mission's prestige; sometimes they even lavished such honours on dead rich citizens, a habit that led the novelist Franco Sacchetti's scathing remark, 'But if this knighthood is worth anything, why don't they also give them out to an ox, or a donkey, or any other beast capable of emotions, what, because they don't have the faculty of reason?'[146]

Instead, Medici and Capponi made do with a banner, a shield bearing the arms of the Florentine people, an extravagant helmet, and a caparisoned horse—the kind of recognition that was far more valuable than a virtually meaningless title—and an additional recompense on top of the fame they'd already earned among their fellow citizens for having been the real victors of the war. Commemorated in Neri's account of the battles in his *Commentaries*, the memory of the role their relatives had played in the victory of Anghiari would remain impressed in the Capponi family's consciousness. When Neri's nephew, Piero Capponi, married Nicolosa Guicciardini in 1466, the family commissioned two hope chests from the workshop of Apollonio di Giovanni di Tomaso (which are now in the possession of the National Gallery of Ireland in Dublin) depicting the capture of Pisa in 1406 as well as the battle of Anghiari. In addition, the fact that the allies' achievement had left an impression on the collective imagination of Florentines can be seen in Paolo Uccello's *The Battle of San Romano*, originally commissioned by Lionardo Bartolini-Salimbeni around 1438–39, but only completed several years later. In 1480, the three panels were described as 'Niccholò Piccinino's rout', and the central panel, which today is housed in the Uffizi Gallery in Florence, depicted a knight being struck and unseated from his horse by a spear-thrust, and this knight has been usually identified as Bernardino Ubaldini della Ciarda, who'd actually been among the defeated at San Romano, but given the location of his wound, it could well have been Astorre Manfredi instead.[147]

Well aware of the role the Almighty had played in securing the victory, the Commune of Florence decided that each year the

Signoria, the Collegi and the captains of the Guelph Party would make a pilgrimage of gratitude at the Church of San Pier Maggiore, one of the most ancient religious buildings in the city and a powerful Benedictine monastery, where every bishop who took possession of the Florentine Diocese was symbolically wed to the Mother Superior in an elaborate ceremony to demonstrate his union with the ecclesiastical community of Florence. (In olden days it had been customary for the bishop to spend his 'first night' in the monastery, a practice quickly abandoned due to the salacious jokes it inspired.) Despite the fact that the victory at Anghiari had been the result of a collective effort between the armies of various governments, the Florentines were swift to claim all the credit for themselves. Because a devotee of the Carmelite Andrea Corsini, a bishop of Fiesole who'd died in 1373, had had a vision a few days before the battle that the dead prelate had foretold the campaign's successful outcome, it was decreed that the Signoria would visit the Church of Santa Maria del Carmine on every anniversary of the battle to pay their respects to Corsini's remains, which were housed in the church. Given the Carmelite's miraculous intervention in the allies' triumph, Eugenius IV beatified the bishop and Filippo Lippi was commissioned to decorate Corsini's reliquary. (He would have to wait until 1629 to be canonised, and it is said that the more than sizeable sum the Corsini family had to spend in order to publish the necessary documentation had led the Corsini patriarch to exclaim: 'From now on we'll be good, but certainly not saints!') After serving the spiritual panem, the Commune also provided for the *circenses* by holding a palio that involved riderless wild horses for the Feast of St. John. This race of the *bàrberi* would be a

feature of Florentine life until 1858, but by then its origins had long been consigned to the dustbin of history.

Even Eugenius IV dispensed lavish rewards, especially when it came to Trevisa, who, during the consistory held on July 1, 1440, was elevated to Cardinal, which came with the Church of Saint Lawrence in the House of Damasus; he was given his archiepiscopal hat during a solemn ceremony the following year, on July 20. A few months later, Trevisan was also appointed to the prestigious and lu-crative position of Camerlengo of the Holy Roman Church, and in his capacity as the administrator of the Church's annuities, he could give free rein to his taste for luxury, forever earning himself a repu-tation as 'Cardinal Lucullus' among ordinary Romans. Eugenius was right to be grateful to the spirited prelate, given that Piccinino's rout hadn't only saved the Council of Florence from dissolution but had also considerably dashed the hopes of the Synod of Basel. Even the Venetians rejoiced over the victory at Anghiari: 'The victory was magnificent and great, and every lord of the League celebrated and gave thanks unto the Creator', as the diarist Marin Sanudo noted.[148] Rightly recognising the role Micheletto Attendolo had played in Pic-cinino's defeat, the following year the Serenissima took up Francesco Sforza's suggestion that it employ him as one of its captain-generals, replacing the defunct Gattamelata. Rather understandably, Filippo Maria Visconti wasn't at all pleased with the defeat inflicted on his finest captain, but at least Piccinino had brought the majority of his men back with him, even though they'd lost most of their equip-ment. The duke warmly welcomed Piccinino, who blamed his defeat at Anghiari on the interventions of the apostles Peter and Paul, even

telling him the story of the snake and the fig tree—a story that would have undoubtedly impressed the superstitious duke. Visconti himself remembered something that had happened prior to Piccinino's departure for Tuscany, which was subsequently considered an omen: a lightning bolt had struck the castle of Milan, killing a few blackbirds perched on the walls and setting fire to the stables, and while smoke had spread through the duke's residence, 'the horses broke away from their reins, wandering here and there, like a horrible foreboding of the battle to come.'[149]

But there wasn't any time to play the blame game with Sforza threatening the dukedom's eastern borders and the allies advancing from the south: the castles of Dovadola, Bagnacavallo, Massa Lombarda and Portico had already fallen into their hands, the latter having been conquered thanks to the defection of Sigismondo Pandolfo Malatesta; the Ordelaffis of Forlì might have defected as well, were it not for the presence of Milanese troops. With Astorre Manfredi imprisoned, Faenza was focused on defending its own territories, and with even Bologna about to fall into enemy hands, Filippo Maria risked winding up without any allies in the Romagna. He was therefore willing not to bother too much with his commander's failure, focusing instead on the importance of restoring the Braccescho troops to their pristine efficiency. Heavily in debt and reluctant to increase the already burdensome pressure on his subjects, Visconti preferred to entrust Piccinino with the odious task of sourcing the necessary funds to re-equip his army, and while Piccinino 'didn't respect men of the cloth, or courtiers, nor anyone else for that matter, he managed to find three hundred thousand ducats in no time;

and immediately paid his soldiers and put his army back in order.'[150] Despite it being late in the winter season, he immediately headed to Forlì to give the Ordelaffis a hand, and then went to Parma. Having arrived there, he met with a delegation of noblemen from Bologna from whom he managed to extort 15,000 ducats in exchange for 100 lances, and the Bolognese also agreed to pay the salaries of 100 foot soldiers to be garrisoned there. Thanks to Piccinino's energetic efforts, Visconti managed to contain the damage inflicted by the defeat at Anghiari.

Filippo Maria hadn't been wrong to place his trust in Piccinino, given that at the end of January 1441, Piccinino defied the winter cold—against the usual practice of war—crossed the Oglio river, entered the Bresciano and captured numerous castles, among them the castles of Chiari and Soncino. There he captured the Venetian superintendent Michele Gritti, and simultaneously managed to recruit the condottiere Sarpellione da Parma, one of Francesco Sforza's friends and acolytes, to Visconti's cause. Sforza, who'd been in Venice to attend the celebrations of Jacopo Foscari's wedding at the time, was caught unawares by this lightning-fast attack and had been forced to rush back to the front. Nevertheless, Piccinino's principal aim in this campaign had been to source the necessary weapons, horses and victuals, but by March he had been obliged to withdraw back towards Milan due to enemy attacks and the lack of fodder and pay for his soldiers. Yet Sforza failed to regain the strategic initiative and the Milanese were free to do as they liked in Lombardy for the remainder of the spring. On June 25, Sforza attempted a coup against the pro-Milanese government in Cignano, but he was forced

to withdraw when the promised Venetian troops didn't show up, suffering several hundred losses as a result. Exploiting his advantage, Piccinino marched towards Cremona, while Sforza avoided giving chase and instead attacked Martinengo, in the Bergamasco, where he aimed to re-establish the lines of communication between Bergamo and Brescia. However, Piccinino had foreseen Sforza's move and taken care to reinforce the garrison at Martinengo, which put up a stiff resistance, thus allowing the majority of the Milanese army to come to its aid. Piccinino built a series of field fortifications to cut off the enemy camp's supply lines, and Sforza very quickly went from besieger to besieged. The two armies were in close proximity for twenty days, but just when Sforza, by then on the ropes, was considering committing his last resources to fight his way out, the military situation changed abruptly, and with it Italy's political situation as a whole. Perhaps Sforza hadn't been expecting an old acquaintance to visit him, especially not someone trusted by Filippo Maria Visconti, but the news that Antonio Guidoboni da Tortona brought him surely gave him great joy and relief: the Duke of Milan had finally decided to let him marry his daughter, Bianca Maria Visconti.

Filippo Maria's unexpected solution to the problem had been triggered by a grave political error on Niccolò Piccinino's part. On seeing the enemy troops powerless before him, and certain that victory was in his grasp, Piccinino had chosen to present his employer with a bill for services rendered, following the example of the duke's other condottieri who'd demanded feudal territories in lieu of outstanding wages: Taliano Furlano had asked for several castles in the Alessandrino; Luigi dal Verme had asked for Tortona; while Luigi da

San Severino asked for Novara. Piccinino put forward a claim on Piacenza, justifying his request with extreme clarity: he said that it was 'high time, after so many promises and hard work, to have a place where I can spend the last years of my life after a tiring career'; moreover, as he held the fate of the Venetian army—and by extension that of Lombardy—in the palm of his hand, his request for Piacenza didn't seem that excessive, and he warned that the duke's response 'would make the difference between winning and losing'. Piccinino wasn't merely seeking to increase his prestige, he was primarily interested in the economic resources and recruitment opportunities that such a feud could provide him, and which had been denied to him when he had failed to become the Lord of Perugia. Nevertheless, Piccinino's request, which came coupled with a thinly veiled threat, provoked fierce indignation on the duke's part:

> So this is what these condottieri have come to, if they lose, we have to put up with their impertinence, while if they win, we have to satisfy all their desires and prostrate ourselves at their feet; would it be that much worse if they were our enemies instead? Should the Duke of Milan purchase a victory achieved by his own soldiers and lose one's shirt just to pay for their favours? We accept terms from our enemies, but we dictate them to our subjects; and if we have to give in, then we might as well do so with only the worthiest, and we've already done that.[151]

Filippo Maria's outburst is frequently cited as an example of how greedy mercenaries often were, but there's also another side of the

coin: as a matter of fact, Piccinino had spent years loyally serving the duke, and had often received meagre rewards for it, especially given that his lord's disloyalty to his own condottieri was well known. Visconti's 'giving in' to Francesco Sforza was part and parcel with this, which, besides placing Piccinino in check, also overturned the entire political landscape of Italy. By making Sforza his son-in-law, albeit by sacrificing his daughter Bianca Maria, who was the most precious diplomatic pawn he had to play (Filippo Maria was very fond of card games and owned an exquisite stack of illuminated tarot cards), the Duke of Milan was counting on depriving Venice and the League of their important captain while simultaneously driving a wedge into the Church's territories, given that Sforza ruled the March of Ancona. In addition, given the ties of friendship that existed between Sforza and Cosimo de' Medici, there was also a chance that the latter would abandon his alliance with the Pope and the Venetians and switch to Milan's side.

Filippo Maria's views on the matter had been partly right, given that Cosimo, who'd always assumed that Sforza would sooner or later succeed to the Dukedom of Milan, had already contemplated changing his city's traditional alliances. It was no coincidence that on September 6, the condottiere Baldaccio of Anghiari—who had days earlier been hired by the Pope—had been treacherously murdered in Florence, apparently on Sforza's orders. Baldaccio, who'd been close to both the Malatestas and the Varanos, the Lords of Camerino, owned the castle of Sorci in the Val Tiberina, and the Florentines weren't willing to contemplate the possibility of a likely enemy controlling the road between Borgo Sansepolcro and the Adriatic coast.

Machiavelli would later attribute the death of Baldaccio to his friend-ship with Neri Capponi, thus placing the murder in the context of Florence's internal power struggles.[152] As it happens, the two versions of events weren't mutually exclusive, given that Capponi had been a staunch supporter of the Florentine-Venetian alliance, in the name of a traditional pattern of alliances and a similar mind-set. How-ever, Cosimo was fast realising that he could only shore up Florence's military weakness through an alliance with Sforza, which would also help cement his own control over the city and create a bulwark against Venetian expansion in the north of Italy, which aimed to incorporate the entirety of Lombardy and the Romagna into its own state. It was no coincidence that Niccolò d'Este, the Marquess of Fer-rara, had also been worrying over the Serenissima's aggressive politics and had been one of the key supporters of his friend Sforza's marriage to Bianca Maria Visconti; in addition, Florence saw Ferrara as a vital buffer zone between its domains and Venice's. The downsizing of the Milanese threat in the wake of Anghiari was, at least from a psycho-logical point of view, beginning to have long-term political effects.

Although he accepted the offer of Bianca Maria's hand in mar-riage, Sforza was too canny to definitively break off his ties with the Venetians: not only was his reputation at stake, but he was also keen to keep his options open in case Visconti decided to change his mind, as he often did. In fact, before accepting the marriage pro-posal, he insisted that the Milanese come to terms with Venice and relinquish the territories in the Bergamesco and the Bresciano that it had conquered from the Serenissima, including Martinengo; and he also managed to convince the sceptical Venetian Senate to accept the

duke's generous overtures. Understandably, Piccinino wasn't at all pleased with this turn of events, and he began openly complaining that Filippo Maria had betrayed him, now that he was crippled and old, despite the many times he'd managed to so diligently recover all that the duke had lost. Refusing to accept Piccinino's interpretation of events, the duke informed his most loyal captain that if he didn't agree to cease all hostilities, the duke would send the full might of Sforza's troops against him, as well as those of his other condottieri. Piccinino was forced to accept, and during his very friendly meeting with Sforza under the walls of Martinengo, the two condottieri secretly agreed to divide the territories of the Church and the Commune of Siena among themselves. It was certainly in Sforza's interests to stay on good terms with Piccinino, since the latter was the de facto ruler of Bologna; the duke knew how important it was to keep Piccinino close, so much so that on November 7, 1441, he issued a decree limiting the power of his feudal lords, except for 'Lieutenant and Captain-General' Piccinino. In so doing, Filippo Maria managed to please Piccinino but also create a counterweight to Sforza's power. To further emphasise this, the duke led others to believe, as he pretended to do, the accusations that Piccinino had levelled against Rolando Pallavicini, the Lord of Busseto, giving Piccinino his tacit consent to assail and conquer Pallavicini's lands, a campaign that gave Piccinino territories in Umbria, a handful of castles, and a booty of 400,000 ducats.

The marriage between Sforza and Visconti's daughter was solemnly celebrated on October 24, 1441, at Cremona, a city the bride had received as part of her dowry, along with Pontremoli and its

respective territories. Sforza also added another string to his bow of alliances by marrying his illegitimate daughter Polissena to Sigismondo Pandolfo Malatesta, thus warding himself against any likely reprisals against his feuds in the Marche from the Lord of Rimini (insofar as he could, given the Malatestas' mercurial character), and ensuring his free passage between the Po Valley and the Adriatic coast. Sforza had also insisted that the negotiations between Milan and the League commence immediately, and an agreement that more or less stipulated a return to the status quo before 1438 was concluded on November 20 by the plenipotentiaries, who'd gathered at Cavriana, and was ratified by the various governments in December. But Sforza did not relocate to his wife's home, and was careful to remain at Sanguinetto, deep in Venetian territory, where he wintered alongside his troops, protected by the Serenissima. Sforza had every reason to stay out of Filippo Maria's reach, as he had meanwhile renewed his contract with the League for another three years, plus an extra year, out of both respect for his relationship with the allies and a suspicion that the harmony between him and his father-in-law wouldn't last for long.

The Pope had been rather displeased by the Treaty of Cavriana, and he couldn't tolerate the fact that Piccinino was under no obligation to return Bologna to him for another two years; additionally, although he'd been forced to accept it, he was furious that Sforza would remain in the March of Ancona, and waited for the right moment to rid himself of his unwelcome guest. The occasion arrived when Sforza decided to intervene in the Kingdom of Naples in favour of René of Anjou in his fight against Alfonso of Aragon, who

in Sforza's eyes was guilty of confiscating his feuds in southern Italy. The Pope had hitherto favoured Anjou's cause, in virtue of the fact that the Aragonese was a supporter of the Synod of Basel; but when Alfonso made it clear that he would gladly switch his allegiance in exchange for the Kingdom of Naples, Eugenius didn't think twice before accepting (a decision made all the easier by Alfonso's military successes, and as it happens, Alfonso entered Naples as its conqueror on June 2, 1442).

At the same time, irritated that Sforza hadn't forsaken the Venetians, and had instead taken up arms against his ally Alfonso, the Duke of Milan had offered Piccinino's services to the Pope, employing his usual trick of officially firing him (while still secretly paying him) so that the Pontiff could recruit him, and the Pope even made him Gonfalonier of the Church (yet another instance of the unscrupulousness of politics in Renaissance Italy). Incidentally, supposedly aware of the agreement Sforza and Piccinino had struck, Eugenius knew that when Sforza succeeded his father-in-law, the Holy See would risk finding itself at the mercy of a potentate far more dangerous than Visconti, and Milan would probably ally itself with Florence and—in case Alfonso of Aragon lost—Naples too. Like all the other Italian rulers, Eugenius knew that duplicity was the price one needed to pay for political survival. In order to give his action legal weight, the Pope excommunicated Sforza under specious pretences in April 1442, and immediately gave Piccinino free rein to reconquer the Marche. However, this turnaround had made Eugenius's prolonged presence in Florence untenable, and he therefore decided to go back to Rome, which had been pacified by then, using the excuse

THE TABLEAU OF POWER

that the council had been relocated to the Lateran. He thus left Florence on March 7, 1443, despite 'the great argument over whether he should be allowed to leave or not; because the Venetians were doing all they could to pressure the Florentines to keep him there by force and not let him leave.'[153] Once he'd reached Siena, Eugenius met with Piccinino to discuss the campaign against Sforza and concluded his negotiations with Alfonso of Aragon. He returned to Rome on September 28, after an eight-year absence, and was unenthusiastically received by the local populace.

Piccinino's campaign in the Marche would be the last he would ever embark on, and he waged it with his habitual speed and competence, as usual keeping an eye out for potential territorial gains. After conquering Assisi, which Alessandro Sforza had defended, he allowed his soldiers to loot it mercilessly, refusing to spare even the convents of St Francis and St Claire, but turned down the Perugians, who'd offered him 15,000 ducats to raze the city to the ground, in the hope that he would eventually become that city's lord, and use it as a base from which to keep Perugia—where he was incredibly popular—under his control. Piccinino also took over Norcia, Gualdo Tadino and other localities. It appeared as though Piccinino were about to repeat Braccio da Montone's feats, but despite the fact that his troops—reinforced by an Aragonese regiment—had managed to prevail over enemy forces in most cases, Piccinino would be dealt a sound and definitive defeat on a political level: in one of the frequent changes of position for which he had become famous, Filippo Maria Visconti, who had no wish to see his son-in-law overly weakened, recalled Piccinino to Milan after having convinced the

Pope to fire him. Tired, ill and disheartened, Piccinino took his leave from his soldiers during a moving ceremony before heading back to Lombardy. He retired to his villa at Corsico, and passed away sometime in mid-October 1444, having succumbed to an edema that had long plagued him. His death was likely accelerated by the news that his son Francesco had been beaten at Montolmo and taken prisoner. Pietro Candido Decembrio composed a funerary oration in courtly Latin in his honour and the duke ordered that a statue, which was subsequently destroyed by Francesco Sforza, be erected in his memory.

Piccinino's principal employer, Filippo Maria Visconti, survived him by three years and died on August 13, 1447, six months after his old rival, and occasional ally, Eugenius IV, and after having heard the rumble of Venetian bombards at the gates of Milan. Indeed, under the pretext of defending Cremona, one of Sforza's feuds, the Serenissima had opened hostilities against Milan at the beginning of 1446, dispatching Micheletto Attendolo to Lombardy. On September 28, Attendolo inflicted a devastating defeat on the Milanese at Casalmaggiore, and by the following June he had reached the walls of Milan, thus hoping to trigger an anti-Visconti uprising in the city. In dire straits, Visconti had begun negotiating with Francesco Sforza in February to convince him to return to his service, despite his other condottieri's staunch opposition to this plan. Nevertheless, Filippo Maria died before Sforza's arrival, and, according to some witnesses, refused in extremis the last sacraments, and was hastily interred in Milan's duomo since his corpse 'was already decomposing in all that fat of his.'[154] According to the arrangements he'd made in his elusive

political testament, which nobody ever laid eyes on, the dukedom should have passed to Alfonso of Aragon, even though there are serious grounds to believe that this rumour had been circulated by Sforza's numerous enemies in Visconti's court.

There were many pretenders to the Dukedom of Milan: the Holy Roman Emperor Frederick III, Filippo Maria's overlord, demanded that the dukedom revert to the Empire due to the lack of a legitimate male heir; the Duke of Orléans put forward his own claim due to the fact that his mother, Valentina Visconti, was Filippo Maria's sister; while Francesco Sforza, by virtue of having married Bianca Maria, also asserted his rights, since his father-in-law had often promised that he would be his heir, even though he'd retracted his pledge on several occasions. Perhaps the weakest of these claimants was the Duke of Savoy, who was related to Maria of Savoy, the duke's widow. Finally, there was Venice, and even though the city did not have any legal right to it, it aimed to conquer Lombardy *manu militari*, since the Serenissima knew that possession was nine tenths of the law. Likewise, Genoa, Mantua, Ferrara and the Marquess Montferrat, alongside other petty potentates of northern Italy, had come forward to try and gnaw as much as they could from the carcass of Visconti's state. However, none of them had taken the Milanese populace into account, and on the day following Filippo Maria's demise, the city's inhabitants, led by a few of their noblemen, proclaimed the Golden Ambrosian Republic into being, invoking the authority of the city's ancient parliament, and the republic's establishment was celebrated by looting the ducal palace, and much to the misfortune of future historians, setting Visconti's archives on fire.

Given the difficulties he was experiencing in the Marche, Francesco Sforza had welcomed his father-in-law's invitation with a measure of relief. However, before leaving for Milan, he had taken care to reach an agreement with Pope Nicholas V, Eugenius IV's successor, and even managed to coax him out of several thousand ducats in exchange for the return of Jesi and other territories in the Marche (the Bracceschi in Visconti's service had done all they could to prevent the Duke from giving his son-in-law the hiring bonus he'd been promised) and simultaneously struck a deal with Alfonso of Aragon. By the time he'd reached Milan, Sforza found the city in the grips of utter chaos, with the majority of the Bracceschis favouring the Aragonese succession, Attendolo's Venetian troops safely inside the walls of Lodi, and the Duke of Orléans' soldiers approaching the Dukedom's eastern borders. Although eyed with suspicion by the oligarchs who effectively ruled the new Republic, Sforza's seeming weakness (he had only brought a few thousand knights and soldiers with him, all of whom were in a shoddy state, with Sforza having been obliged to mortgage Pontremoli and his wife's jewels to usurers in the Marche and Ferrara) made the Milanese, who were looking for a capable commander, think of him as the lesser evil. Meanwhile, a Milanese army led by Bartolomeo Colleoni had inflicted a bloody defeat on the Duke of Orléans' soldiers at Bosco Marengo (in the province of Alessandria). Yet Sforza's greatest stroke of fortune lay in forcing Pavia, the Dukedom's second most important city, to yield to terms, and the Republic reluctantly consented to making him the Count of that city out of fear that it would otherwise wind up in the hands of the Venetians. Sforza guaranteed all of the city's old

freedoms and refrained from levying new taxes, thus earning him the support of its inhabitants and a valuable logistical base to boot.

Needing to buy himself some time to widen his support base in Milan, and to make himself indispensable to the Republic, Sforza successfully obstructed all peace settlements with the Venetians throughout that winter and the following spring, against the wishes of the Bracceschis and the Piccinino brothers, his efforts having been aided by Colleoni's defection to the Serenissima. Sforza appeared to be emerging as the victor when, in the summer of 1448, he inflicted two spectacular drubbings on the Serenissima's armies, one of which was a truly disastrous defeat on Micheletto Attendolo at Caravaggio. However, following that, the suspicions of the emboldened Milanese, as well as the Bracceschis' back-stabbing intrigues, led Sforza to make a political calculation and come to terms with the Serenissima, promising it ownership of the entirety of the Bresciano and Bergamasco regions in exchange for their help in becoming the Lord of Milan. This proposition suited the Venetians, in that it enabled them to tilt the military situation in their favour, and wait for the right moment to gazump the elusive condottiere.

Sforza, however, proved far more cunning than his former employers and spent the entirety of 1449 not only waging war against the Ambrosian Republic, but also strengthening his own political base in Lombardy and abroad. In addition, he exploited the various divisions among the condottieri in the Republic's service, especially the Bracceschi, so as to bring as many of them as possible over to his side. As for the Piccinino brothers, Francesco succumbed to an edema in October 1449, just like his father, while Sforza convinced

Jacopo to switch sides by promising to give him his daughter Drusi-
ana in marriage. (Nevertheless, Piccinino didn't take long to change
his mind and returned to serving Milan). By the time the Vene-
tians decided to drop Sforza, it was already too late: besieged and
reduced to hunger—a contemporary account tells us that wheat was
being sold at ten ducats per moggio (roughly 150 litres)[155]—and tir-
ing of the demagogues who'd taken over the Republic, the Milanese
yielded in March 1450, and Sforza made his triumphal entry into the
city through the Ticino Gate on the 23rd of that month. Florence
was among the first to officially recognise his regime, and Cosimo
de' Medici had already managed to convince his fellow citizens to
abandon their alliance with Venice, arguing that, as the Florentine
historian Francesco Guicciardini would sum up many years later, 'if
he hadn't done that, the Venetians would have undoubtedly made
themselves the masters of that state, and taken over the rest of Italy
soon afterwards.'[156] The Visconti threat had long managed to trouble
their sleep, but the very idea of Venice's hegemony extending over the
entirety of northern Italy was a veritable nightmare. For this reason,
Milan and Florence would enjoy relatively good relations for more
than four decades, save for a few normal spats here and there, which
were merely dictated by the two states' different strategic needs.[157] Af-
ter all, having the new masters of Visconti's Dukedom as their allies
meant the Florentines could rely on a strong military force, which
would prove endlessly useful despite the frequent need to contribute to
Sforza's chronic lack of funds, which had been caused by the heavy—
albeit necessary—expenses that Sforza had had to make to guaran-
tee an effectively functional state, as well as his dynasty's prestige.

Francesco Sforza's conquest of Milan hadn't only been a personal triumph, but it also represented the victory of the system innovated by Muzio Attendolo, which relied on mixing family with war. Unlike the Bracceschi, the Sforzeschi never lacked a solid recruitment base, namely Cotignola, which granted them a certain measure of autonomy from the potentates that employed them from time to time. Moreover, the extended coterie that the Attendolis and later the Attendoli-Sforzas could draw from allowed them to forge enduring dynastic and territorial alliances: for instance, Alessandro Sforza married Constance da Varano, who was related to the lords of Camerino, and later Sveva da Montefeltro, who was related to the Counts of Urbino, and in 1445 he became the Lord of Pesaro. Over the course of the following generations, the marriage links of the Sforzas would considerably increase the family's power, up until foreign invasions, which began in 1494, and the resulting Italian wars upset the peninsula's political balance. This was exactly what Braccio da Montone and his successor Niccolò Piccinino had lacked, since, aside from a very brief period of time, neither of them had commanded anything more than handfuls of Umbrian exiles or armies made up entirely of mercenaries, who, like the Manfredis of Faenza, were independent lords with their own political agendas. Reliant as he was on Filippo Maria Visconti for his sustenance, Piccinino never enjoyed the room for manoeuvre that Sforza had at his disposal: Piccinino's hopes to become the Lord of Perugia had been dashed not once, but twice, in 1440 and 1444, simply because the duke had changed his mind at the last minute; however, if Piccinino had triumphed at Anghiari, he would have been able to fulfil his territorial ambitions and

thus secure a base as solid as Sforza's. Given that Piccinino had also sought Bianca Maria Visconti's hand, his marriage to Filippo Maria's heir might have led to a Braccescho dynasty in Lombardy, thus altering the course of Italian history, as well as the artistic development during the Renaissance.

This last aspect should not be underestimated. Art, like all things in this world, needs money in order to survive, as well as the political infrastructure to allow it to develop. Even if it hadn't brought about a regime change in Florence, a defeat for the allies at Anghiari would have nevertheless weakened Cosimo de' Medici's position in the city, thereby hindering his architectural and artistic projects, like building a new palace or commissioning Donatello's *David* or *Judith and Holofernes*. At a time when the Commune risked being overwhelmed by external forces, the Florentines, envious and hypocritical by nature, probably would not have looked kindly on these projects. One could also argue that a Milanese victory in 1440 could have interrupted the trend towards naturalism, which we associate with the Renaissance today, and which was then starting to prevail in Florentine artistic activities. The survival of the International Gothic style in Florence can be detected in the resistance that the painter Paolo Uccello encountered when he was working on the fresco depicting the condottiere John Hawkwood in the Basilica of Santa Maria del Fiore (commonly referred to as the Duomo), a situation partly caused by Uccello's politics, but primarily explained by the Florentines' typically conservative leanings.[158] Hence, the aforementioned *The Battle of San Romano* could also be interpreted as the victory of an artistic style that the majority of the public still found

difficult to accept; indeed, the success of the Renaissance style in Florence can largely be attributed to the efforts of private patrons, and especially the Medici oligarchy that consolidated its hold on power in the wake of the battle of Anghiari. Furthermore, the allies' victory allowed the Council of Florence to carry on its work, and those four years of intense cultural exchanges between the West and the East would contribute a great deal to the diffusion of humanism in Italy. The Florence–Milan axis, which would later include Naples and, depending on the Pontiff in power, occasionally Rome, would prove an excellent vehicle for the spread of these new cultural trends, especially following the Treaty of Lodi in 1454. In addition, many of the petty courts of central Italy, which were tied to these powers in one way or another, would become important centres of cultural and artistic production during the Renaissance.

To a certain extent, the defeat of the Milanese on June 29, 1440, and the political developments that ensued, benefited Eugenius IV. Without the Duke of Milan's backing, Antipope Felix V was left powerless, and gradually all of the other rulers who'd supported the Synod of Basel opted to reconcile with Rome. Nonetheless, the 'little Western schism' left its mark, and over the course of the following century, the conciliarist spirit would give rise to the Protestant Reformation. More than anything else, the decade of division within the Church had weakened the Pope's temporal authority in more ways than one (one need only consider the Pragmatic Sanction of Bourges[159]), while the Pope's spiritual authority would be constantly undermined throughout the second half of the fifteenth century by the various pontiffs' materialism, nepotism and whoring, not to

mention their scepticism. It is no coincidence that one of the victors of Anghiari, the Patriarch of Aquileia, Lodovico Trevisan, like his predecessor Cardinal Vitelleschi, embodied all the attitudes and vices of Renaissance clergymen. Renowned for his profligacy and penchant for luxury, legend has it that Trevisan once gambled away 8,000 ducats in a single night, but still enjoyed the favour of Eugenius IV's successors, until the wrath and pain of seeing his old enemy Pietro Barbo (Paul II) elevated to the Papacy led him to his death on March 22, 1465. He left his nephews a considerable fortune, which ironically was confiscated by Paul II to fund a few religious charities.

By the time of Trevisan's death, the main protagonists of Anghiari had already died or would soon do so. Astorre Manfredi, who'd been gravely wounded during the battle and taken prisoner by Niccolò Gambacorti, ended up being sold by the latter to the Florentines for 3,000 florins and locked up in the Stinche. Manfredi believed that Gambacorti's conduct had infringed upon the rules of war (although he couldn't have done otherwise given the agreements he'd made with his employers), and he'd sworn he would exact his revenge: as soon as he was released, following the Treaty of Cavriana, one of the first things Manfredi did was find Gambacorti and stab him to death. Manfredi spent the rest of his life in the service of other Italian states, fighting against the French at Bosco Marengo and against the Florentines at the battle of Riccardina in 1467, succeeding to fulfil his goal of preserving the independence of his state, and died at Faenza in March 1468. After the disaster at Caravaggio, the Venetians dismissed Micheletto Attendolo from their service. Although the Venetians weren't that upset by his loss, they were outraged by

his soldiers' looting, to the detriment of the Serenissima's subjects, during their retreat from Lombardy. With much of his reputation in tatters and by then an old man, Attendolo was routinely humiliated after he began fighting for the Florentines in 1452, when they refused to pay his salary or equip his troops. In the end, after much insistence, his cousin Francesco Sforza gave him the feud of Pozzolo Formigaro in the Alessandrino, and Attendolo died there in 1463, having been forgotten by everyone. His old friend Neri Capponi had passed away six years prior, his body laid to rest in a marble sarcophagus commissioned from Bernardo Rossellino, which can still be seen in the Church of Santo Spirito. For various reasons, one could call him a survivor, rooted in the same politics espoused by his father Gino: Florence had to be governed by honest, decent men who loved their state 'more than their own soul', and not by vile sectarians, nor anyone who had designs on creating a personal regime. Inspired by these principles, Capponi had lent his support to Cosimo de' Medici's rise against Rinaldo degli Albizzi, but it hadn't taken him long to realise that Cosimo had no intention of abiding by the old rules of the Florentine oligarchy. Medici would prove to be a better strategist than Capponi during the clandestine struggles that characterised much of Italian politics after Anghiari, and he never bothered to create a power base loyal to him. Capponi's final defeat was the shift in alliances after Francesco Sforza conquered Milan. Having grown used to considering the Dukedom of Milan as the enemy of all that Florence stood for, and unconvinced by the Venetian threat, this development had been a serious blow to Capponi, who was aggravated that he'd been obliged to join the diplomatic embassy Florence

had dispatched to Venice in 1450, which ended in the dissolution of the alliance between the Commune and the Serenissima. After all, Capponi and the Florentine Bracceschi had never had the military resources they'd needed—given that Jacopo Piccinino and Carlo da Montone had by then entered Venice's service, which was now hostile to Florence—and Capponi had been far too loyal a citizen to try and seek help from the Commune's enemies. He continued to serve his city with the utmost devotion, and his reputation was such that Cosimo never dared give his ambitions for power free rein so long as Capponi was still alive, or at least that's what Machiavelli tells us.[160]

It's rather significant that barely a year after Capponi's death, Medici felt sufficiently strong to carry out a real coup d'état, using the sovereign will of the people as a fig leaf. The Treaty of Lodi in 1454, which led to the creation of the Italic League, grouped the major Italian powers into a stable alliance, but at the same time removed the emergency conditions that had allowed the *balìa* to keep its hold on power since 1434. The return of free elections to appoint the members of all the major magistracies and the restoration of the municipal councils' powers in the realms of electoral and fiscal legislation had threatened Cosimo's power: on more than one occasion the bimonthly Signorie had been controlled by strong anti-Medici majorities, and during secret meetings, these councils had vetoed laws and measures sponsored by the Medici oligarchy.

When one of the Medici's most loyal minions, Luca Pitti, had attempted to introduce public voting, he had been stopped by the decisive intervention of the Archbishop of Florence Antonino Pierozzi, who threatened to excommunicate anyone who threatened the

liberties of Florentine citizens. Medici decided to act. Having unsurprisingly secured Francesco Sforza's military backing, the strongly pro-Medici Signoria elected for the months of July and August 1458 convened a parliament and took care to surround the square where the assembly would convene with soldiers. Faced with this display of brute power, Florence's citizens could do little but approve the creation of a new *balìa*, which shortly afterwards led to the creation of the Council of One Hundred, which was jam-packed with Medici supporters and exercised power over all financial, electoral and military aspects of the city's life. The regime further tightened its hold on power by exiling all those who opposed this new political order, or taxed them into ruin. Although Cosimo had become, as Pius II put it, 'a king in all but name and pomp', he continued to behave just like any other ordinary citizen, even though all the important decisions now took place in his new Medici Palace on Via Larga. Not everyone in Florence was happy with the situation and 'some claimed that Cosimo's influence was intolerable,'[161] even in comparison to the city's other oligarchs.

Medici died in 1464, bequeathing his son a legacy that included, among other things, the support of the Sforza dynasty. Before passing away in March 1466, the Duke of Milan[162] would do his old friend—and himself—an additional favour by killing Jacopo Piccinino in collusion with the King of Naples, Ferdinand I of Aragon, who'd succeeded his father Alfonso in 1458. Having been lured to Naples, Piccinino was betrayed; he was arrested along with his sons and strangled to death at Castelnuovo in July 1465. After the Treaty of Lodi, Piccinino had become a troublesome presence in Italian

politics, having tried to conquer both Siena and Perugia manu mili-
tari and become their lord, and fighting for John II of Anjou, the
son of René, when John tried to reconquer the Kingdom of Naples
after Alfonso's death. Moreover, as was later proved by the question-
ing of Piccinino's secretary, Brocardo da Persico, Jacopo had been in
touch with anti-Medici dissidents in Florence, some of whom even
belonged to Cosimo's inner circle, who'd been intent on restoring
the pre-1458 status quo. The downfall of the Medici regime might
have led to a renewed alliance between Florence and Venice (not to
mention Pope Paul II), upset the equilibrium of Italian politics, and
brought about the return of the Bracceschis' glory days, a decid-
edly nightmarish outlook for the Sforzas. It was no coincidence that
when the anti-Medicis tried to violently overthrow Piero de' Medici
in August 1466, the latter secured the help of the new Duke of Mi-
lan, Galeazzo Maria Sforza, and it was the Venetians who aided the
Florentine exiles in their attempt to re-enter the city the following
year, supported by troops led by the old Braccescho stalwart Bar-
tolomeo Colleoni. But with Jacopo Piccinino dead and his sons in
prison, Ferdinand of Aragon had been all too right to claim that 'all
the roots of the Bracceschi had been pulled out.'[163] The drama that
had begun with Niccolò Piccinino's defeat at Anghiari had reached
its denouement. Rinaldo degli Albizzi had been among the first to
realise that the outcome of Anghiari had led to the entrenchment of
the Medici regime. Having resigned himself to his fate, Rinaldo had
sought relief from his disgrace in the bosom of religion; he made a
pilgrimage to the Church of the Holy Sepulchre in Jerusalem and
died in Ancona in 1442. Palla Strozzi was the last of his acolytes to

die, and he breathed his last at the age of ninety in Padua in 1462. Strozzi had continued to play patron of the arts and had hopes of returning to his native city right to the very end, despite the fact that Florence's rulers had haughtily renewed his exile every time his sentence had run its course. One can still gaze at Strozzi's features in Gentile da Fabriano's *Adoration of the Magi*, now housed in the Uffizi Gallery in Florence, where he can be clearly spotted in the background, at a respectful distance from the major characters. Cosimo de' Medici wasn't anywhere near as humble when he commissioned Benozzo Gozzoli to paint a series of frescoes depicting the procession of the Magi for the chapel of the Medici Palace: in this painting, Cosimo and his son Piero are in the foreground, followed by a crowd of characters including Sigismondo Pandolfo Malatesta and Galeazzo Maria Sforza. This wasn't merely the deification of Medici power, it was also the apotheosis of naturalism as an artistic style, as well as of the political stability that Cosimo had helped forge in Italy. In this sense, we can also consider it as the triumphal cortege of the victory of Anghiari.

Epilogue

A MACHIAVELLIAN DESTINY

Giorgio Vasari spent a long time examining the hall of what had become known as the Palazzo Vecchio ever since the ruling family had left it for another building, which had once belonged to the Pitti family. The Arezzan artist had a large commission to complete: the Duke of Florence, Cosimo I de' Medici, had instructed him to redecorate the entire palace 'to emphasize the principles of the state and its gradual spread.'[164] *In other words, the pictorial cycle he was about to begin would need to celebrate the glory of Florence through the eyes of the House of Medici. There was only one problem left to resolve, but it wasn't insignificant: what would he do with the frescoes that adorned what had been the Great Council Hall of the Florentine Republic? It would certainly have been easier to destroy them, but neither the duke nor Vasari could afford to be labelled uncivilised. After all, the paintings had been carried out by that undisputed genius, Leonardo da Vinci.*

Not that the master's work had been perfect on that occasion, mostly owing to his obsession with experimentation: 'Wanting to paint his

colours on the wall in oil, he prepared a mixture so thick for the plaster that while he continued to paint his fresco in that room, the plaster began to drip, so much so that he quickly had to abandon it.'[165] *There were stories that said Leonardo had tried to dry the paint by using open braziers and that the artist had been bamboozled by the person who'd sold him the linseed oil, which had caused the plaster mix to flake and fall apart. Nevertheless, what remained on the wall was an isolated episode, an incomplete but extremely beautiful snippet of what would have been a series of frescoes dedicated to the battle of Anghiari; but the tangled mass of men and horses was also an obstacle to the ambitions of the Duke of Florence and the Arezzan painter.*

Vasari knew he had to proceed with caution, but he had no intention of stopping. He was one of the most distinguished artists at the Medici court, and he had many rivals who were just as accomplished and ambitious. That braggart Benvenuto Cellini and that con artist Baccio Bandinelli had often caused him many problems. Luckily, Michelangelo had remained in Rome, despite Cosimo's invitation to return to his native land: Buonarroti would have been impossible to compete with, even though he'd also left a trail of unfinished projects in his wake. In the very room where Vasari now stood, Michelangelo had once tried to paint The Battle of Cascina, *but he'd given up on it after completing only a few cartoons. The Arezzan artist now had the opportunity to achieve what greater artists had failed to accomplish. Decorating that hall would allow him to take his revenge against his Florentine colleagues, who'd nicknamed him 'Little George' due to his short stature and who'd teased him for his native Arezzan accent, which he'd never been able to get rid of. However, for the time being he would have to come up with a solution*

that would allow him the best of both worlds: to execute the project that
he and the duke had conceived without destroying the existing frescoes.
Besides, there was no reason why he had to use the same wall that Leon-
ardo had painted on . . .

For more than sixty years, Visconti's banners, which had been
captured at Anghiari, gathered dust in the Palazzo della Signoria
(now the Palazzo Vecchio): the passing of time, the consolidation of
the Medici regime and the shift of alliances in Italy had coalesced
in dimming the memory of that battle until it had grown weaker
and weaker. Once the major protagonists had died, the recollec-
tion of that day remained confined to the writings of a handful of
historians, or a few grey-haired survivors who refused to heed God's
summons.

In 1494, a French army led by Charles VIII of Valois fell upon
Italy, slicing through the peninsula like a knife through butter. The
king's invasion triggered a political earthquake in Florence, where
the reigning Medici family was exiled from the city, and a new, more
democratic constitution initiated by the Domincan friar Girolamo
Savonarola was put into place. However, the newly born Florentine
Republic was immediately thrown into a series of conflicts, chief
among them the re-conquest of Pisa, which had rebelled against Flor-
ence's rule slightly prior to that. The war immediately took a turn for
the worse, as Florence lacked the military capacity to take decisive
action and was once again forced to rely on condottieri, who were
often treacherous. The failure to subdue Pisa, coupled with internal

tensions, would eventually lead to Savonarola's arrest and execution in 1498. Nevertheless, this did not lead to a better outcome in the Pisan war, and the Florentines even went so far as to accuse their commander in chief Paolo Vitelli and have him executed. It was only thanks to a considerable stroke of good fortune that Florence managed to overcome several crises over the course of the following years, among them the rebellion of many of its territories, engineered primarily by Cesare Borgia, the son of Pope Alexander VI. The death of this pope in 1503 gave the city a little respite, but it was still burdened by the Pisan problem and its scant military capacity. It furthermore lacked a cohesive force to bind all the various political groups in the city, which were often locked in bitter sectarian conflict.

This was the climate in which the project to redecorate the hall of the Great Council, the main legislative body of Florence, with paintings exalting past military glories, was birthed. The choice of subjects to be depicted in these paintings came down to two episodes from its history, perhaps the only ones that the Florentines could truly claim as their own: the battle of Cascina and the battle of Anghiari. The battle of Cascina, which had been fought in 1363, had the indisputable advantage that the Florentines prevailed against the Pisans (the fact that Pisa had later hired John Hawkwood's company could be easily omitted). Choosing Anghiari, on the other hand, would have presented a few problems: while it had certainly been a triumph of Florentine liberties, it had come at a moment when Florence had been ruled by the oligarchy of Cosimo 'the Elder' de' Medici, not to mention the fact that one of the Florentine commissioners present at the battle had been one Bernardetto de' Medici, and anti-Medici

spirit was one of the Republic's pillars. Besides, Florence had been allied to Venice at the time, and the Serenissima was by then doing everything that it could to prevent Florence from re-conquering Pisa. But then there was also the fact that Neri Capponi could be considered one of the principal architects of the victory, and his nephew Piero had defended the city's freedom, which had been threatened by the exorbitant demands of Charles VIII. The presence of Visconti's captured banners in the Great Council Hall was an additional incentive, and thus, in October 1502, Leonardo da Vinci was commissioned to paint a great fresco depicting the battle of Anghiari.

Aside from a very brief period, Leonardo had been absent from Florence for roughly a couple of decades, having gone to work for the Sforzas of Milan from 1482 to 1500, as well as for other rulers, including Cesare Borgia, up until 1502. Having been in the grips of an economic crisis for approximately a decade, Florence was in no position to offer an artist of Leonardo's calibre many palatable prospects, and it is of some significance that the commission for the Anghiari fresco had come at a time in which Florence was starting to recover and a modest amount of money had started to trickle through the city again. During his stay in Milan, Leonardo had planned the great equestrian statue to commemorate Francesco Sforza and completed his celebrated *The Last Supper*. The French invasion of Milan in 1499 had forced the artist to emigrate, and his model for the equestrian statue had been left to the mercy of the elements and the vandalism of the occupying forces. Even *The Last Supper* was causing him problems thanks to the technique he'd employed to paint it: the humidity of its setting had made the colours run. Nevertheless, Leonardo was

considered one of the great master painters, and it was very presti-
gious for Florence to have employed him.

In his notes, da Vinci had drawn up the plans for his fresco,
which was imbued with religious and classical references: Trevisan
was to be depicted kneeling in prayer as a counterpoint to the trophy
held aloft by the defeated enemies. Indeed, Trevisan loomed large in
Leonardo's plans, and he would effectively have been shown as the
true victor of the battle, rather than the Florentine commissioners or
the other allied condottiere, even though Leonardo had also planned
to include Neri Capponi, Bernardetto de' Medici, Micheletto At-
tendolo, Pietro Giampaolo Orsini and Niccolò Gambacorti among
his cast.[166] Why Leonardo chose to emphasise Trevisan's role in these
events remains enshrouded in mystery, but it is fair to hazard a few
guesses. For starters, one should remember that the project was the
result of a few meetings between the artist and the Florentine author-
ities, who were adamant that the fresco should not be a vindication
of the Medici regime. Secondly, the gonfalonier in charge at the time
had been Piero Soderini, one of the leaders of the *populares* faction
which was opposed to that of the *optimates*—even though Soderini
technically belonged to the latter by virtue of his birth—which
counted the Capponis among its members. Thirdly, highlighting
Attendolo's role would mean paying tribute to the Venetians—the
same argument applied to the other condottieri, who had caused
Florence so many difficulties in recent years, and who were abhorred
by Niccolò Machiavelli, the secretary of the Dieci di Balìa. Lastly,
emphasising Trevisan's presence was part and parcel with the Flo-
rentine Republic's desire to be grounded in religious values, if not its

allegiance to the Papacy, which nevertheless required it to portray the Church as the earthly embodiment of Jesus Christ.

One can only imagine what someone like Machiavelli must have thought of that whole matter, considering his notoriously critical stance towards both religion and the clergy, and it can't be ruled out that he might have been involved in the fresco's planning, and certain issues raised in Leonardo's notes cannot preclude one from assuming that the secretary of the Ten might have exerted his powerful influence. Yet glossing over the accuracy of what had really happened at Anghiari might have seemed like a political necessity, meaning the historical truth would be sacrificed for reasons of state. After all, Machiavelli would continue to dedicate himself to the subject of that battle and would determine its relevance in future historiographies.

Leonardo worked on the fresco for two and a half years, abandoning work on the project in May 1506 to return once again to Milan, where he was summoned by the French governor Charles II d'Amboise. This was the official reason given, but Leonardo's contemporaries believed that his real motivation lay in the failure of the technique that he'd employed, which, for whatever reason, had caused the colours to run. Leonardo's decision might have also been influenced by his quarrelling with Michelangelo, who'd been commissioned to paint *The Battle of Cascina*; and da Vinci would have probably preferred to relocate to Milan, where he would have been at the top of the pile, rather than staying in Florence and sharing the laurels with his fiercest rival. The fact remains that Buonarroti also left his painting unfinished and the only memento of either artist's having been in the Great Council Hall is enshrined in Leonardo's

scene depicting *The Battle of the Standard*, one of the most important moments of the battle of Anghiari.

The Great Council Hall was vacated by its representatives in 1512, when the Medici returned to Florence at the head of Spanish troops fresh from the brutal sack of Prato. Machiavelli was one of the victims of this political revolution, and he was dismissed from his post as secretary and forced to retire to the countryside for some time. Years later, after he had worked his way back into the Medicis' graces, they entrusted Machiavelli with the task of writing the *Florentine Histories*, in which he also discussed the battle of Anghiari. In those pages, he skilfully traced the decisive consequences of that clash, writing: 'This victory proved much more advantageous for Tuscany than injurious to Duke Filippo; for, if the Florentines had lost the battle, Tuscany would have been his.' So far, so good; the problem, rather, was that Machiavelli had very peculiar ideas as to what constituted historical truth. In fact, he also added:

[. . .] and in so complete a rout and so long a combat, which lasted nearly twenty-four hours, there was only one man killed, and he was not wounded nor struck down by a valiant blow, but fell from his horse and was trampled to death.[167]

Machiavelli had a grudge against mercenaries, devoid as they were of the civic virtues behind the Florentine militia that he had helped establish in 1506. Describing Anghiari as a battle that only caused a single casualty was an instance of him using his quill to wage a personal vendetta against professional soldiers, the very same

people who'd inflicted a stinging defeat on his militia at Prato. Given that Machiavelli was surely well acquainted with the works of Flavius Blondus and Bartolomeo Platina, both of whom cited far higher casualties, it's not wrong to assume that the *Florentine Histories* was a fraudulent piece of literature. Yet Machiavelli's reputation would ensure that the battle of Anghiari would be remembered for that single casualty who 'fell from his horse and was trampled to death' rather than for its more lasting consequences. Even though the German historian Willibald Block clearly demonstrated at the beginning of the twentieth century that Anghiari hadn't at all been a 'bloodless battle,'[168] the myth of wars during the Renaissance being a 'joke' has endured.

That the memory of the battle was consigned to oblivion was also aided by the disappearance of Leonardo's fresco. In 1563, when Duke Cosimo I charged Giorgio Vasari with refurbishing and redecorating what had once served as the Great Council Hall, the Arezzan artist was commanded to cover the walls with paintings depicting all the glorious successes of the House of Medici, thus blotting out *The Battle of the Standard*. Nevertheless, Vasari probably wouldn't have dared to destroy Leonardo's work, knowing that it would have stirred up a hornet's nest of criticism. Yet throughout the ensuing four centuries, it was widely assumed that the Anghiari fresco had been lost forever, and that it only survived in a handful of more or less accurate reproductions, produced by those who'd managed to see it before Vasari's interference.

However, there has been a renewed interest in the vanished work for the past few years and several figures in the art world have

become convinced that this lost masterpiece could be salvaged. Employing sophisticated modern techniques, the Florentine engineer Maurizio Seracini has managed to carry out a series of non-invasive tests on the eastern wall of what today is called the Hall of the Five Hundred. His research produced an amazing result: the discovery of a sixteen-centimetre gap behind the painting of *The Battle of Marciano*, which is marked by the inscription 'seek and you shall find' on one of the battle-standards. Perhaps this was the message that Vasari left behind in order to avoid the *damnatio memoriae* that would have rained down upon him if he'd gone ahead and destroyed Leonardo's painting.[169] Further research would require fairly generous funding and tremendous political willpower; after all, the story of the battle of Anghiari is an equal mix of money and power: *nervos belli pecuniam infinitam*, or, 'endless money forms the sinews of war'.

BIBLIOGRAPHICAL
NOTES AND
FURTHER READING

Sextodecimos leave no margin for error, especially at a time when a publisher's costs have risen exponentially more or less despite the advent of new, sophisticated technologies. For this reason, aside from restricting the number of references in this text to their absolute minimum, I opted to compile a bibliographical summary of all my chapter notes rather that produce an exhaustive list of sources that would be tens of pages long. Nevertheless, I trust that this will allow the reader to avail themselves of more constructive suggestions—even in the case of more specialist literature—rather than spend hours trawling through archives, libraries or the Internet only to wind up finding books that might turn out to be of little interest.

PRIMARY SOURCES, MANUSCRIPTS AND PRINT MEDIA

The main manuscripts used in the writing of this volume are available in various archives and libraries.

On the subject of Florence, one should especially see the following in the Florence State Archives: *Dieci di Balìa, Consulte e pratiche, Signori, Provvisioni, Miscellanea repubblicana, Carte strozziane.* The entirety of the *Mediceo avanti il Principato* collection has been scanned and is available online: www.archiviodistato.firenze. it. As for the more relevant print collections, one should refer to the four volumes of *Capitoli del comune di Firenze. Inventario e regesto* (Florence: Cellini, 1866–1893) and the three-volume *Commissioni di Rinaldo Degli Albizzi per il Comune di Firenze dal 1399 al 1433*, edited by C. Guasti (Florence: Cellini, 1867–1873). The hefty documentary appendix to F. C. Pellegrini's *Sulla Repubblica fiorentina a tempo di Cosimo il Vecchio* (Pisa: Nistri, 1889) is also of great interest.

On the subject of ecclesiastical domains, all the relevant documentation can be accessed at the Archivio di Stato di Roma (Rome State Archives) and in the collections to be found in Vatican City. As for print media, one should refer to the works edited by G. Gualdo: *Sussidi per la consultazione dell'Archivio Vaticano. Lo Schedario Garampi—I Registri Vaticani—I Registri Lateranensi—Le 'Rationes Camerae'—l'Archivio* (Vatican City: Archivio Segreto Vaticano, 1989). Also those edited by M.L. Lombardo, 'Rubricelle, repertori, indici per la ricerca degli atti dei segretari e cancellieri della Camera apostolica nell'Archivio di Stato di Roma', in *Archivi e cultura*, 1974, vol. viii, pp. 38–43 e 46–47; and those by G. Ramacciotti, *Gli archivi della Reverenda camera apostolica con inventario analitico-descrittivo dei registri camerali conservati nell'Archivio di Stato di Roma nel fondo Camerale primo* (Rome: Palombi, 1961). As for all documents of a military nature, one should consult the Rome State Archives'

following collections: *Soldatesche e Galere e Mandati Camerali*; as well as the *Armarium xxxiv. Instrumenta cameralia (1313–1826), Armarium xxix. Diversa cameralia (1389–1578) collections* in the Archivio Segreto Vaticano.

Venetian collections are particularly bountiful and the most important collections in the Archivio di Stato di Venezia are: *Consiglio dei Dieci, Maggior Consiglio, Senato e Commemoriali*. The manuscript collections in the Biblioteca Nazionale Marciana and the Biblioteca del Museo Correr are a veritable gold mine for historical and literary works written around the period in question. As for print media, one should consult the five-volume work edited by R. Predelli, *I libri commemoriali della Repubblica di Venezia. Regesti* (Venice: Società Veneta di Storia Patria, 1879-1901). As for Milan, the burning of the Ducal Archives on Filippo Maria Visconti's death doesn't afford one the same opportunity for as extensive research as one might conduct on other states at the time. Even various trips paid to various peripheral archives in cities that once belonged to the dukedom hasn't yielded many significant rewards. As for the Archivio di Stato di Milano, one should especially consult the following collections in the 'Archivi Viscontei' section: *Carteggio Visconteo* and *Registri Viscontei*. Among the most important print collections are G. P. Bognetti's *Per la storia dello stato visconteo. Un registro di decreti della cancelleria di Filippo Maria Visconti*, to be found in ASL,1927, a. liv, pp. 237–57; C. Manaresi's *I registri viscontei* (Milan: Palazzo del Senato, 1915, vol. I); C. Morbio's *Codice visconteo-Sforzescho, ossia raccolta di leggi, decreti e lettere famigliari dei duchi di Milano* (Milan: Società tipografica de' classici italiani, 1846); L. Osio's *Documenti diplomatici tratti dagli*

archivi Milanesi (Milan: Bernardoni, 1877, vol. III); and G. Vittani's *Gli atti cancellereschi viscontei* (Milan: Cisalpino-Goliardica, 1971, 2 vols.). As for the events regarding the Visconti papers, see F. Leverotti's 'L'archivio dei Visconti signori di Milano', in *Reti Medievali*, 2008, a. ix, which is available online at www.retimedievali.it.

The Archivio della Fraternita dei Laici di Arezzo holds all of Antonio di Viviano's documents, and he was the chief clerk of Micheletto Attendolo's mercenary company. One should consult A. Antoniella's *L'archivio della Fraternita dei laici di Arezzo* (Scandicci: La Nuova Italia, 1985, 2 vols.). Yale University owns the vast microfilm collection that was bequeathed to its library by the late Professor Vincent Ilardi, which features copies of various documents drawn from Italian and foreign archives and is a treasure trove for anyone researching the subject of Renaissance Italy. The collection's catalogue can be consulted online at www.library.yale.edu.

Anyone interested in primary chronicles and biographies besides those mentioned in the reference notes and in the chapter bibliographies should refer to the various volumes of the RIS and RRIISS, as well as the publications of the Archivio Storico italiano starting from 1840.

INTRODUCTION

For a historiographical analysis on the importance of historical events, see G. A. Brucker's 'The Horseshoe Nail: Structure and Contingency in Medieval and Renaissance Italy', in *Renaissance Quarterly*, 2001, vol. 54, n. 1, pp. 1–19.

PROLOGUE

For sources on the battle itself, I will refer the reader to Chapter 7. As for all information regarding the commissioning of Leonardo da Vinci's fresco on the battle of Anghiari, this can be found in L. Beltrami's *Documenti e memorie riguardanti la vita e le opere di Leonardo da Vinci* (Milan: F.lli Treves, 1919).

CHAPTER 1: 'NOW YOU HAE TO PUT UP WITH WAR . . .'

For Gian Galeazzo Visconti and the politics of the Visconti dukedom, see F. Cognasso, 'Il ducato visconteo da Gian Galeazzo a Filippo Maria', in Aa.Vv., *Storia di Milano*, vol. VI: *Il ducato visconteo e la repubblica ambrosiana (1392–1450)* (Milan: Fondazione Treccani, 1955, pp. 296–304); G. Franceschini's *La politica di Gian Galeazzo Visconti'*, *in Atti e Memorie del Primo Congresso Storico Lombardo* (Milan: A. Cordani, 1937, pp. 181–91); D. M. Bueno de Mesquita's *Gian Galeazzo Visconti, Duke of Milan (1351–1402)* (Cambridge: Cambridge University Press, 1941). For the dukedom's crisis following Gian Galeazzo's death see N. Valeri's 'Lo Stato Visconteo alla morte di Gian Galeazzo', in NRS, 1935, vol. xix, pp. 461–73. For the reconquest of the dukedom by Filippo Maria Visconti see G. Romano's 'Contributi alla Storia della ricostituzione del Ducato Milanese sotto Filippo Maria Visconti (1412–1421)', in ASL, 1896, vol. xxiii, s. 2, pp. 231–90 and ASL, 1897, vol. xxiv, s. 1, pp. 67–146; Nino Valeri's 'Facino Cane e la politica subalpina alla morte di Gian Galeazzo Visconti', in *Bollettino Storico Bibliografico Subalpino*, 1935, vol. xxxvii, pp. 17–45; F.

Cengarle's 'Gerarchie e sfere d'influenza nella pace di Milano del 1420. Il Reggiano tra Filippo Maria Visconti e Niccolò iii d'Este,' in *Medioevo Reggiano. Studi in ricordo di Odoardo Rombaldi*, edited by G. Badini and A. Gamberini (Milan: Franco Angeli, 2007).

As for Venetian expansion on the mainland, this is amply covered in G. Cozzi and M. Knapton's *La Repubblica di Venezia nell'età moderna. Dalla guerra di Chioggia al 1517* (Turin: UTET, 1986). Also consult G. Gullino's 'La politica veneziana di espansione in Terraferma', in *Il primo dominio veneziano a Verona (1405–1509)*, papers from the conference held at Verona on September 16–17, 1988 (Verona: Fiorini, 1991, pp. 7–16). For Venetian politics during the period in question see the excellent volume by D. Romano, *The Likeness of Venice. A Life of Doge Francesco Foscari, 1373–1457* (New Haven: Yale University Press, 2007).

For Florentine politics and the city's resistance to Gian Galeazzo Visconti, this is studied extensively in G.A. Brucker's, *Dal Comune alla Signoria. La vita pubblica a Firenze nel primo Rinascimento* (Bologna: Il Mulino, 1981). For Florence's territorial politics before and after Gian Galeazzo Visconti's death see M. Luzzati, 'Firenze e l'area toscana', in *Storia d'Italia* (Turin: UTET, 1987, vol. vii, t. i, pp. 561–828); P. Silva's 'Pisa sotto Firenze dal 1406 al 1433', in *Studi storici*, 1909, n. 18, pp. 133–83. For the relationship between Florence and its domains, see A. Zorzi and W. Connell's *Lo Stato territoriale fiorentino (secoli xiv–xv). Ricerche, linguaggi, confronti* (Pisa: Pacini, 2002).

For the crisis of the Papacy at the beginning of the fifteenth century, the Council of Constance and the 'conciliarist' thesis, see L. Tosti's *Storia del Concilio di Constance* (Naples: Stabilimento

Tipografico di Poliorama, 1853, vol. 2); B. Tierney's *Foundation of the Conciliar Theory. The Contribution of the Medieval Canonists from Gratian to the Great Schism* (Leiden: Brill, 1998); P. Fedele's 'I Capitoli della pace fra re Ladislao e Giovanni xxiii', in *ASPN*, 1905, n. 30, pp. 179–212; D. Girgensohn's '"Io esghonbro per paura". Roma minacciata da Ladislao di Angiò Durazzo (1407–1408)', in *Per la storia del Mezzogiorno medievale e moderno. Studi in memoria di Jole Mazzoleni* (Rome: Ministero dei Beni culturali ambientali, 1998, pp. 249–70). For the Church's territories under Martin V see P. Partner's *The Papal State under Martin V. The Administration and Government of the Temporal Power in the Early Fifteenth Century* (London: British School in Rome, 1958). For Martin V's relationship with Braccio da Montone see L. Pasqualucci's *Braccio da Montone al soldo di Martino V* (Trani: Vecchi, 1880); R. Valentini, 'Lo stato di Braccio e la guerra Aquilana nella politica di Martino v', in *ASRSP*, 1929, vol. LII, pp. 223–380. As for Braccio da Montone, in addition to Campano's biography which is cited in the notes, also see M. V. Baruti Ceccopieri's *Braccio da Montone e i Fortebracci*, papers relating to the international conference of studies (Montone 23–25 March, 1990), Centro Studi Storici, Narni 1993).

Visconti's occupation of Genoa is examined in R. Musso's 'Le istituzioni ducali dello "Stato di Genova" durante la signoria di Filippo Maria Visconti', in *L'età dei Visconti. Il dominio di Milano tra xiii e xv secolo*, edited by L. Chiappa Mauri, L. De Angelis Cappabianca and P. Mainoni (Milan: La Storia, 1998, pp. 65–111). For the conflict that took place between 1424 and 1428, see S. Bombardini's 'L'espansione viscontea in Romagna (1424–1426)', in *Studi*

Romagnoli, 1991, vol. xlii, pp. 447–69; I. Raulich's 'La prima guerra fra i Veneziani e Filippo Maria Visconti', in *RSI*, 1888, a.5, pp. 441–68, 661–96; L. Mascanzoni's 'La battaglia di Zagonara (28 luglio 1424)', in *La norma e la memoria. Studi per Augusto Vasina*, edited by T. Lazzari, L. Mascanzoni and R. Rinaldi (Rome: Istituto storico italiano per il Medioevo, 2004, pp. 595–49).

R. Fubini's volume *Italia quattrocentesca. Politica e diplomazia nell'età di Lorenzo il Magnifico* (Rome: Franco Angeli, 1994) is useful for understanding the political situation in fifteenth-century Italy.

CHAPTER 2: MARS, THE MERCENARY

For an overview on the practices of war during the Middle Ages see P. Contamine's *La guerra nel Medioevo* (Bologna: Il Mulino, 2005). For an Italian perspective see A. Settia's *Comuni in guerra. Armi ed eserciti nell'Italia delle città* (Bologna: Clueb, 1993); in addition to the old, but still valid study by P. Pieri, *Il Rinascimento e la crisi militare italiana* (Turin: Einaudi, 1970). For everything regarding mercenary companies, M. E. Mallett's *Mercenaries and Their Masters: Warfare In Renaissance Italy* (London: The Bodley Head, 1974); still of some value is E. Ricotti's four-volume work, *Storia delle compagnie di ventura in Italia* (Turin: E. Pomba, 1845).

There are very few recently published biographies of mercenary captains, and they tend to be of a fairly bad quality. The exceptions to this rule are W. P. Caferro's *John Hawkwood. An English Mercenary in Fourteenth-Century Italy* (Baltimore: The Johns Hopkins University Press, 2006); L. Mascanzoni's 'Muzio Attendolo da Cotignola,

capostipite degli Sforza', in *NRS*, 2005, vol. lxxxix, n. 1, pp. 55–82.
For a more cogent discussion see S. Ferente's, *La sfortuna di Jacopo
Piccinino. Storia dei bracceschi in Italia 1423–1465* (Florence: Olschki,
2005), as it deals with the Piccinino dynasty of condottieri. Among
older works see A. Battistella's *Il conte Carmagnola* (Genoa: Stab.
Tip. e Lit. dell'Annuario Generale d'Italia, 1889); B. Belotti's *La vita
di Bartolomeo Colleoni* (Bergamo: Istituto Italiano d'arti grafiche,
1951); G. Benadduci's *Biografia di Giovanni Mauruzi da Tolentino*
(Tolentino: Filelfo, 1887); A. Fabretti's *Biografie di capitani ventu-
rieri dell'Umbria* (Montepulciano: Furni, 1843, 3 vols.); E. Rubieri's
Francesco I Sforza (Florence: Le Monnier, 1879); N. Valeri's *La vita
di Facino Cane* (Turin: Società Subalpina Editrice, 1940). For bio-
graphical accounts produced during the period in question see G.A.
Campano and G.B. Poggio's, *L'Historie et vite di Braccio Fortebracci
detto da Montone, et di Nicolo Piccinino Perugians. Scritte in latino,
quella da Gio. Antonio Campano, e questa da Giovambattista Pog-
gio Fiorentino, e tradotte in volgare da M. Pompeo Pellini Perugino*
(Venice: Francesco Zilletti, 1572); A. Minuti's 'Vita di Muzio At-
tendolo Sforza', edited by G. Porro Lambertenghi, in *Miscellanea
di storia italiana*, 1869, vol. vii; G. Simonetta's *Sfortiade fatta itali-
ana de li gesti del generoso & invitto Francesco Sforza, qual per pro-
pria vertù divenne duca di Milano, distinta in lib. 30* (Venice: Curzio
Troiano, 1543); L. Spirito's *Incomincia il libro chiamato Altro Marte.
Della vita [e] gesti dello illustrissimo [e] potentissimo capitanio Nicolo
Picinino da Perosa, Visconti de Aragonia* (Verona: Simone Bevil-
acqua, 1489).

Recent years have seen a few efforts to bring Italian military

structures into focus, in particular C. Ancona's 'Milizie e condot-
tieri', in *Storia d'Italia. I Documenti*, edited by R. Romano and C.
Vivianti (Turin: Einaudi, 1973, vol. v, t. i, pp. 643–65); P. Blasten-
brei's *Die Sforza und ihr Heer. Studien zur Struktur-,Wirtschafts- und
Sozialgeschichte des Soldnerwesens in der italienischen Frührenaissance*
(Heidelberg: Winter Universitätsverlag, 1987); W.P. Caferro's 'War-
fare and Economy in Renaissance Italy, 1350–1450', in *Journal of In-
terdisciplinary History*, 2008, vol. xxxix, n. 2, pp. 167–209; M. N.
Covini's '"Alle spese di Zoan villano": gli alloggiamenti militari nel
dominio visconteo-Sforzescho', in *NRS*, 1992, vol. lxxxv, pp. 1–56;
id., *L'esercito del duca. Organizzazione militare e istituzioni al tempo
degli Sforza 1450–1480* (Rome: Istituto Storico Italiano per il Me-
dioevo, 1998); id., 'Per la storia delle milizie viscontee. I familiari
armigeri di Filippo Maria Visconti', in *L'età dei Visconti*, cit., pp.
35–63; P. Mainoni, 'Mutui alle compagnie di ventura al servizio dei
Visconti', in id., *Economia e politica nella Lombardia medievale. Da
Bergamo a Milano fra xiii e xv secolo* (Cavallermaggiore: Gribaudo,
1994, pp. 129–58); M. E. Mallett's *L'organizzazione militare di Vene-
zia nel Quattrocento* (Rome: Jouvence, 1989); id., 'Preparations for
War in Florence and Venice in the Second Half of the Fifteenth Cen-
tury', in the volume edited by S. Bertelli, N. Rubinstein and C. H.
Smyth, *Florence and Venice. Comparisons and Relations. Acts of Two
Conferences at Villa I Tatti in 1976–1977* (Florence: La Nuova Italia
Editrice, 1979, vol. I, pp. 149–64); id., 'The Military Organisation of
Florence and Venice in the Fifteenth Century,' a paper delivered at
the sixteenth week of studies at the Istituto internazionale di Storia
economica 'F. Datini' dedicated to the 'Economic aspects of war

in Europe between the fourteenth and eighteenth centuries) which took place in Prato on May 5–9, 1984.

Micheletto Attendolo's mercenary company has been the beneficiary of a fair few studies, thanks to the availability of documentation. See M. Del Treppo's 'Gli aspetti organizzativi, economici e sociali di una compagnia di ventura italiana', in *RSI*, 1973, a. 85, n. ii, pp. 253–75; id., 'Sulla struttura della compagnia o condotta militare', in *Condottieri e uomini d'arme nell'Italia del Rinascimento*, edited by M. Del Treppo (Naples: Liguori, 2001, pp. 417–51); E. Vittozzi's 'Micheletto degli Attendoli e la sua condotta nel regno di Napoli (1435–1439)', in *ASPN*, 2006, n. 124, pp. 21–111. However, there is still a great deal of research to be done regarding military organizations in fifteenth-century Italy, if one keeps in mind for example that the only existing study on the pontifical army is the rather ancient A. Da Mosto's 'Ordinamenti militari delle soldatesche dello Stato Romano nel secolo xvi', in *Quellen und Forschungen aus italienischen Archiven und Bibliotheken*, 1904, vol. vi, pp. 72–133. G. Canestrini's old analysis 'Documenti per servire alla storia della milizia italiana. Dal xiii secolo al xvi', in *ASI*, 1851, a. xv, is still fairly useful in regards to its use of primary sources.

There aren't many works on the practice of war in fifteenth-century Italy; aside from the first part of P. Pieri's *Il Rinascimento e la crisi militare*, cit., and chapter VII in M.E. Mallett's *Mercenaries and Their Masters*, I would refer the reader to C. J. Rogers's 'Tactics and the face of battle', in F. Tallet and D.J.B. Trim's *European Warfare, 1350–1750* (Cambridge: Cambridge University Press, 2010, pp. 203–35); A. Settia's *De re militari. Pratica e teoria nella guerra medievale*

(Rome: Viella, 2008); although it focuses more on modern rather than medieval aspects, B. S. Hall's *Weapons and Warfare in Renaissance Europe* (Baltimore: The Johns Hopkins University Press, 1997) is still very useful. As for the dynamics of pitched battled, due to academic snobbery against the histoire bataille genre we must still rely on W. Block's, 'Die Condottieri. Studien über die sogenannten "unblutige Schlachten"', in *Historische Studien* (Berlin: Ebering, 1913).

CHAPTER 3: THE WAR OF ART

For an analysis of Palla Strozzi's commissions, see H. Gregory's 'Palla Strozzi's Patronage and Pre-Medicean Florence', in *Patronage, Art and Society in Renaissance Italy*, edited by F. W. Kent and P. Simmons (Oxford: Clarendon Press, 1987). For the Brancacci Chapel see various essays in N. A. Eckstein's edited volume, *The Brancacci Chapel. Form, Function and Setting* (Florence: Olschki, 2007).

For Maso degli Albizzi's politics see R. Ninci's 'Maso degli Albizzi e la strategia del consenso', in A. Degrandi's *Scritti in onore di Girolamo Arnaldi offerti dalla Scuola Nazionale di Studi medioevali* (Rome: Istituto Storico Italiano per il Medioevo, 2001, pp. 355–91). On the catasto of 1427, see O. Karmin's *La legge del catasto fiorentino del 1427. Testo, Introduzione e Note* (Florence: Seeber, 1906); D. V. Herlihy and C. Klapisch-Zuber's *Tuscans and their Families. A Study of the Florentine catasto of 1427* (New Haven: Yale University Press, 1989). The Florentine uprising trigged by the introduction of the catasto is dealt with in L. Fabbri's *La sottomissione di Volterra allo stato fiorentino. Controllo istituzionale e strategie di governo*

(1361–1435), doctoral thesis, Università degli Studi di Firenze, 1994.
For the war against Filippo Maria Visconti from 1430 to 1433 see
C. C. Bayley's *War and Society in Renaissance Florence. The De mili-
tia of Leonardo Bruni* (Toronto: Toronto University Press, 1961, pp.
100–10); A. Baldrighi's 'La battaglia navale sul Po del 1431', in *ASL*,
1977, a. 103, pp. 331–36; P. Pertici's 'Condottieri senesi e la Rotta di
San Romano di Paolo Uccello', in *ASI*, 1999, a. clvii, pp. 551–62; F. C.
Pellegrini's *Sulla Repubblica Fiorentina a tempo di Cosimo il Vecchio*,
cit., pp. 46–77.

Paolo Guinigi's downfall is described in the first chapters of
M. E. Bratchel's *Lucca 1430–1494. The Reconstruction of an Italian
City-Republic* (New York: Oxford University Press, 1995); see also
P. Pertici's 'La caduta di Paolo Guinigi e la parte senese nei fatti di
Lucca', in *Quaderni Lucchesi sul Medioevo e sul Rinascimento*, 2003,
a. 4, nn. 1–2, pp. 207–37. For Brunelleschi's activities during the war
see P. Benigni e P. Ruschi's 'Il contributo di Filippo Brunelleschi
all'assedio di Lucca', in *Filippo Brunelleschi, la sua opera e il suo tempo*
(Florence: Centro Di, 1980, vol. 2, pp. 517–33).

For Neri Capponi see M. E. Mallett, s.v., in *DBI*, 1976, vol. 19, pp.
70–75. On the Capponis' Florentine politics see F. W. Kent's *House-
hold and Lineage in Renaissance Florence. The family life of the Cap-
poni, Ginori, and Rucellai* (Princeton: Princeton University Press,
1977).

CHAPTER 4: A CURE FOR THE STATE

The plan of the Anghiari fresco is published in J. P. Richter's *The
Notebooks of Leonardo da Vinci* (New York: Dover Publications, 1970,

vol. i, pp. 348–49). The struggle between the Albizzi and the Medici are described in D. Kent's *The Rise of the Medici Faction in Florence, 1426–1434* (Oxford: Oxford University Press, 1978).

For an excellent biographical profile of Filippo Maria Visconti, which also features a summary analysis of Italian politics during the first half of the fifteenth century, see G. Soldi Rondinini, s.v., in *DBI,* 1997, vol. xlvii, pp. 772–82.

For Francesco Sforza and his conquest of the March of Ancona see G. Benaducci's *Della signoria di Francesco Sforza nella Marca e peculiarmente in Tolentino (decembre 1433–agosto 1447)* (Tolentino: Filelfo, 1892); A. Gianandrea's 'Della signoria di Francesco Sforza nella Marca', in *ASL,* 1881, a. 8, pp. 68–108 e 315–47.

For the difficult relationship between Eugenius IV and Rome see L. Fumi's 'I Colonna contro Roma e papa Eugenio iv nel 1431', from the dispatches in the Municipal Archive of Orvieto, in *Bollettino della Deputazione di Storia Patria per l'Umbria, 1895,* vol. I, pp. 611–18. For Eugenius IV and the Council of Basel, see M. Decauwe's *A Successful Defeat: Eugenius IV's Struggle with the Council of Basel for ultimate Authority in the Church, 1431–1449* (Bruxelles: Brepols, 2010); J. W. Stieber's *Pope Eugenius IV, the Council of Basel, and the Secular and Ecclesiastical Authorities in the Empire. The Conflict over Supreme Authority and Power in the Church* (Leiden: Brill, 1978); D. L. Bilderback's 'Eugenius IV and the First Dissolution of the Council of Basle', in *Church History,* 1967, vol. xxxvi, pp. 243–53. For a biographical sketch of the Pontiff see D. Hay, s.v., in *DBI,* 1993, vol. xliii, pp. 496–502.

CHAPTER 5: A CARDINAL PROBLEM

For the cartoons of the Anghiari fresco see C. C. Bambach's 'The Purchases of Cartoon Paper for Leonardo's "Battle of Anghiari" and Michelangelo's "Battle of Cascina"', in *I Tatti Studies. Essays in the Renaissance* (Florence, 1999, vol. viii, pp. 105–33).

As for Cardinal Vitelleschi, I will refer the reader to the already cited article by J. E. Law, 'Giovanni Vitelleschi: 'prelato guerriero', in *Renaissance Studies*, 1998, vol. xii, a. 1, pp. 40–66. For the relationship between Eugenius IV and the Council of Basel, refer to the previous chapter. For the Council of Florence, see the essays in the volume edited by P. Viti, *Firenze e il Concilio del 1439*, from the conference held in Florence on November 29–December 2, 1989 (Florence: Olschki, 1994).

For Alfonso of Aragon's politics and his financial troubles see C. Cuadrada's 'Política italiana de Alfonso v de Aragón (1420–1442)', in *Acta Mediaevalia et archaeologica*, 1986–1987, nn. vii–viii, pp. 269–309; E. Dupré Theseider's *La politica italiana di Alfonso d'Aragona* (Bologna: Patron, 1956); A.J. Mira Jódar's 'La financiación de las empresas mediterráneas de Alfonso el Magnánimo. Bailía general, subsidios de Cortes y Crédito Institucional en Valencia (1419–1455)', in *Anuario de estudios medievales*, 2003, vol. xxxiii, pp. 695–727. For the conflict between Aragon and Anjou after the death of Joanna II see N. F. Faraglia's *Storia della lotta tra Alfonso v d'Aragona e Renato d'Angiò* (Lanciano: Tip. R. Carabba, 1908).

For Milan's occupation of Bologna see M. Longhi's 'Niccolò Piccinino in Bologna 1438–1443', in *Atti e memorie della R. Deputazione*

di Storia Patria per le Province di Romagna, 1905–1906, vol. xxiv, pp. 145–338 and 461–507; 1906–1907, vol. xxv, pp. 109–62 and 273–377.

For the wars in northern Italy from 1438 to 1440 one must pay special attention to G. Soranzo's 'Battaglie sul Garda nella guerra veneto-viscontea', in *Nova Historia*, 1962, a. 14, pp. 38–71; id., 'L'ultima campagna del Gattamelata al servizio della Repubblica Veneta (luglio 1438–gennaio 1440)', in *Archivio Veneto*, 1957, vols. lx–lxi, pp. 79–114.

CHAPTER 6: HORSES CAN'T EAT STONES

The comment that Job wouldn't have put up with Michelangelo Buonarroti for a single day can be found in G. Corti's 'Una ricordanza di Giovanni Battista Figiovanni', in *Paragone*, 1961, a. 12, n. 175, pp. 24–31. For Leonardo da Vinci's thoughts on painting, see C. J. Farago's *Leonardo da Vinci's Paragone. A Critical Interpretation with a New Edition of the Text* (Leiden: Brill, 1992); id., 'Leonardo's Battle of Anghiari. A Study in the Exchange between Theory and Practice', in *The Art Bulletin*, 1994, vol. lxxvi, n. 2, pp. 301–30.

For the political situation in Pistoia during the fifteenth century, see W. J. Connell's *La città dei crucci. Fazioni e clientele in uno stato repubblicano* (Florence: Nuova Toscana Editrice, 2000). The relationship between Guidi and Florence, as well as between Count Francesco and Niccolò Piccinino, is examined extensively in Chapter 6 of M. Bicchierai's *Ai confini della Repubblica di Firenze. Poppi dalla signoria dei conti Guidi al vicariato del Casentino, 1360–1480* (Florence: Olschki, 2005). As for Cardinal Trevisan, P. Paschini's

Lodovico Cardinal Camerlengo (Rome: Istituto grafico tiberino, 1939) remains invaluable. Piccinino's campaign in Tuscany and Umbria is described, albeit with some inaccuracies, in C. C. Bayley's *War and Society*, cit., pp. 162–67.

CHAPTER 7: THE LEOPARD'S LEAP

Although it is not entirely accurate, the finest reconstruction of the battle of Anghiari can be found in the second chapter of W. Block's *Die Condottieri*, cit., whose bibliography I also highly recommend. For a discussion of military heraldry, see essays by M. Predonzani, which are available online at www.stemmieimprese.it.

CHAPTER 8: THE TABLEAU OF POWER

For all aspects of the battle of Anghiari and the cult of St. Andrea Corsini associated with it, see G. Ciappelli's *Un santo alla battaglia di Anghiari. La 'Vita' e il culto di Andrea Corsini nella Firenze del Rinascimento* (Florence: Sismel Edizioni del Galluzzo, 2007).

For Filippo Maria Visconti's tarot cards see S. Bandera Bistoletti's *Tarocchi viscontei della Pinacoteca di Brera* (Milan: Martello libreria, 1991); G. Mulazzani's *I tarocchi viscontei e Bonifacio Bembo. Il mazzo di Yale* (Milan: Shell Italia, 1981).

Francesco Sforza's marriage to Bianca Maria Visconti is examined in M. Visioli's 'Le nozze ducali del 1441. Documenti e iconografia', in *Artes*, 2004, a. 12, pp. 43–52.

For Alfonso of Aragon's conquest of the Kingdom of Naples, see J. A. Blázquez's 'La conquista de Nápoles por Alfonso "el

Magnánimo"', in *Historia*, 2005, a. 16, n. 353, pp. 67–75. Also consult M. E. Soldani's 'Alfonso il Magnanimo in Italia. Pacificatore o crudele tiranno? Dinamiche politico-economiche e organizzazione del consenso nella prima fase della guerra con Firenze (1447–1448)', in *ASI*, 2007, a. clv, pp. 267–324.

The entrenchment of the Medici regime in Florence is richly described in N. Rubinstein's *The Government of Florence under the Medici (1434 to 1494)* (Oxford: Clarendon Press, 1966). For Baldaccio d'Anghiari and the political struggle in Florence, see L. Passerini's 'Baldaccio da Anghiari', in *ASI*, 1866, a. xxiv, pp. 131–66.

For the events in the wake of Filippo Maria Visconti's death and the Ambrosian Republic, see M. Spinelli's, *La Repubblica ambrosiana (1447–1450). Aspetti e problemi*, doctoral thesis, Università degli studi di Milano, 1990; L. Rossi's 'Firenze e Venezia dopo la battaglia di Caravaggio (14 settembre 1448)', in *ASI*, 1904, a. lxii, pp. 158–79.

As for the Treaty of Lodi and the Italic League, the following works are very useful: F. Antonini's 'La pace di Lodi ed i segreti maneggi che la prepararono', in *ASL*, 1930, a. lvii, pp. 233–96; C. Canetta's 'La pace di Lodi (9 aprile 1454)', in *RSI*, 1885, a. ii, pp. 516–64; P. Majocchi's 'Francesco Sforza e la Pace di Lodi, 9 aprile 1454', in *Archivio Storico Lodigiano*, 2008, a. cxxvii, pp. 141–204; G. Soranzo's *La Lega italica (1454–1455)* (Milan: Vita e Pensiero, 1923); P. Zanfini's 'La pace di Lodi (1454)', in the volume edited by A. Falcioni, *La signoria di Sigismondo Pandolfo Malatesti. Vol. II: La politica e le imprese militari* (Rimini: Ghigi, 2006, pp. 103–16). For Benozzo Gozzoli's frescoes in the Medici Palace see C. Acidini Luchinat and E. Daunt's *The Chapel of the Magi. Benozzo Gozzoli's Frescoes in the*

Palazzo Medici-Riccardi Florence (New York: W. W. Norton, 1994); M. Oxley's 'The Medici and Gozzoli's Magi', in *History Today*, 1994, vol. xliv, n. 12, pp. 16–21.

EPILOGUE: SAINT PETER

For Giorgio Vasari's work in the Palazzo Vecchio, see P. Tinagli Baxter's 'Rileggendo i "Ragionamenti"', in the volume edited by G. C. Garfagnini, *Giorgio Vasari tra decorazione ambientale e storiografia artistica* (Florence: Olschki, 1985, pp. 83–93).

The Florentine Republic after 1494 is closely examined in H. C. Butters's *Governors and Government in Early Sixteenth-Century Florence, 1502–1519* (Oxford: Clarendon Press, 1985). For Machiavelli's stances on historiography, see N. Capponi's *An Unlikely Prince. The Life and Times of Machiavelli* (Cambridge, Mass.: Da Capo Press, 2010, pp. 239–55).

A fair few of Maurizio Seracini's essays regarding his research to rediscover Leonardo da Vinci's lost fresco can be consulted online at www.sciencedirect.com.

NOTES

Abbreviations

ASF	Archivio di Stato di Firenze
	Florence State Archives
ASI	Archivio Storico italiano
	Italian Historical Archive
ASL	Archivio Storico lombardo
	Lombard Historical Archive
ASPN	Archivio Storico per le Provincie napoletane
	Historical Archive for the Neapolitan Provinces
ASRPS	Archivio della Società romana di Storia patria
	Roman Society's Archive for the History of the Motherland
ASV	Archivio di Stato di Venezia
	Venice State Archive
BMCV	Biblioteca del Museo Correr, Venezia
	Correr Museum's Library, Venice
c.	carta
	paper
CP	*Consulte e pratiche*
CS	*Carte strozziane*
CX	*Consiglio dei Dieci*
DBI	*Dizionario Biografico degli Italiani*, 72+ vols., Istituto della Enciclopedia italiana, Roma, 1960–.
MaP	*Mediceo avanti il Principato*
MP	*Mediceo del Principato*
n.	numero

NRS	Nuova Rivista Storica
r.	recto
RIS	*Rerum Italicarum Scriptores*, a cura di L. A. Muratori, 25 vols., Società Palatina, Milano, 1723–1751.
RRIISS	*Rerum Italicarum Scriptores*, nuova edizione, a cura di G. Carducci et alii, 33 vols., S. Lapi, Città di Castello e Zanichelli, Bologna, 1900–79.
RSI	Rivista storica italiana
r-v.	recto-verso
v.	verso
xB	*Dieci di Balìa*

•

1. *Serenissima*: from the Italian 'serenissimo', meaning the most serene, or happiest.
2. G. Capponi: 'Questi sono certi Ricordi, fatti da Gino di Neri Capponi, i quali fece in sua vecchiezza, quando stava in casa infermo del male, del quale si morì: e fu nell'anno 1420', in RIS, 1731, vol. xviii, p. 1149.
3. The title of 'King of the Romans' was reserved for the Roman Emperor (the official title of the head of the Holy Roman Empire) while he waited to be crowned as such by the Pope.
4. F. Flamini, *La lirica toscana del Rinascimento anteriore ai tempi del Magnifico* (Pisa: Nistri, 1891), p. 72.
5. Comment by Giovanni Morelli. 'Ricordi fatti in Firenze per Giovanni di Jacopo Morelli cittadino di quella', in I di San Luigi (ed.), *Delizie degli eruditi toscani*, vol. xix (Florence: Cambiagi, 1785), p. 43.
6. P. C. Decembrio, *Vita di Filippo Maria Visconti*, edited by E. Bartolini (Milan: Adelphi, 1983), p. 79.
7. Pius II (Enea Silvio Piccolomini), *La descrittione de l'Asia et Europa* (Venice: Vincenzo Vaugris, 1544), p. 267.
8. M. Mallett, *Mercenaries and Their Masters: Warfare in Renaissance Italy* (London: The Bodley Head, 1974), p. 54.
9. 'Diario di Palla di Noferi Strozzi', in *ASI*, 1883, s. iv, vol. xii, p. 21.
10. G. Cavalcanti, *Istorie fiorentine*, vol. I, edited by F. L. Polidori (Florence: All'insegna di Dante, 1838), p. 67.
11. H. von Aue, *Die Werke Hartmanns von Aue. IV. Gregorius*, edited by H. Paul and Max Niemeyer (Halle, 1882), pp. 40–41, vv. 1547–1553.
12. W. Caferro, *Mercenary Companies and the Decline of Siena* (Baltimore: Johns Hopkins University Press, 1998).
13. F. Belsanti, 'La situazione militare italiana nel primo Quattrocento. Una sintesi' in *Medioevo italiano*. Rassegna storica online, 2000, n. 1, pp. 12–17. www.storiaonline.org/mi/belsanti.situazione.pdf (26/08/2010).

14. F. Sacchetti, *Il Trecentonovelle*, edited by E. Faccioli (Turin: Einaudi, 1970, novella clxxxi).

15. The Italian verb *sforzare* means to cause bodily harm, and thus led to the nickname.

16. A. Minuti, 'Vita di Muzio Attendolo Sforza', edited by G. Porro Lambertenghi, in *Miscellanea di storia italiana*, 1869, vol. vii, p. 116.

17. C. J. Rogers, 'Tactics and the Face of Battle', in *European Warfare, 1350–1750*, edited by F. Tallett and D.J.B. Trim (Cambridge: Cambridge University Press, 2010), pp. 209–11.

18. A. K. Isaacs, 'Condottieri, stati e territori nell'Italia centrale', in *Federico da Montefeltro. Lo stato, le arti, la cultura*, vol. i, edited by G. Cerboni Baiardi, G. Chittolini and P. Floriani (Rome: Bulzoni, 1986, Lo stato), pp. 23–60.

19. M. N. Covini, 'In Lomellina nel Quattrocento: il declino delle stirpi locali e i "feudi accomprati"', in F. Cengarle, G. Chittolini, G. M. Varanini (eds.), *Poteri signorili e feudali nelle campagne dell'Italia settentrionale fra Tre e Quattrocento: fondamenti di legittimità e forme di esercizio* (Florence: Florence University Press, 2004), pp. 127–74. E-book available online at centri.univr.it/RM/e-book/dwnld/Poteri_signorili.pdf (27/08/2010).

20. M. Del Treppo, 'Sulla struttura della compagnia o condotta militare', in *Condottieri e uomini d'arme nell'Italia del Rinascimento*, edited by id. (Naples: Liguori, 2001), pp. 417–51. See also P. Blastenbrei, *Die Sforza und ihr Heer. Studien zur Struktur-, Wirtschafts- und Sozialgeschichte des Soldnerwesens in der italienischen Frührenaissance* (Heidelberg: Winter Universitätsverlag, 1987), pp. 101–106.

21. A. Settia, Comuni in guerra. *Armi ed eserciti nell'Italia delle città* (Bologna: Clueb, 1993), pp. 102–103.

22. H. A. Rennert, *History of Florence and of the Affairs of Italy by Niccolò Machiavelli* (M. W. Dunne, 1901). Accessed December 12, 2014. E-book available online at www.gutenberg.org/files/2464/2464-h/2464-h.htm.

23. G. Capponi, 'Ricordi', cit., p. 1150.

24. G. A. Campano, 'De vita et gestis Brachii', in *RIS*, 1731, vol. xxii, pp. 584–87.

25. G. Graziani, 'Cronaca della città di Perugia, dal 1309 al 1491', edited by A. Fabretti in *ASI*, 1850, s. i, vol. xvi, p. 513.

26. Literally, 'broken lances'.

27. M. N. Covini, 'Per la storia delle milizie viscontee. I familiari armigeri di Filippo Maria Visconti', in *L'età dei Visconti. Il dominio di Milano tra xiii e xv secolo*, edited by L. Chiappa Mauri, L. De Angelis Cappabianca and P. Mainoni (Milan: La Storia, 1998), pp. 35–63.

28. M. Mallett, *Mercenaries and Their Masters: Warfare in Renaissance Italy* (London: The Bodley Head, 1974, p.120).

29. W. Caferro, 'Continuity, Long-Term Service, and Permanent Forces: A Reassessment of the Florentine Army in the Fourteenth Century', in *The Journal of Modern History*, 2008, n. 80, pp. 219–51.

30. ASF, *xB, Responsive*, 9, c. 2r (copy of Belpetro Manelmi letter to Doge Francesco Foscari, February 14, 1431, from Brescia).

31. For the history of the Medici until Giovanni di Bicci, see G. A. Brucker, 'The Medici in the Fourteenth Century', in *Speculum*, 1957, a. 32, n. 1, pp. 1–26.

32. S. Tognetti, Il banco Cambin. *Affari e mercati di una compagnia mercantile-bancaria nella Firenze del xv secolo* (Florence: Olschki, 1999).

33. *ASF*, catasto 1427, Campioni, 975, c. 668r. W. Roscoe, *Life of Lorenzo de' Medici*, vol. I, appendix xii, p. 344.

34. *ASF*, Cp, 48, c. 123r (December 5, 1429).

35. G. Capponi, 'Ricordi', cit., p. 1150.

36. G. Cavalcanti, op. cit., p. 332.

37. C. Guasti (ed.), *Commissioni di Rinaldo Degli Albizzi per il Comune di Firenze dal 1399 al 1433*, vol. III (Florence: Cellini, 1873), p. 338.

38. The gonfalone was one of the administrative subdivisions in Florence. Each district was made up of four gonfalones, and there were sixteen of them in the entire city. For a family, the influence they wielded in their gonfalone was of crucial importance, since that was where the votes were counted for all elections to public posts, as well as where a candidate's finances were verified.

39. See N. A. Eckstein, *The District of the Green Dragon: Neighbourhood Life and Social Change in Renaissance Florence* (Florence: Olschki, 1995); F. W. Kent, *Household and Lineage in Renaissance Florence: The Family Life of the Capponi, Ginori, and Rucellai* (Princeton: Princeton University Press, 1977).

40. N. Capponi, 'Commentari di Neri di Gino Capponi di cose seguite in Italia. Dal 1419 al 1456', in *RIS*, 1751, vol. XVIII, p. 1169.

41. G. Morelli, 'Croniche di Giovanni di Jacopo e di Lionardo di Lorenzo Morelli', in I. di San Luigi (ed), *DET* (Cambiagi, Florence, 1785, vol. xix, p. 87).

42. C. Guasti (ed.), *Commissioni di Rinaldo Degli Albizzi per il Comune di Firenze dal 1399 al 1433*, vol. iii (Florence: Cellini, 1867), p. 506.

43. P. Pertici, 'Capolavori, condottieri dimenticati e qualche notizia bibliografica su Siena', in *Accademia dei Rozzi*, 2008, n. 15, p. 13.

44. J. Miller, L. Taylor-Mitchell, 'Donatello's "San Rossore", the Battle of San Romano and the Church of Ognissanti', in *The Burlington Magazine*, October 2006, n. 1243, pp. 685–88.

45. G. Cavalcanti, op. cit., pp. 469–71. The report written by the commissioner Luca degli Albizzi is published in P. Pertici, 'Condottieri senesi e la 'Rotta di San Romano' di Paolo Uccello', in *ASI*, 1999, vol. clvii, n. 581, pp. 551–62.

46. N. Machiavelli, op. cit., p. 171.

47. F. Caglioti, 'Nouveautés sur la Bataille de San Romano de Paolo Uccello', in *Revue du Louvre*, 2001, n. 4, pp. 37–54.

48. N. Capponi, op. cit., p. 1177. M. Palmieri, *Annales*, edited by G. Scaramella, Lapi, Città di Castello 1903, in *RRIISS*, vol. XVI, p. 1, pp. 135–36.

49. L. G. Boccia, 'Le armature di Paolo Uccello', in *L'arte*, 1970, nn. 11–12, pp. 59–91.

50. Pius II (Enea Silvio Picolomini), *La descrittione*, cit., p. 267. P. C. Decembrio, *Vita di Filippo Maria Visconti*, cit., p. 98.

51. H. Baron, *The Crisis of the Early Italian Renaissance: Civic Humanism and Republican Liberty in an Age of Classicism and Tyranny* (Princeton: Princeton University Press, 1966). A. Lanza, *Firenze contro Milano: gli intellettuali fiorentini nelle guerre con i Visconti, 1390–1440* (Anzio: De Rubeis, 1991). J. Hankins (ed.), *Renaissance Civic Humanism. Reappraisals and Reflections* (Cambridge: Cambridge University Press, 2000).

52. *Superba*: The Proud/Haughty one, in reference to Genoa's past glory and numerous monuments.

53. A. Gamberini, 'Principe, comunità e territori nel ducato di Milano. Spunti per una rilettura', in *Quaderni storici*, 2008, n. 127, pp. 243–65. G. Petti Balbi, 'Il consolato genovese di Tunisi nel Quattrocento', in *ASI*, 1998, vol. CLVI, n. 576, disp. Ii, pp. 227–56.

54. ASV, *CX, Misti*, reg. 11, cc. 37v–45r. A. Battistella, *Il conte Carmagnola. Studio storico con documenti inediti* (Stabilimento tip. e lit. dell'Annuario Generale d'Italia, Genova, 1889, pp. 339–63).

55. M. Mallett, *L'organizzazione militare di Venezia nel '400* (Rome: Jouvence, 1989), p. 54.

56. BMCV, 'Cod. Cicogna', in *Cronachetta Corner*, pp. 3–755.

57. J. Huizinga, *Autunno del Medioevo* (Florence: Sansoni, 1989).

58. L. Bellosi, 'The Chronology of Pisanello's Mantuan Frescoes Reconsidered', in *The Burlington Magazine*, October 1992, vol. cxxxiv, n. 1075, p. 659.

59. B. Facio, *De viris illustribus liber: nunc primum ex. ms. cod. in lucem erutus* (Florence: Joannis Pauli Giovannelli, 1745), p. 51. See also R. Panczenko, 'Cultura umanistica di Gentile da Fabriano', in *Artibus et Historiae*, 1983, a. iv, n. 8, pp. 27–75.

60. Pius II (Enea Silvio Piccolomini), *I commentari*, edited by G. Bernetti, vol. iv (Siena: Cantagalli, 1972), pp. 80–81.

61. P. C. Decembrio, *Vita di Filippo Maria Visconti*, cit., pp. 118–24.

62. G. Cavalcanti, op. cit., p. 509.

63. A. Fabroni, *Vita Magni Cosimi, Excudebat Alexander Landi in aedibus auctoris, Pisis*, vol. ii, p. 96.

64. R. De Roover, *The Rise and Decline of the Medici Bank* (Cambridge, Mass.: Harvard University Press, 1965), p. 54.

65. Families that belonged to the aristocracy and had thus been barred from seeking public office since the 1290s.

66. C. Guasti (ed.), *Commissioni*, cit., vol. iii, p. 588.

67. D. Kent, *The Rise of the Medici: Faction in Florence, 1426–1434* (Oxford: Oxford University Press, 1978), p. 199.

68. V. da Bisticci, *Vite di uomini illustri del xv secolo*, edited by L. Frati, vol. iii (Bologna: Romagnoli, 1892–1893), p. 164.

69. G. Cavalcanti, op. cit., p. 555.
70. D. Velluti, *La cronica domestica di Messer Donato Velluti, scritta fra il 1367 e il 1370, con le addizioni di Paolo Velluti, scritte fra il 1555 e il 1560 dai manoscritti originali*, edited by I. del Lungo and G. Volpi (Florence: Sansoni, 1914), p. 165.
71. A. Gelli, 'L'esilio di Cosimo de' Medici', in *ASI*, 1882, s. iv, vol. x, pp. 163.
72. ASF, *CS*, s. iii, a. cxii, c. 176r (Giovanni Strozzi to Matteo Strozzi, May 24, 1434).
73. F. Guicciardini, 'Ricordi di famiglia', in *Opere inedite di Francesco Guicciardini*, edited by G. Canestrini, vol. X (Florence: Cellini, 1867), p. 13.
74. Diplomatic documents drawn from Milanese Archives, edited by di L. Osio, vol. III (Milan: Bernardoni, 1877), pp. 111 (Francesco da Bologna to Niccolò Fortebracci, January 27, 1434).
75. M. Sanudo, *Le vite dei dogi, 1423–1474*, edited by A. Caracciolo Aricò, transcribed by C. Frison, vol. I (Venice: La Malcontenta, 1999), p. 128.
76. ASF, *MaP*, 4, n. 331, c. 347r (Giacomo Donaldo to Francesco di Giuliano de' Medici, September 11, 1434, from Venice).
77. G. Cavalcanti, op. cit., p. 580.
78. U. Martelli, *Ricordanze dal 1433 al 1483*, edited by F. Pezzarossa (Rome: Edizioni di storia e letteratura, 1989), p. 119.
79. The Italian verb *tartagliare* means 'to stutter'.
80. For Vitelleschi's biography: J. E. Law, 'Giovanni Vitelleschi: "prelato guerriero"', in *Renaissance Studies*, 1998, a. i, vol. XII, pp. 40–66.
81. M. F. Faraglia, *Storia della lotta fra Alfonso v d'Aragona e Renato d'Angiò* (Lanciano: Carabba, 1908).
82. For Alfonso of Aragon's Mediterranean politics see A. Rydler, *Alfonso the Magnanimous, King of Aragon, Naples, and Sicily 1396–1458* (Oxford: Oxford University Press, 1990).
83. C. C. Bayley, *War and Society in Renaissance Florence. The De Militia of Leonardo Bruni* (Toronto: University of Toronto Press, 1961), pp. 184–95.
84. F. Biondo, *Le decadi* (Forlì: Comune di Forlì, 1963), pp. 801–802.
85. J. M. Madurell Marimon, *Mensajeros barceloneses en la corte de Nápoles de Alfonso v de Aragón, 1435–1458*, doc. 84 (Barcelona: CSIC, 1963), pp. 156–58; G. Musso, 'Politica e cultura a Genova alla metà del Quattrocento', in *Miscellanea di storia ligure in onore di Giorgio Falco* (Milan: Feltrinelli, 1962), pp. 346–47.
86. N. Rubinstein, *The Government of Florence Under the Medici, 1434–94* (Oxford: Clarendon Press, 1966), pp. 11–14.
87. T. Earenfight, *The King's Other Body. María of Castile and the Crown of Aragon* (Philadelphia: University of Pennsylvania Press, 2009), pp. 76–80.
88. J. Davies, *Florence and Its University During the Early Renaissance* (Leiden: Brill, 1998), pp. 85–86.
89. G. Morelli, op. cit., p. 149.
90. A. Field, 'Leonardo Bruni, Florentine Traitor? Bruni, the Medici, and an

Aretine Conspiracy of 1437', in *Renaissance Quarterly*, 1998, a. li, n. 4, pp. 1109–50.

91. For a detailed discussion on the affair involving Paolo Uccello's fresco, see H. Hudson, *Paolo Uccello. Artist of the Florentine Renaissance Republic* (Saarbrücken: VDM Verlag, 2008).

92. L. Pastor, *The History of the Popes from the Close of the Middle Ages*, vol. I (London: Routledge and Kegan Paul, 1906), p. 311.

93. G. Canestrini, 'Documenti per servire alla storia della milizia italiana: dal xiii secolo al xvi', in *ASI*, 1851, s. xv, vol. xxvi, pp. 146–53.

94. G. Cavalcanti, op. cit., vol. ii, p. 67.

95. P. C. Decembrio, 'Vita di Niccolò Piccinino', in RIS, 1751, vol. XXI, p. 1080.

96. G. Mancini, *Vita di Lorenzo Valla* (Florence: Sansoni, 1891), p. 290.

97. L. Pastor, op. cit., pp. 398–99.

98. ASF, *MaP*, xiii, n. 110 (Bartolomeo Vitelleschi to Cosimo and Lorenzo de' Medici, March 26, 1440, from Siena).

99. L. Bonincontri, 'Annales', in *RIS*, 1751, vol. XXI, p. 149.

100. S. Ammirato, *Istorie fiorentine*, vol. VII (Florence: Marchini e Becherini, 1826), p. 291.

101. G. Cavalcanti, op. cit., vol. ii, pp. 76–85.

102. G. F. Poggio Bracciolini, *Historia de messer Poggio tradocta di latino in nostra lingua da Iacopo suo figliuolo* (Venice: Iacopo de' Rossi, 1476, p.n.n. at the end of the seventh book).

103. G. Cavalcanti, op. cit., vol. ii, pp. 87–92.

104. G. di Pagolo Morelli, 'Ricordi', in V. Branca, *Mercanti scrittori* (Milan: Rusconi, 1986), p. 247.

105. ASF, *MaP*, xi, n. 59 (Francesco Guidi to Cosimo de' Medici, February 15, 1435).

106. G. Capponi, 'Ricordi', cit., p. 1150.

107. N. Machiavelli, op. cit., p. 266. English translation: A. Gilbert, *Machiavelli: The Chief Works and Others, Volume 3 edited by Niccolò Machiavelli* (Durham, NC: Duke University Press Books, 1989), p. 1275.

108. M. Sanudo, op. cit., p. 321. To this day, Trevisan is still know under the spurious name of 'Scarampi', see P. Paschini, 'La famiglia di Lodovico Cardinal camerlengo', in *L'Arcadia*, a. v, 1926, p. 91.

109. G. Cavalcanti, op. cit., vol. ii, p. 127; N. Capponi, 'Commentari', cit., p. 1194.

110. ASF, *xB, Responsive*, 16, c. 1771 (Neri Capponi to the Dieci, May 5, 1440, from Arezzo).

111. Ibid., 15, c. 191 (Neri Capponi and Luigi Guicciardini to the Dieci, May 25, 1440).

112. F. Biondo, op. cit., p. 898.

113. G. Cavalcanti, op. cit., vol. ii, p. 128.

114. N. Capponi, 'La cacciata del conte di Poppi e acquisto di quello stato pel

popolo fiorentino', in *RIS*, 1751, vol. XVIII, p. 1219.

115. G. Graziani, op. cit., p. 454.

116. Ibid., p. 457.

117. Ser Giusto Giusti D'Anghiari, 'I giornali (1437–1482)', edited by N. Newbigin, in *Letteratura italiana antica*, 2002, III, p. 63.

118. P. C. Decembrio, *Vita di Niccolò Piccinino*, cit., p. 1081.

119. ASF, *xB, Responsive*, 17, c. 318 (Neri Capponi and Bernardetto de' Medici to the Dieci, June 29, 1440).

120. Anonymous, 'La fuga del capitano', in A. Fabretti, *Biografie dei capitani venturieri dell'Umbria. Scritte e illustrate con documenti* (Montepulciano: Angiolo Fumi, 1842, single volume), p. 251.

121. Cfr. M. Predonzani, *Stemmi e imprese della battaglia di Anghiari dipinta sul fronte di cassone conservato alla National Gallery di Dublino*, www.stemmie-imprese.it/anghiaridublino.htm Accessed: 28/07/2010.

122. F. Biondo, op. cit., p. 906.

123. A trotting horse can achieve a velocity of roughly thirty kilometres per hour; however, it's quite likely that Piccinino's riders had gone at a slower pace so as not to exhaust their horses.

124. G. B. Poggio, 'Vita di Niccolò Piccinino', in *L'Historie et vite di Braccio Fortebracci detto da Montone, et di Nicolo Piccinino Perugians. Scritte in latino, quella da Gio. Antonio Campano, e questa da Giovambattista Poggio Fiorentino, e tradotte in volgare da M. Pompeo Pellini Perugino* (Venice: Francesco Zilletti, 1572), p. 167.

125. ASF, *MaP*, LXXXIX, n. 94 (Copy of letter by Neri Capponi and Bernardetto de' Medici, June 30, 1440).

126. Anonymous, 'La fuga del capitano', in op. cit., p. 265.

127. L. Taglieschi, *Annali della terra d'Anghiari* (Sansepolcro: Grafiche Borgo, 2005), p. 172.

128. Cfr. P. C. Decembrio, *Vita di Niccolò Piccinino*, cit., p. 1082. F. Biondo, op. cit., p. 907; G. B. Poggio, 'Vita di Niccolò Piccinino', in cit., p. 167.

129. F. Biondo, op. cit., p. 907.

130. 'Iacopo Guicciardini to Francesco Guicciardini, April 23 1512', in *Opere inedite di Francesco Guicciardini*, vol. vi (Florence: Cellini, 1864), p. 39.

131. F. Biondo, op. cit., p. 907.

132. L. Spirito, *Incomincia il libro chiamato Altro Marte: della vita [e] gesti dello illustrissimo [e] potentissimo capitanio Nicolo Picinino da Perosa, Visconti de Aragonia*, Book Two, Chapter 2, LVIII (Verona: Simone Bevilacqua, 1489), pp. 132–33.

133. Anonymous, 'La fuga del capitano', in cit., p. 267.

134. ASF, *MaP*, XI, n. 402 (Micheletto Attendolo to Cosimo de' Medici, July 7, 1440, from Celle).

135. ASF, *MaP*, LXXXIX, n. 94 (copy of letter by Neri Capponi and Bernardetto de' Medici, June 30, 1440).

136. N. Capponi, 'Commentari', cit., p. 1195.

137. B. Platina, 'Historia Urbis Mantuae ab eius origine usque ad annum mcdlx', in *RIS*, 1731, vol. XX, pp. 835–36.
138. For this incident, see A. Gow, G. Griffiths, 'Pope Eugenius IV and Jewish Money-Lending in Florence. The Case of Salomone di Bonaventura during the Chancellorship of Leonardo Bruni', in *Renaissance Quarterly*, 1994, 47, 2, pp. 282–39.
139. G. Capponi, *Storia della repubblica di Firenze* (Barbera, Florence, 1875, vol. ii, p. 25).
140. ASF, *xB, Responsive*, 18, c. 164 (Neri Capponi to the Dieci di Balìa, July 7, 1440).
141. G. Capponi, Storia della repubblica di Firenze, cit., p. 25.
142. N. Capponi, 'La cacciata', cit., p. 1220.
143. G. Capponi, Storia della repubblica di Firenze, cit., p. 25.
144. ASF, *MaP*, XI, n. 402 (Micheletto Attendolo to Cosimo de' Medici, July 7, 1440, from Celle).
145. ASF, *MaP*, XI, n. 389r (Bernardetto de' Medici and Neri Capponi to Cosimo de' Medici, June 29, 1440).
146. F. Sacchetti, op. cit., novella CLIII.
147. F. Caglioti, 'Nouveautés sur la Bataille de San Romano de Paolo Uccello', in *Revue du Louvre*, 2001, 4, pp. 37–54. A. Roy, D. Gordon, 'Uccello's Battle of San Romano', in *The National Gallery Technical Bulletin*, 2001, 22, 1, pp. 4–17. The hypothesis that at least two panels of the battle of San Romano actually depicted scenes from the battle of Anghiari was first put forward in P. Roccasecca, *Paolo Uccello. Le battaglie* (Milan: Electa, 1997).
148. M. Sanudo, op. cit., p. 339.
149. P. C. Decembrio, *Vita di Filippo Maria Visconti*, cit., p. 125.
150. G. P. Cagnola, 'Storia di Milano', in *ASI*, 1842, vol. III, p. 54.
151. E. Ricotti, *Compagnie di ventura*, III, pp. 82–83.
152. N. Machiavelli, op. cit., p. 285.
153. V. Da Bisticci, op. cit., p. 171.
154. P. C. Decembrio, *Vita di Filippo Maria Visconti*, cit., p. 128.
155. M. A. Sabellico, *Historia Venitiana*, p. 422.
156. F. Guicciardini, *Storie Fiorentine*, p. 9.
157. Cfr. R. Fubini, *Italia quattrocentesca. Politica e diplomazia nell'età di Lorenzo il Magnifico* (Rome: Franco Angeli, 1994), pp. 224–25.
158. H. Hudson, 'The Politics of War. Paolo Uccello's Equestrian Monument for Sir John Hawkwood in the Cathedral of Florence', in *Parergon*, 2006, 23, 2, pp. 1–28.
159. Decree issued by Charles VII of France on July 7, 1438, which required a council with authority over the Pope to be convened every decade.
160. N. Machiavelli, op. cit., p. 305.
161. Pius II (Enea Silvio Piccolomini), *Commentarii rerum memorabilium, quae temporibus suis contigerunt* (Rome: Domenico Basa, 1584), p. 89.
162. Technically, Francesco Sforza was merely the Lord of Milan. The Milanese granted him the title of Duke in the wake of his conquest of Lombardy,

and he was recognised as such by other Italian rulers only after the Treaty of Lodi. However, as Milan was a feud of the Holy Roman Empire, only the Emperor himself could legally elevate him to a duke, a title eventually bestowed on Francesco's son Ludovico Sforza, nicknamed 'The Moor', in 1494.

163. S. Ferente, *La sfortuna di Jacopo Piccinino. Storia dei bracceschi in Italia 1423–1465* (Florence: Olschki, 2005), p. 166.

164. ASF, *MP*, 219, c. 70r (Cosimo I de' Medici to Giorgio Vasari, March 14, 1563, from Pisa).

165. G. Vasari, *Le vite de' più eccellenti architetti, pittori, et scultori italiani*, vol. III (Florence: Lorenzo Torrentino, 1550), p. 573.

166. For a description of the painting's development, see J. P. Richter (ed.), *The Notebooks of Leonardo da Vinci*, vol. I (New York: Dover Editions, 1970), pp. 348–49.

167. N. Machiavelli, op. cit., p. 271. English translations: C. E. Detmold, *The historical, political, and diplomatic writings of Niccolò Machiavelli* (Oxford: Oxford University, 1882), pp. 261–62.

168. W. Block, 'Die Condottieri. Studien über die sogenannten "unblutige Schlachten"', in *Historische Studien*, 110 (Berlin, 1913).

169. For the events surrounding this case see R. Hatfield, Finding Leonardo. *The Case for Recovering the Battle of Anghiari* (Florence: The Florentine Press, 2007).

INDEX